A HISTORY OF BISHOP'S CLEEVE AND WOODMANCOTE

A HISTORY OF BISHOP'S CLEEVE AND WOODMANCOTE

DAVID H. ALDRED

David H. Aldred

AMBERLEY

First published 2009

Amberley Publishing Plc
Cirencester Road, Chalford,
Stroud, Gloucestershire, GL6 8PE

www.amberleybooks.com

British Library Cataloguing in Publication Data.
A catalogue record for this book is available from the British Library.

ISBN 978 1 84868 727 1

Typesetting and Origination byAmberley Publishing
Printed in Great Britain

CONTENTS

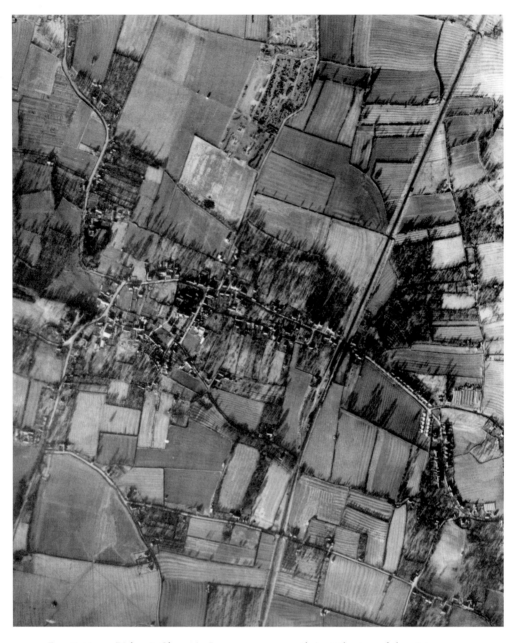

Frontispiece: Bishop's Cleeve in January 1947; north is at the top of the picture. The ridge and furrow of medieval farming still dominates the farmland. The pattern of the village had changed little for centuries. Only Crowfield in Woodmancote is a new development. (English Heritage [NMR] RAF photography)

PREFACE

A book of this nature could not have been written without the help and support of many people. Most of the documentary evidence lies in Gloucestershire Archives and I would like to thank the staff who over many years have been unfailingly helpful. The interest and help of the staff at Cheltenham Local Studies and Bishop's Cleeve libraries have never failed. I have profited enormously from the expertise of Gloucestershire County Council's Archaeological Services (GCCAS), in particular Charles Parry, Eloise Marwick and Kurt Adams. Alistair Barber and Dawn Enright of Cotswold Archaeology guided me through their excavations in Bishop's Cleeve and Kevin Colls of Birmingham Archaeology has shared his findings of the Dean's Lea site.

I am indebted to a number of people who have been willing to discuss my on-going work. I owe most to Christopher Dyer of Leicester University who has been a companion in the quest almost since its origins, not only for commenting upon the text, but also by kindly making available his transcripts of the records of the Bishops of Worcester and rectors of Bishop's Cleeve. He and Joe Bettey, Steven Bassett, Michael Hare, Carolyn Heighway, Neil Holbrook and Charles Parry have generously commented upon early drafts to prevent my straying too far from the evidence.

A number of local people have been generous with their knowledge and support: Peter Badham, Peter Cresswell, Mary Hughes, Don Leech, Margaret Minett, Stuart Minett, Eunice Powell, the late Bernard and Barbara Rawes, Trixie Reed, Eileen and Hemming Shipway, Thelma and Alec Stevenson. Then there are an untold number of residents who over many years have allowed me to visit their homes and take photographs. Several have moved on and have probably forgotten my visit, but I remain in their debt. Particular thanks must go to the late Hugh Denham for including me on so many of his visits to various houses in Woodmancote and to Sheila Denham who made available Hugh's history notes, which are now in Gloucestershire Archives (D9965).

My old school friend Tim Curr has accompanied me many times on my walks around the area and stimulated my thinking on what we saw. He also supplied several photographs from his extensive collection. Julian Rawes has kindly allowed me to use material from his father Bernard.

I must acknowledge the members of a long-suffering family. My mother has always been interested in local history and has spurred me on. Sons Peter and Tim were my companions on many occasions. In our fieldwalking along the line of the bypass they really did support the archaeologists' theory that the eyes of eight-year-olds are at the optimum distance above the ground for noticing artefacts! My wife Margaret has supported me through the long writing-up.

Despite all the assistance I have received I alone am responsible, of course, for what now follows.

David Aldred
June 2009

CONVENTIONS

Personal names and place names have been given in their modern form. Where there is some doubt the original name has been used and placed in *italics*. Distance and area have been given in both metric and imperial measures, but I have made no effort to decimalise money, for values have changed too much for this to make sense. £1 was worth 20s and 240d. Acknowledgement for permission to publish has been placed in brackets at the end of the relevent captions. I have made every effort to contact copyright holders.

INTRODUCTION

Several delightful villages cluster round Cheltenham, particularly under the hills … To the north, Bishop's Cleeve lies under the shadow of the great escarpment that rears its bare head above wooded slopes, the highest point in the whole Cotswold range, well named Cleeve Cloud.
J.D. Newth, *Gloucestershire*, 1927.

This is a book I have been waiting to write for over 20 years, in fact since before my book on Cleeve Hill appeared in 1990. Yet it seemed sensible to wait, for it appeared obvious that from the late 1980s Bishop's Cleeve would be subjected to an enormous expansion linked to the new bypass. This expansion looked likely to add greatly to our knowledge of the early history of the area and so it has proved. Now that this particular development appears to be coming to an end it seems reasonable to try to bring together all the evidence of landscape and document into a narrative history that would be attractive to those who have known the area for a long time, to those who have moved in and to anyone else who has an interest in what has gone before. This has been my intention in writing the book.

I have chosen to write a narrative history, as I believe this has the greatest appeal to the general reader, but it does have its dangers. In order to make it more readable the story is divided into chapters but this could lead to the impression that the past was actually divided in this way, when the chapter is no more than a convenience for making the story more intelligible. There is also the danger that the past can only seem important because it explains the present and I have tried to guard against this by stressing that the people who lived in the past lived in their present and must therefore be seen in their own terms.

In order to bring some continuity to the story I have introduced themes; the main one being that over time people's experiences became increasingly

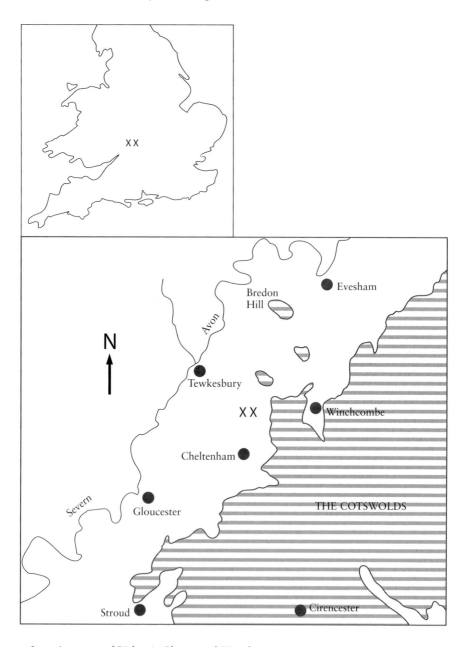

1 Location map of Bishop's Cleeve and Woodmancote

differentiated, that means that each person's experience became increasingly different from that of anyone else. At the start of our story everybody lived by hunting and collecting; now hardly any two people share exactly the same daily experiences. I have also been anxious to introduce other themes, of home and work and leisure, and I have tried to dispel some of the myths about the past when the evidence does not support them. These range from the nature of the landscape before the Saxon period to the Victorian values as they affected the church and the family in the nineteenth century. At all times I have tried to relate the story to what can still be seen in and around the villages today. I hope the illustrations will make these links clearer.

The main constraint has been the fragmentary nature of the evidence. Different evidence survives from different times in the past and therefore it has not been possible always to make direct comparisons across the years. For the prehistoric period we have to rely on physical objects; we have no written documents. When the documents begin to appear they are very limited so that in the Anglo-Saxon period we know more about the landscape on the boundaries of the settlement, but in the later Middle Ages we know more about how the villagers lived but not so much about the landscape. Not until the sixteenth century do we find reasonably accurate records (of baptisms, marriages and burials) which can be used to understand what was happening to the population. From the nineteenth century onwards the problem becomes one of too much material and I have had to be especially careful that the selection I have made to continue my story has enabled me to write a reasonably accurate account.

Why is this the story of both Bishop's Cleeve and Woodmancote? The simple explanation is that until 1953 the boundaries had artificially divided the one community of Bishop's Cleeve. For over 600 years they were both in the same manor of the Bishop of Worcester and so it is often impossible to distinguish them in his records. The Saxon land grants which gave rise to the ancient ecclesiastical parish of Cleeve also included the neighbouring settlements of Gotherington, Southam and Brockhampton and Stoke Orchard and from time to time our story would not be complete without reference to these places. Then in the Romano-British and prehistoric periods we have no knowledge of land boundaries and so I have sometimes strayed a little farther in order to increase our understanding of what was happening. Yet this is essentially my story of Bishop's Cleeve and Woodmancote. It is based on the surviving evidence and it has been written to help all those who have an interest in the villages to understand them better by tracing their development over the last 12,000 years. Our story begins with just two people and ends with nearly 15,000.

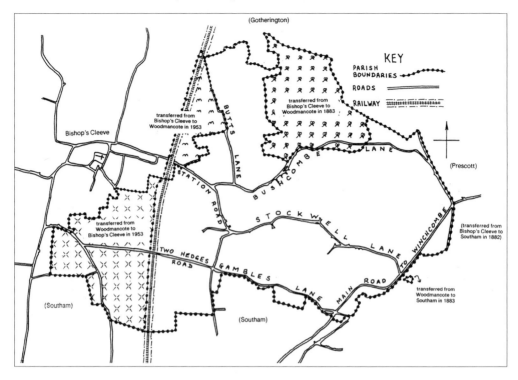

2 This delightful map from *The Woodmancote Book* illustrates well the complicated boundaries between Bishop's Cleeve and Woodmancote until 1953. (D. Beaumont)

SOURCES AND FURTHER READING

There are very few publications which cover the history of Bishop's Cleeve and Woodmancote; therefore the purpose of this book is to fill that gap. However two volumes are of use: C.R. Elrington (ed.) *The Victoria History of the County of Gloucester* Vol. VIII (Oxford University Press 1968) pp. 1-25; and Hugh Denham *The Woodmancote Book* (Privately published [Woodmancote] 1997).

I

THE STORY BEGINS
(BEFORE *c*.AD 500)

Numerous evaluations and excavations have taken place since 1989 in response to the rapid expansion of the village, if such it can still be called. Remains of virtually all periods between the Bronze Age and the 18th century AD have been revealed.

Neil Holbrook in *Twenty Five Years of Archaeology in Gloucestershire*, 2003

THE FIRST STEPS

Our story starts with a middle-aged woman buried in a stone-lined grave over 1700 years ago. She was 1.56m tall (5ft 1in) suffering pain from osteoarthritis, gum disease and severe tooth decay. Who was she? In her lifetime she had been a daughter and possibly a sister, wife, mother and friend. To Charles Parry of the Gloucestershire Excavation Unit who led the team of archaeologists in the excavations at Gilder's Paddock in 1989, she was Skeleton 228. To us she could be one of the earliest known residents of Bishop's Cleeve. Seven graves (four adults and three children) were found here in 1989. Although there was no proof that they had spent their lives in Bishop's Cleeve, it was usual for people at this time to be buried near the settlement where they lived. Charles identified this small cemetery on the eastern edge of a small settlement at Home Farm, now Lidl.

In 1997 five similar burials were discovered in Stoke Road near the entrance to Stoke Park Close. Here we might find our earliest male resident, again identified only by the archaeologists' label, as Burial B. Only 70 per cent of the skeleton survived but this provided enough evidence to show that he had been well over the average height of 1.75m (5ft 8in). He had been 1.86m tall (6ft 1in) and his muscular frame suggested that had he lived a physically demanding life. Like Skeleton 228 he had latterly suffered much pain, from

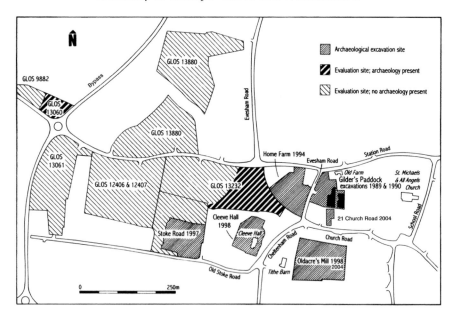

3 The key excavations in the centre of Bishop's Cleeve used in this chapter, based on a plan by Charles Parry (GCCAS). The plan also shows areas close to the centre where no finds were made

a degenerative disc disease, from the beginnings of osteoarthritis and from a long-standing toe infection which must have made it difficult to walk. Unfortunately the missing bones included his skull, so no further conclusions could be drawn. Two fragments of pottery suggested all the burials belonged to the third or fourth century AD – the Romano-British period.

For the moment, these 12 burials represent the earliest inhabitants of what became Bishop's Cleeve, if we discount the four undated fragments of a skull found on the line of the bypass near The Grange in 1988 and the two Iron Age skeletons found at Dean's Lea in 2005, for these lay outside the heart of the present village. Yet what the 12 tell us remains tantalisingly limited. Not one is complete, as centuries of digging, ditching and ploughing cut into their resting places. Burial B had lost his skull when a later Roman ditch cut through his grave. We can only speculate the ditch diggers' reaction, but it perhaps indicates the grave had not been marked with a gravestone. Did they destroy other burials there? The number of graves is low when all the other evidence suggests long-term human activity in the area. We don't really know why, except such finds might have been unrecorded in earlier centuries; a report in the *Cheltenham Examiner* in February 1887 recorded 'Roman remains at Bishop's Cleeve' with a reference to a burial found at Home Farm.

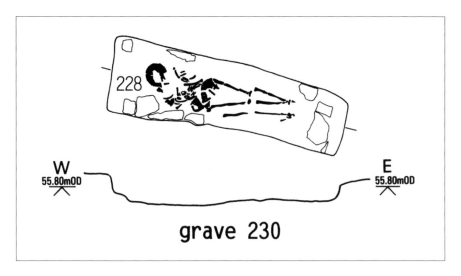

4 Skeleton 228 from the archaeologists' report. (Charles Parry GCCAS)

At the moment all we can say definitely is that our knowledge of the village in the prehistoric and Romano-British periods (*c*.10,000 BC-*c*.AD 500) has mushroomed with its expansion since the late 1980s. So what story is emerging of the earliest known history of Bishop's Cleeve and Woodmancote? This chapter attempts to tell it.

THE IMPACT OF MODERN ARCHAEOLOGY

When the *Victoria County History* began its account of the history of Bishop's Cleeve in 1968 the author began with the sentence, 'The number of prehistoric earthworks is a feature of the parish'. These earthworks on Cleeve and Nottingham Hills have been recognized for least 200 years. Our knowledge of prehistory only 40 years ago was still dominated by such upland features, which had led people to the conclusion that before the arrival of the Saxons in the eighth century, the Severn Vale remained a vast area of impenetrable woodland. Then came the revolution in archaeological thinking. The very next year (1969) the M5 motorway was carved through the vale; approximately every kilometre (half mile) a previously unknown Iron Age (*c*.800 BC-AD 43) or Romano-British (AD 43-*c*.AD 500) site was discovered, one of which was excavated at nearby Tredington. 'The archaeology of Gloucestershire was made' exclaimed archaeologist Peter Fowler of Bristol University who led the investigations. Every patch of well-drained sand and gravel seemed

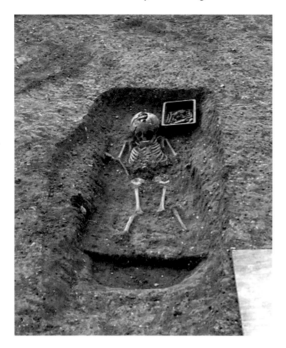

5 The skeleton of a child aged 3-4 can be seen here in Gilder's Paddock cemetery

to have attracted settlement of some sort on the otherwise heavy lias clay of the lower Severn Vale. Archaeologists began to look at other sand and gravel scatters for more settlements ... and they began to find them. Not many at first, but then two different threads came together in Bishop's Cleeve to ensure an explosion of knowledge. The first emerged in 1970 when Gloucestershire County Council selected the already expanding village as a preferred area for population growth within the county. The nature of the quality of the landscape protected by the Cotswold Area of Outstanding Natural Beauty prevented large-scale growth to the east, so the area of most expansion lay on the fields to the south and west. The proposals were fleshed out in 1974 and developments were proposed in conjunction with a bypass. The final details were published by Tewkesbury Borough Council in May 1988 outlining the line of the bypass and six phases of development. Work started in 1989.

The second strand came from national government in November 1990. Despite the bureaucratic title of Planning Policy Guidance note 16, or PPG16 as it became known, the note made developers fund archaeological investigation of areas they wanted to develop. Its importance can be seen from the statistics that in Gloucestershire alone the number of excavations of Iron Age sites in the Severn Vale and Cotswolds doubled from just over 60 in 1980-89 to over 120 in 1990-99. Although it came after much development along the bypass had actually received planning permission, the message it gave out did

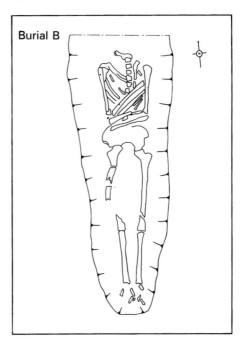

6 Burial B from Stoke Road.
(Cotswold Archaeology)

encourage developers to fund excavation. Modern archaeologists are skilled at extracting every last bit of information from their excavations. It was no surprise, then, that the findings revolutionised our knowledge and showed clearly that 2000 years ago there already existed a well-developed landscape of small farms surrounded by enclosures and hedged fields. However, the impact of PPG16 has not been straightforward. Neil Holbrook of Cotswold Archaeology has remarked that his organisation is but one of five which have been awarded contracts to investigate different areas of development in Bishop's Cleeve, and as Neil has commented, they have not been obliged to work with each other to create an overall picture. Another issue from PPG16 is that the sites are chosen because of modern needs and not archaeological value, although most have subsequently unearthed some significant features and finds, in doing so, of course, the site is destroyed so there is no chance of a second look. The present situation also highlights what might have been lost in the earlier expansion of Bishop's Cleeve and Woodmancote since 1940. However, we must remember that developer-funded archaeology, although of tremendous importance, has not been the only means to unlock the secrets hidden in the landscape. Amateur archaeologists fieldwalking to pick up recognisable artefacts, mostly pottery sherds and flints, had already found several sites before 1995. The late Bernard and Barbara Rawes of the Gloucester and District Archaeological Research Group were particularly

7 Gloucestershire County Council's proposals for the development in Bishop's Cleeve were published in March 1974

active in our area. We shall meet Bernard's work again later in this chapter. In concluding this summary of recent archaeological developments, readers particularly interested in Woodmancote will no doubt have noted that most of this knowledge is of Bishop's Cleeve. Woodmancote still seems to be a blank for archaeology, between the riches of the vale and the well-known features on Cleeve and Nottingham Hills, and its story will emerge more slowly. But what is the story which seems to be emerging from the archaeological record of the nature of Bishop's Cleeve before the end of the fifth century AD?

IN SEARCH OF THE EARLIEST PEOPLE

About 12,000 years ago the glaciers of the last Ice Age began to retreat from their southernmost edge around Bredon Hill. For the next 6000 years the climate gradually warmed to be similar to today's. This was followed by a slight deterioration, and then it fluctuated so that by the first century BC it was again very similar to that of today. Bishop's Cleeve and Woodmancote lie at the junction of two distinct landscape zones – the Severn Vale and the Cotswold Hills. However, they both lie in what might be called the lower Severn Valley catchment area, with the local streams flowing westwards off

the scarp into the River Severn – Dean Brook, Hyde Brook and Tirle Brook. This brings a unity to the area which might be helpful for our understanding (*colour plate 1*). As the glaciers retreated, areas of well-drained sands and gravels, attractive to settlers, were spread across the lias clay of the vale. Today the area is mostly classified as Grade 3 agricultural land, i.e. suitable for both arable and pasture (crops and animals).

Our knowledge of the emerging local landscape comes from investigations during the 1970s in the River Severn flood plain. Trapped in the sediments lay pollen to show that, at first, lime was the most common tree, together with smaller quantities of oak, elm and hazel, indicating that deciduous woodland began to cover the area as the climate warmed. The earliest evidence for the appearance of humans into this landscape is very limited. In Bishop's Cleeve all we have is a single flint blade dated *c*.15,000 BC-*c*.10,000 BC found near Cleeve Hall in 2002. Flint does not occur naturally within 100 miles of the county so its presence in any period not only denotes human activity, but also trade. Very little else is known of the Palaeolithic (Old Stone Age) period and not until after *c*.6500 BC, in the period known as the Mesolithic (Middle Stone Age), do finds become more numerous.

The untutored eye might never recognise tiny fragments of flint, but to the archaeologist they provide evidence for small groups of people who lived by hunting and collecting. In 1984 Alan Saville in *Archaeology in Gloucestershire* noted the existence of 40 known Mesolithic sites from the Cotswolds. During the next seven years over 50 new sites were discovered as people began to recognise the significance of the tiny flints picked from ploughed fields. Scatters of these small fragments probably represented the temporary halts of the hunter-gatherers as they followed their animal prey. As the weather warmed to the level of our recent summers and as the rain fell plentifully, elm, alder and oak became more common, but lime still dominated the tree cover. In the lower Severn Vale only a handful of Mesolithic sites have been recorded, but the excavations in Bishop's Cleeve reinforce the theory that it might be the result of a lack of searching and recognition rather than the lack of actual evidence, because some microliths have turned up in the excavation of sites of other periods. Three were found in Bernard Rawes' excavation (1975-84) at Haymes Farm on the western slope of Cleeve Hill and a single microlith was found in the 1997 excavations in Stoke Road. This is hardly overwhelming evidence and certainly not evidence of occupation, but fits into a pattern of small-scale clearances of woodland. Even at this early time we must not think of woodland in the vale as dense and impenetrable. There were many clearances as a result of nature as the trees grew old and died. Today's visitor to the Forest of Dean will notice how young saplings have to be protected from damage, especially from deer. Over 8000 years ago there

was no Forestry Commission to lend a helping hand to regenerate woodland, and natural events such as storms and fires could create clearings without any help from humans, although no doubt Mesolithic people did create clearings where animals could graze and where they would be easier to track down and kill: deer, wild pig and wild cattle, to which they added a whole range of woodland fruits including hazelnuts.

This way of life began to fade *c*.4000 BC as farming developed in Britain and the first great human revolution took place as the hunter-gatherer way of life was gradually replaced by farming based on the rearing of cattle, pigs, sheep and goats and the somewhat later development of early strains of wheat and barley. Archaeologists still debate how this happened. They generally agree that change was slow, taking more than 500 years. Mesolithic people were practising a very simple form of farming when they herded the wild animals within the clearings. They probably trained more docile wolves to help in hunting as dogs, but the domesticated strains of cattle, pigs, sheep and goats, together with the seeds of wheat and barley, came from the continent. Were they just traded or did their users migrate here bringing this new way of life with them? Recent studies of human DNA suggest that only one in five people in Western Europe are descended from the first farmers who spread from the Middle East with their ideas. That leaves 80 per cent descended from the native populations who gradually adopted the new ideas and way of life, but the debate continues and we have no local information.

During the Neolithic (New Stone Age) period, which lasted about 2000 years (*c*.4000 BC-*c*.2000 BC) clearings were developed into much larger areas of grassland. According to archaeologist Francis Pryor, the population of Britain increased in these years from about 100,000 to 250,000. Evidence from elsewhere, from Kempley in the Severn Vale and Hazleton on the Cotswolds, suggests larger scale clearances of the woodlands were taking place between *c*.4000 BC and *c*.3000 BC, especially as lime was being used at the time for animal feed. Now the archaeologists have more evidence, not just flints, but pottery, axes and quern stones (used for grinding corn by hand) from the living, and monuments to the dead, notably long barrows; yet the actual settlements still remain hard to find. This is not surprising as they were probably only temporary and were destroyed by later land uses. So what seems to have been happening in Bishop's Cleeve and Woodmancote?

Sometime during these years someone deposited in the ground three high-quality stone axe heads which were found 20 years ago one metre under the modern surface in a garden in Oakfield Road, to the east of the present centre of the village. Two were identified as Cornish stone and one came from North Wales. How did they come to Bishop's Cleeve? As it is extremely unlikely the depositor personally collected the axe heads ready-made at the quarries,

they must have reached here by a series of exchanges showing that even over 5000 years ago no group of people could be regarded as isolated in its own landscape. Although over 20 such axe heads have been found in the county, the Bishop's Cleeve three, now in Cheltenham Museum, remain the most spectacular. Yet key questions remain unanswered. As they showed no signs of any wear, they were probably put in the ground in some religious ritual. We know the landscape itself held religious significance in prehistory, but we have very little understanding of religion and ritual until the appearance of written records about the time of Christ and so we can only really guess about these all-important aspects of life in the distant past, but it helps if we remember that people's view of the world was very different from our own. When pottery and metal were transformed from one state to another by fire, this was not a technological event but a magical process and the potter and smith were held to hold magical powers, perhaps forming some of the first élites in society.

It has been known for many years that fieldwalking anywhere across the ploughed fields of the Cotswolds is likely to pick up scattered pieces of flint worked into scrapers, arrowheads and knives, and even the remaining 'core' from which these tools were fashioned. At the very least these finds represent land cleared of trees. The lack of arable land in the vale today has prevented such large-scale investigation, but the evidence we have of thinner scatters suggests fewer clearances here, although further investigations might alter this picture. As with the Mesolithic microliths, many of the finds have been by-products of other investigations: an early Neolithic arrowhead, a scraper and two pottery fragments were found at Cleeve Hall. At the Stoke Road excavation several flints dating to the late Neolithic or early Bronze Age were not enough to suggest a settlement, according to the excavators from Cotswold Archaeology. Several scrapers have been picked up from fieldwalking between Gotherington Lane and the railway line at Homelands Farm. Two flint fragments were found at Lower Farm and a further fragment near the northern roundabout of the bypass. A well-designed knife from the earlier Neolithic period turned up in the soil spoil from the eastern end of Finlay Way. Dr Alistair Marshall of the Cotswold Archaeological Group recorded an extensive scatter of flints on the top of Nottingham Hill, an area of common grazing like Cleeve Common before it was enclosed in 1807, since when it has been part of Gotherington parish. There he also discovered in 1982 a very rare example of rock art – a cup-shaped depression in a piece of limestone. Its function is unknown, especially as it seems to have been broken from a larger object, but it is important for archaeologists as it remains the farthest south that such a carving has been found, although there are reports of another having once been found on Cleeve Hill. It could date from *c*.3000-*c*.2000 BC.

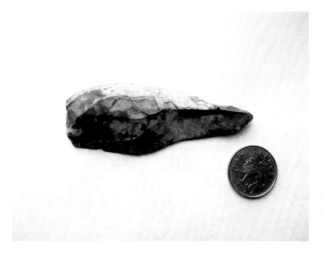

8 The neolithic flint knife found at the east end of Finlay Way during its construction in 1989

A few flints were found on Cleeve Common in the early twentieth century, at the King's Beeches and the Stables' Quarry. Sixty-four flints found at Haymes Farm suggest the possible Mesolithic clearance continued into the Neolithic period in what later became Southam and Woodmancote. However, with the possible exception of Nottingham Hill, where Alistair later discovered evidence for some settlement near the ramparts at the eastern end of the hillfort, none of these finds definitely indicates a settlement, either temporary or permanent. In fact, in the whole of Gloucestershire only two Neolithic settlement site investigations have been published; one at Hazleton on the Cotswolds before the later north long barrow was built and the other at Frocester farther south in the Severn Vale. Hazleton produced evidence that wheat and barley had been grown, hazelnuts had been collected and cattle, sheep and pigs farmed. At Frocester over 100 flint instruments were uncovered. So, to summarise our present knowledge of the Neolithic period, the picture which has emerged is of large-scale clearances on the hilltops, smaller scale clearances in the vale and continuing woodland on the slopes of Cleeve and Nottingham Hills with a possible exception in the area of Haymes Farm.

One Neolithic structure literally stands out in the local landscape – Belas Knap. Before moving into the Bronze Age (*c.*2000 BC-*c.*800 BC) we should pause to take a look at how Belas Knap can help our understanding of the wider local picture. It is one of 100 similar structures, properly called the Cotswold-Severn chambered tombs, which stretch from Bath in the south to Shipston on Stour in the north. Belas Knap lies not far from the present parish boundary of Bishop's Cleeve but about 6000 years ago when it was built such a boundary would not have existed and so it would be foolish to ignore it, if we bear in mind that what we see today is largely a reconstruction after

BELLER'S NAP, BARROW.

CELL,—NORTHERN SIDE, AND WESTERN ENTRANCE.

9 Belas Knap before restoration, as drawn for Emma Dent's *Annals of Winchcombe and Sudeley* (1877)

the last excavations from 1928 to 1930. The earliest excavations took place in 1863-65 at a time when it was fashionable to investigate long barrows. These first investigations found it had been built over two earlier graves. One at the northern end contained the remains of a young man of 20 and five children between six months and eight years, together with bones of horse and pig, several flint flakes and fragments of coarse pottery. The other grave, known to archaeologists as a rotunda (i.e. round) grave 2.2m (7ft 2in) in diameter was found under the main part of the long barrow. It contained a single burial. Of course, none of these features need have been built very long before the long barrow itself. In its final version the barrow had four separate side-chambers and Sir James Berry, the excavator in 1928-30, suggested each might have been built separately at different times before the monument was completed, but his reconstruction unfortunately now makes it very difficult to test this theory. Each chamber is under a metre (3ft 3in) high. The stone for the construction probably came from immediately round the monument, from the ditches which are still visible today. One red deer antler pick from the site is now in Winchcombe Museum. In total the bones of 38 people were discovered together with the bones of pig and horse, fragments of pottery and flint flakes. One skeleton had been buried crouching, kept upright by inserting fingers into his nose. One child had been killed by a massive blow to the head. Other people were only represented by bone fragments. Recent studies using radiocarbon to date similar long barrows, including Hazleton North, have suggested these monuments were actually used for a very short period of time, at most from c.3800 BC to c.3650 BC – much shorter than was previously thought. So who were these people buried here? Why were they so few? What ceremonies took place at burial? Does the damaged child's skull indicate a tragic accident or is it the result of conflict? Not very far away at Crickley Hill we know there was a battle during these years. Does this indicate that the Neolithic people were living in a more violent and dangerous time than we have previously thought? Long barrows have been the object of endless fascination and not just in recent times. Coins and pottery of the late third century AD found at Belas Knap suggest a fascination in Romano-British times, and in the later nineteenth century Emma Dent from Sudeley Castle was certain they had been worshippers of Baal, supporting her theory with the very name of Belas Knap! In more recent years Professor Tim Darvill of Bournemouth University, an expert on the Cotswold-Severn long barrows, considered that a long barrow might have served as 'a solid, robust and long-lived territorial marker legitimated by the presence of ancestral remains.' If so, which territory, and where it stretched, remains another mystery.

The work in the early 1980s by Alan Saville at Hazleton North long barrow discovered that before the long barrow had been built, the ground under it

had previously been used for growing small plots of cereals and for a wooden structure which he thought might have been a house. He knew this had been abandoned long before the barrow was built because he found that hazel had grown over the site. Probably because the excavation of Belas Knap was much less sophisticated 80 years ago, nothing like this was discovered there, but investigations by Alistair Marshall discovered a scatter of flints which might just indicate a Neolithic habitation site 300m (325yds) south of the long barrow. Random finds of worked flint picked up on the common itself suggests that there had been clearings here, as on neighbouring Nottingham Hill. And that is about all we can say at present. Yet the evidence which has emerged from Belas Knap, despite all the uncertainties, does enable us to have a glimpse of the wider area round Bishop's Cleeve some 5000 to 6000 years ago. Small groups of people exploited clearings in the woodland, farmed their animals, grew grain and collected the natural resources. Then they moved on allowing the woodland to regenerate. The comparative lack of Neolithic finds in our area of the Severn Vale might reflect the overall limited nature of archaeological investigation or that there actually were fewer people and fewer clearings compared to the Cotswolds, where Belas Knap might suggest the landscape was already being divided into territories claimed by different groups – and fought over, as at Crickley.

THE LANDSCAPE FILLS UP

The picture of Bishop's Cleeve itself begins to become clearer in the Bronze Age. Generally the landscape began to fill up and the 'wild wood' cleared permanently. Francis Pryor estimates that during this time the population doubled to half a million people. This was the age of round barrow building, when barrows were no longer communal resting places but built for individuals. Unfortunately we can only guess at the changes in belief that this represented. Over 300 round barrows are known in the county, but most are on the Cotswolds, particularly in the Upper Thames Valley area around Lechlade, an area of intensive settlement. For Bishop's Cleeve and Woodmancote we still rely on the references of eighteenth- and nineteenth-century historians for any evidence of round barrows. They wrote of four possible round barrows on Cleeve Hill in or near Milestone Quarry; in 1904 the archaeologist G.W.S. Brewer collected bones from a barrow which he described as being at the top of the quarry. Then there were two on West Down and three on Nottingham Hill. Further finds of a religious or ritual nature have been found. A miniature bronze dagger and ploughshare together with coins found near Cleeve Cloud hillfort suggest another religious site. In 1856 men working for Emma Dent

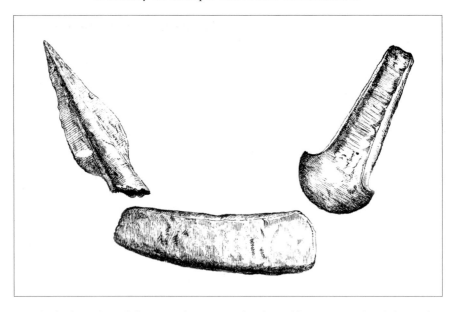

10 The high quality of these two bronze axe heads and bronze spearhead drawn for Emma Dent's book suggests they came from one of the lost burials on Cleeve Hill

of Sudeley Castle found a bronze axe head and other items, probably grave goods, somewhere on Cleeve Hill. In 1863 the *Gloucester Journal* reported that quarrymen had opened 'what are termed locally soldiers' graves' with burnt bones, coins and 'other relics', all unfortunately since lost. However, this is enough evidence that the top of Cleeve Hill had been cleared of trees and by the end of the Bronze Age had possibly been divided by the bank and ditch which is still traceable running across the common from the King's Beeches to Postlip. This could reinforce the idea that territories were being set up. As it seems likely that people moved between vale and hill, it's possible that the lines of the modern Granna, Bushcombe, Stockwell, Gambles and Sunset Lanes were being established; in places they have the appearance of holloways where the track is below the surrounding land and generally thought to be evidence of ancient tracks. Our knowledge of Cleeve Hill in the Bronze Age has changed very little since 1990 but ideas of what it means might be changing. From work carried out on famous sites such as Stonehenge and Avebury, archaeologists have seen landscapes divided into zones for the living and zones for the dead or the ancestors, the latter having huge religious significance. It is just possible the cleared heights above Bishop's Cleeve and Woodmancote had become the home of the ancestors looking down on the living and to be approached with care. Even if some barrows were out of sight of the vale, the living would have looked up to them on the hilltops and the ancestors would have looked down on them

in the vale, to legitimise their presence on the land. It is an interesting idea which could help us to understand how the hill and vale were part of one landscape.

In the vale in 1996 the long-awaited eastern bypass of Tewkesbury was started. The archaeologists were able to present a surprising general picture of the lower Severn Vale in the Bronze Age. Already by c.2000 BC the woodland was being cleared so that by c.400 BC (the Middle Iron Age) the vegetation was no longer soaking up the increasing rainfall. The excavators wrote that the modern River Severn flood plain had already been established. During these early years, it seems some sort of settlement was being established in Bishop's Cleeve, for the excavations by Wessex Archaeology on the Tesco site in 1998 and 2004 found evidence for the earliest human occupation in the present village. Much of the store stands on land that about 4000 years ago was marshland cut by water channels. The water seems to have flowed westwards from Cleeve Hill, then through the marsh and away down the line of Stoke Road as a tributary of Dean Brook to the Swilgate, and then on into the River Severn at Tewkesbury. Although the water and the marsh meant that this area remained on the edge of the settlement through to Saxon times, it has provided us with a variety of evidence from which it is possible to paint pictures of prehistoric and later landscapes. The main conclusion is that by c.2000 BC the landscape around Bishop's Cleeve was largely open with a few scrubby areas where trees and bushes grew. Preserved pollen and seeds indicated that wheat was grown for bread, and barley possibly for brewing. Sloe and hazelnuts were collected for food. We know oats, rye and peas were also being grown by the later Bronze Age (c.1000 BC) because their seeds were found in other excavations in 2004 behind 21 Church Road (now Maxwell Place). Although there seems to be no direct evidence for animal farming in Bishop's Cleeve, the excavations along the Tewkesbury bypass established that by c.1500 BC the vale, in general, was more pastoral than arable. Around our small area of settlement grew hazel, ash, blackthorn and oak with the marshland becoming an important local resource – the reeds providing thatch and bedding, the soft mud could have been used for walls (although unfortunately no actual houses were found) and, of course, the water was used for drinking and washing. In very general terms this landscape, divided by hedges into a mixture of arable and pasture with patches of scrubland and trees, seems to have lasted nearly 2000 years into the Saxon period; a significant continuity in the village's history. But what of the actual people? Unfortunately, once again, we know very little. The nearest we can come to them is through their pottery. The earliest finds were made at Lower Farm in 1969, when six sherds from three separate pottery vessels from the early Bronze Age were found in a pit during the excavation of a Saxon cemetery. The pottery was similar to that found at Holt, higher up the River Severn in Worcestershire; another small indication

of the importance of trade and the inter-dependence of communities. Neil Holbrook writing in 2000 considered that they might represent another now-destroyed round barrow which served as a focus for the later Saxon cemetery. We shall return to the question of lost barrows in the vale in the next chapter.

These are important recent findings, but of all the Bronze Age discoveries in and around Bishop's Cleeve, the most spectacular remains the Nottingham Hill hoard of 25 objects found in a shallow wooden box, including three bronze swords which are on display in Cheltenham Museum. Ploughed up in 1972 it seems that they were buried for the practical purpose of safekeeping rather than as part of a ritual, for they were found with rivets and rings which seemed to suggest they belonged to a smith, almost as work in progress. Dating from *c*.800 BC-*c*.700 BC the hoard also suggests the hillfort was already in use, as large hillforts like Nottingham Hill are now thought to have been built between *c*.800 BC and *c*.600 BC, although its purpose remains a mystery. Further work obviously needs to be carried out here but Alistair Marshall found thin scatters of flints, a fragment of a stone saddle quern (more evidence that crops were being grown not too far away) and heat-cracked pebbles used in cooking to heat water. Francis Pryor has made the general point that most Bronze Age swords found in England show no signs of wear, which he takes to mean that the period was generally peaceful. It could just be, however, that these were ritual swords and that damaged swords were re-smelted into new weapons.

THE FIRST SETTLEMENTS APPEAR

In the popular mind each age in the prehistoric period is recognisable by its icons – cave dwelling in the Palaeolithic or Old Stone Age; tiny fragments of flint in the Mesolithic or Middle Stone Age; long barrows in the Neolithic or New Stone Age; round barrows in the Bronze Age and hillforts in the Iron Age. Such icons are useful identifiers but oversimplify an increasingly complex understanding of each period. We have now arrived at the Iron Age (*c*.800 BC-AD 43). Again, the change from bronze to iron did not take place overnight and the labels are there for the historians' convenience rather than being significant to those living at the time. However, they do help us to make greater sense of the past by providing markers on our journey through time.

To the east of Bishop's Cleeve lie two great hillforts. On Nottingham Hill a double ditch and bank marks out a 40ha (120acres) hilltop enclosure. On Cleeve Cloud only 1ha (3acres) of a double-banked and ditched enclosure has survived quarrying. In 1779 Samuel Rudder wrote in his history of the county that it stretched 350yds along the summit of the hill in the form of

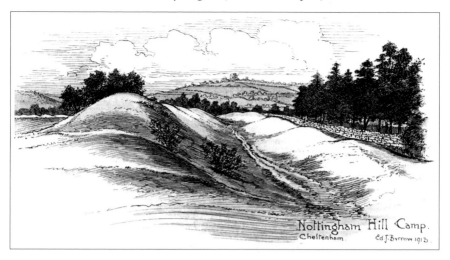

11 The ramparts on Nottingham Hill in 1913. Today the undergrowth masks their shape. Edward J. Burrows in his book *The Ancient Entrenchments and Camps of Gloucestershire* refers to an excavation here in 1863 – another lost investigation

a crescent and was inaccessible except from the front. This size seems very improbable, but otherwise this description indicates how much has been lost to quarrying. In December 1911 the Cleeve Common conservators threatened to take quarryman Arthur Yiend to court if he did not stop the blasting which was destroying the 'Roman camp'. The excavation on Nottingham Hill, which followed the discovery of the Bronze Age hoard, found hearths and other features of human occupation. This has led Tim Darvill to suggest the enclosure had been a defended food store (with the grain kept in pits) and used for keeping animals, perhaps with limited human occupation before *c*.300 BC. To this we can now add the findings of Alistair Marshall who carried out a magnetic survey in 2004 which indicated in the third and second centuries BC there had been some sort of occupation either side of Granna Lane near the ramparts at the eastern end of the hillfort. The remnant of the hillfort on Cleeve Cloud has yielded two sherds of pottery dating *c*.700 BC-*c*.500 BC which suggests it was built somewhat later than that on Nottingham Hill and was contemporary with Crickley and Leckhampton hillforts, but unlike them has no sign of deliberate destruction by fire *c*.400 BC. Pottery from the second century BC has also been found here.

Recent research suggests that such hillforts were not the homes of chieftains who ruled over the people of the vale, as had once been believed, but perhaps reflected seasonal occupations for farming purposes and their uses could have changed over time. Very recently Stephen Yeates in his book *The Tribe of*

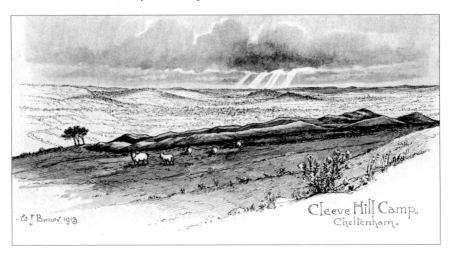

12 The hillfort on Cleeve Hill in 1913, showing the trees known as the Three Sisters in the background

Witches has built up a theory based on the old name for Nottingham Hill: Cockbury. Cocca was an Irish god of war and fostering, so Stephen thinks the hillfort was used as a summer camp to train boys for war, which could explain the evidence of occupation. This adds another ingredient into the debate about how hillforts were used. Yet why these hillforts should be defended when undefended settlement sites from the same period existed on Cleeve Hill, at the King's Beeches and near the Stables' Quarry, remains a mystery (*colour plates* 2 and 3). The site at the King's Beeches was excavated as long ago as 1902. It was occupied from *c.*500 BC to the first century AD and proved to be a site where pottery was actually made. Remains were also found of a wattle and daub house whose inhabitants ate meat from sheep and pigs, kept dogs, horses and oxen and hunted for deer. The presence of woodland snails indicated woodland stood nearby. Similar pottery found at the Stables' Quarry site suggests it was occupied about the same time, but we have no further details. Stephen has put forward another theory in an attempt to explain 'The Ring' earthwork on the common. There exist parallels as a religious monument with a totem pole in its centre, but this evidence also remains inconclusive.

Such was most of our knowledge of the Iron Age in the Bishop's Cleeve and Woodmancote area only 20 years ago. A few possible sites below the hills had been identified by pottery scatters and crop marks: the field immediately south of Southam Lane railway bridge; the fields west of Lower Farm; to the north of the village to the east of the Evesham Road; and to the north of the Farmer's

13 A general view west from the church tower, taken in 1972. Gilder's Paddock lies immediately behind the new rectory on the left. Home Farm stands further behind it. (T. Curr)

Arms. This evidence had not been systematically discovered or analysed but it did suggest that during the Iron Age there had been some settlement in the area – possibly single farmsteads. The archaeological investigations since 1989 have greatly expanded this knowledge.

So we must now return to our starting point at Gilder's Paddock. When planning permission was granted the land was being used as a vegetable plot which in the centre of the village seemed to offer a crucial opportunity to discover more about the village's history through archaeological investigations. When the topsoil was stripped, it was immediately obvious that the site offered enormous archaeological potential and so the developers, Bovis Retirement Homes, agreed to fund an excavation even before the need to do so because of PPG16. Charles Parry expected to find medieval features but it soon became apparent that here was a site about to disclose new light on the Iron Age. To

31

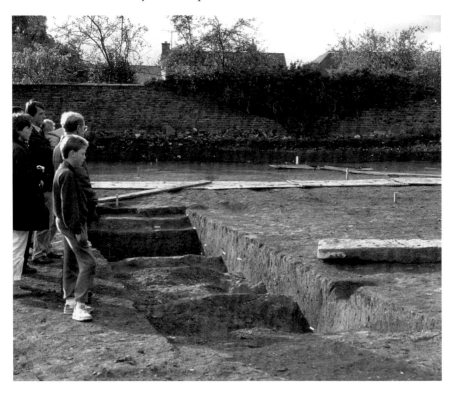

14 Public interest in the excavations at Gilder's Paddock was very high. One of the many groups shown round in 1989 examining a trench cut across the ditches

the interested villagers who were taken round the site on the open days, the key features of pits and ditches looked like just so many holes in the ground. But to the experienced archaeologist a picture soon began to emerge of an intensively used area of enclosure ditches and circular pits. There was some early Iron Age pottery, but most was dated from the fourth century BC to the first century AD. This was about the same time as the settlements on Cleeve Hill were in use. Disappointingly, later land use had destroyed the features which lay above or just below the Iron Age surface, so any evidence of postholes, suggesting buildings, had been lost. Nevertheless the cutting and re-cutting of the ditches indicated long-lasting boundaries of small paddocks to control farm animals, which in turn suggested that the farming recognised in the Bronze Age was continuing. The pits contained fragments of pottery from the Malverns and south Worcestershire and fragments of salt containers from Droitwich. The fragments of quern stones from May Hill gave evidence that corn was being grown. All these items provided further evidence of long-distance trade and exchange and remind us that Cleeve was never isolated from the wider world.

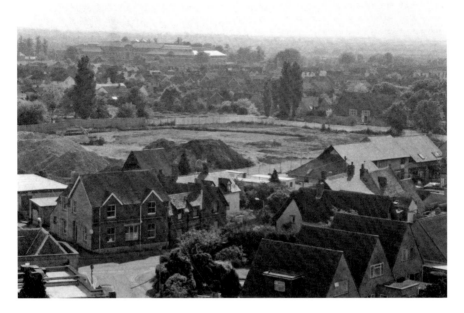

15 This view from the church tower shows the Oldacres' mill site cleared for the building of the Tesco supermarket. The Zurich/Capita building on the bypass can be seen in the distance

But the excavations at Gilder's Paddock gave only one part of a larger picture, for when further excavations took place at the Tesco site in 1998 and 2004, and behind 21 Church Road in 2004, it was found that the pattern of the ditches from Gilder's Paddock stretched to the south and the east, although the pottery from the Tesco site suggested its main period of use was possibly a century or two earlier than the fourth century BC. Perhaps the focus of the settlement had shifted from there to Gilder's Paddock, as it later shifted from Gilder's Paddock to Home Farm by the middle of the second century AD. From 21 Church Road came important evidence for Iron Age farming which confirmed little change from the Bronze Age. Wheat was still the main crop, but barley, oats, rye and peas were also being grown. Cattle, pigs, sheep, goats and horses were being kept and eaten. However, the most exciting finds were from the Tesco site, where remnants of the plans of two round houses, built of timber, and presumably thatched with reeds from the marsh, were found. One was 12m (39ft) in diameter; the other 8m (26ft). How many people driving straight into Tesco's car park realise that they are driving across the only remains of Iron Age housing yet found in the centre of Bishop's Cleeve? The excavators also thought they might have found the remains of a third round

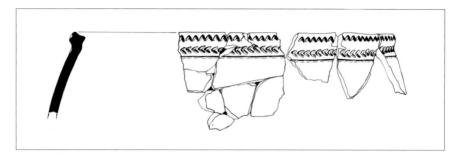

16 A fragment of the Iron Age pottery found at Gilder's Paddock. (Charles Parry GCCAS)

house which indicated the site was occupied for more than one generation. Some attempt had been made to drain the marsh by digging ditches. These ditches produced a number of finds: an antler comb, needles and loom weights, indicating weaving had taken place, and fragments of a whetstone used for sharpening iron knives and possibly sickles, for cutting the corn. At one time iron had actually been smelted there. Yet, significantly, the pattern of the ditches did not cross the Evesham Road to the Home Farm site. Charles Parry considered there must have been a significant feature along the line of the modern road which separated them. It could have been a trackway or even a watercourse, culverted over 60 years ago, running from the marshy area down to Gilder's corner.

Finally, we must now move away from the village centre to the bypass, for in 2006 Birmingham Archaeology investigated Dean's Lea, before it was developed by Bovis homes. Here the most exciting discoveries were of two well-defined timber roundhouses inside an enclosure. This was the clearest evidence in our area for an actual Iron Age farmstead (*colour plates 4* and *5*). Three thousand bone fragments confirmed what was already known regarding farming: cattle, sheep and goats, with a few horses, pigs and dogs but, as before, the very small number of red deer bones suggested hunting. Pollen from hawthorn, wild rose and elderberry suggested that hedges complemented the ditches to keep the animals in their fields, but woodland trees were absent. There was little evidence of grain, which led the excavators to suggest that here was just a seasonal settlement for the grazing of animals kept for food, drink and household items fashioned from their bones and horns, but they did realise that the evidence for such a seasonal settlement was not conclusive. The site then seems to have been deserted early in the Roman period. People looking down from Cleeve Hill *c.*100 BC would have seen a vast plain, broken by hedges into various sized enclosures for animals and crops, with small timber and thatched farmsteads dotted about. Looking more

17 Tesco taking shape in 1998 on the sands and gravels underlying much of the village centre and which here contained evidence of prehistoric and Saxon people

closely they would have noticed men, women and children going about their farming. Women might be weaving and the men carving items from bone and horn. Occasionally traders would appear bringing in pottery and salt. Between the hill and the vale tracks ran through the woodland. The uplands were now exploited for the practical purposes of living and working as people's beliefs had changed and barrow building had stopped. But they could still be seen, which still lent an air of mystery to the place.

This picture is unlikely to have changed by the time of Christ, when the overall population of Britain had probably reached one million. The landscape had filled and the fields divided it into readily identifiable private areas. Boundaries were now important – that's why the ditches were cut and re-cut many times. This was also true of the bigger picture. People were laying claim to territories so that by the first century BC our area lay in the north of the territory of the Dobunni tribe. Their coins have been found from Worcester in the north to Bath in the south and from the upper Thames in the east to the River Usk in the west. The tribe's centre was in or near Cirencester and

their leader *c.*30 BC was a man called *Bodvoc*; the first real personal name to appear in our story and a clear indication some people were more important than others. From fields to tribal territories the accessible land was being claimed and divided up. The political takeover by the Roman Empire after the invasion of AD 43 must have been largely peaceful. We don't know what the tribe might have demanded from the people, but after AD 43 we know they owed taxes to the Roman administration. However, all the archaeological records suggest their day-to-day lives were only gradually Romanised. How the people of our area lived under Roman rule forms the next part of our story.

A ROMAN TAKEOVER?

From the first century AD to the fifth century AD our area lay near the northern edge of one of the most prosperous areas of Roman Britain. Cirencester (Corinium Dobunnorum) became the capital for the Dobunni; Gloucester (Glevum) developed as a colonia for retired army veterans; to the south lay the spa at Bath (Aquae Sulis); whilst across the River Severn Caerwent (Venta Silurum) became the capital of the neighbouring Silures; and for 200 years after the conquest its near neighbour Caerleon (Isca Silurum) served as the legionary fortress on the route into what is now South Wales. The great centres needed supplying and so countless farmsteads, villas and small communities prospered as they were brought into the supply system. These villas and farmsteads seemed to enjoy especial prosperity from the second century AD until the fourth century AD, after which the prosperity declined until the imperial Roman influence was finally lost in the later fifth century AD. The climate now became increasingly favourable for farming. The summers became warmer and drier and the winters wetter – a trend which continued, with a few exceptional years, until the thirteenth century.

As we now move forward into the Romano-British period, we can start by summarising what we already knew before 1989. The scattered sites round the village which produced Iron Age evidence, also produced a few sherds of Romano-British pottery. Fieldwalking in the field immediately south of the Southam Lane railway bridge had produced pottery from the third and fourth centuries AD. This included fragments of mortaria for grinding food, which suggested a small settlement nearby. On Cleeve Hill the Iron Age settlement site at the King's Beeches had been sealed by quarry waste containing three third-century AD coins; a few sherds of third-century AD pottery were found at the Stables' Quarry in 1902. The Roman interest in Belas Knap has already been noted, as has the small settlement brought to light when the M5 motorway

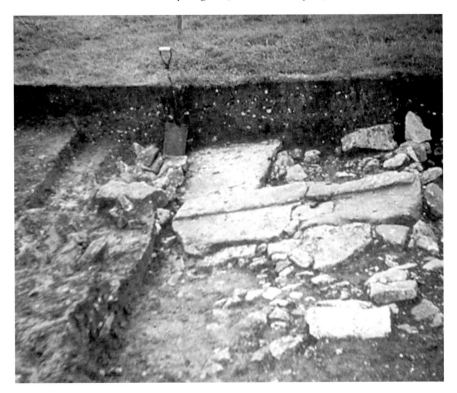

18 The sill stone at Haymes which Bernard Rawes thought might have been a re-used altar stone. (J. Rawes)

was cut through neighbouring Tredington in 1969-70. It was excavated by Bernard Rawes who went on to excavate the more fruitful site at Haymes Farm before it was destroyed by an underground reservoir. The well-known slumping of soil on the side of Cleeve Hill made this site difficult to interpret but the finds indicated a farmstead with a series of timber-framed buildings with thatched roofs, later tiled. The pottery suggested the farmstead had been in use from the first century AD to the fourth century AD and prospered most in the second century AD – as might have been expected. There were two unusual finds at Haymes Farm; one was a small stone altar re-used as a paving stone, presumably when an unknown, and possibly local, religious cult had passed out of favour, and the other an assortment of 16 iron brooches, three of which were of a type in use before the Roman conquest. The reason there were so many brooches in one place remains uncertain, despite Bernard's hypothesis that they were offerings to a shrine represented by the re-used altar. There were no clues why the site was abandoned, except for possible drastic slumping of the ground. However, its existence provides further indication

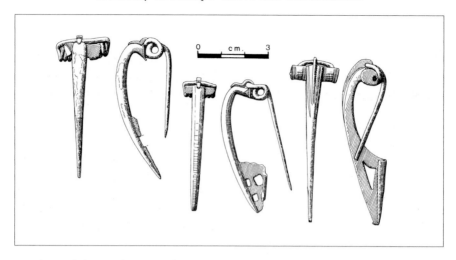

19 Three of the iron brooches found by Bernard Rawes at Haymes. (J. Rawes)

that by the first century AD this part, at least, of the western slope of Cleeve Hill remained cleared of trees and was being used as farmland, both arable and pastoral.

The location map which Bernard drew to accompany his report showed three Romano-British sites in the vale around Bishop's Cleeve but none in what became the heart of the village. Although he and his wife Barbara had discovered several sites in the vale by fieldwalking, the traditional view could still have been argued only 20 years ago that Bishop's Cleeve was a completely new Anglo-Saxon settlement. What the late twentieth-century development of Bishop's Cleeve did for our knowledge of the area in the Iron Age it continued to do for the Roman period. The major conclusion so far is that by the first century AD this part of the lower Severn Vale was densely occupied. Based on work done since 1980 on Bredon Hill and surrounding villages, Tom Moore of Durham University has written, 'the evidence indicates a densely-occupied landscape ... and a picture of enclosures integrated into complex field systems made up of field boundaries, track ways and pit alignments.' There were no 'wildwoods' waiting to be cut down by intrepid Anglo-Saxon adventurers; the landscape was already well-organised and managed.

The major conclusion from the excavations near the modern centre of Bishop's Cleeve is that they suggest a general westward shift of activity from the east to the west of the Evesham Road in the first century AD, with expansion to the south in the third and fourth centuries AD. So what are the details? At Gilder's Paddock only a tenth of the pottery found on the site dates to the first century AD or later. This indicates the Iron Age settlement faded

20 Home Farm in 1989 showing the archaeological potential lying immediately under the topsoil

during the Roman period and although no direct link with the Home Farm site across the road can be shown, it seems sensible to accept Charles Parry's conclusion that the people had moved from one site to the other by the middle of the second century AD although the reasons remain unclear. When Alistair Barber of Cotswold Archaeology investigated at Home Farm he found many re-cut ditches, some of which might have indicated garden plots. Slag, used fuel and burnt clay indicated that a travelling smith had put up a windbreak to make iron and brass items, although unfortunately none of the actual handiwork was found. Was he still regarded as a magician?

Then, between AD 300 and AD 400 the ditches were abandoned. Two bread ovens were dug into one ditch and a limestone wall built as either another windbreak or part of a small building. Some evidence was found to suggest that leather and flax (for linen) were being processed on the site. Part of a quern stone made from Forest of Dean sandstone and a piece of local limestone fashioned into a lamp were found. However, perhaps the most significant feature of the site was a large area of material which seemed

21 A general view across the Stoke Road excavations of 1997

to have been brought onto the site as rubble, likely to have been demolition material from a richer, villa-type building lying to the south but not yet found by the archaeologists. From the evidence of the materials and the seven coins found during the excavation, the 'villa' seems to have reached a high level of quality and comfort by c.AD 300, before declining after c.AD 350. The walls of the villa were plastered, there was a hypocaust to provide heating by hot air, and the roof was made of clay tiles. When the specialists analysed the pottery, they found luxury Samian pottery from the south of France indicating that the inhabitants enjoyed a comfortable lifestyle, which included wines from the Mediterranean region. Almost half of the rest was made quite locally in the Severn Vale and other everyday pottery had come from the Malverns, Oxfordshire and Dorset. Similar debris has also been found close to Cleeve Hall, near the King's Head and on the Tesco site. Also at the Cleeve Hall and Tesco sites large quantities of pottery dating from the late first to the fourth century AD had been used to fill in the watercourses and at the Tesco site further attempts had been made to drain the marshy land by re-cutting earlier drainage ditches. But frustratingly, the biggest

question of all, where exactly had this villa-type building stood, remains at present unanswered.

The evidence from both the Stoke Road and Cleeve Hall excavations points to the main period of use of these sites as the third and fourth centuries AD; rather later than at Home Farm. This led Dawn Enright and Martin Watts of Cotswold Archaeology to conclude that this could well have been an expansion from the Home Farm site. There was little evidence here of earlier Iron Age activity. The small cemetery of five graves described at the start of this chapter lay alongside Stoke Road. To the north of the road lay enclosures, probably for animals, but at one time some smithing of iron had taken place for a hearth was found which had been used between 20 and 34 times. Some iron and coal had come from the Forest of Dean, but some of it had been re-used, or recycled in today's language. Here was evidence of another travelling smith. As on the other sites, about two-thirds of the pottery was local Severn Valley Ware; about a tenth came from Dorset and from Malvern; only five sherds of Samian pottery were found. All this suggests low-status occupation, probably as a 'native' farmstead, like those at Dean's Lea, but here only inconclusive evidence for a house was found at the eastern edge of the site. This strongly suggests that life for the ordinary farmers was changed very little by the Roman occupation, even if they were now producing for new markets such as those in Gloucester and Cirencester. Debris from the nearby 'villa' had also been laid across this area, although the archaeologists were sure this had not happened until the Middle Ages when it was used to form a hard, cobbled surface.

So what do the findings from these sites at the south-west corner of the modern heart of Bishop's Cleeve tell us about the nature of the farming being practised in the third and fourth centuries AD? It was still recognisably Iron Age. From the small number of animal bone fragments which were discovered, the archaeologists could conclude that some of the cattle, sheep, goats and pigs had been eaten, but some sheep had been kept for milk and wool as no butchery marks were found on their bones. Some cattle were mature, suggesting their use as beasts of burden, rather than food, but the butchery marks on the bones of the horses were only the result of cutting up the carcase for disposal, rather than for food. It therefore seems that they had been used in farming, for hauling and possibly riding. Snail shells represented species living in open grassland suggesting there was ample grazing for the animals. Hens and geese were also kept as well as dogs and the single example of red deer again suggests people still went hunting. Wheat (for bread) was the most common crop, then barley, rye and oats, all of which could have been eaten by humans or animals, as could the peas and beans. Goose grass, docks and thistles indicated that weeds were an ever-present nuisance for the farmers.

22 Building by the northern roundabout on the Bishop's Cleeve bypass brought to light an extensive Romano-British settlement now under the houses seen in this view

Perhaps this was partly a result of the lightweight ploughs which did not cut deeply enough to destroy their roots. Above all, what is clear from all this evidence is that the landscape continued to be well-exploited for farmland.

What might the area have looked like? The timber farmsteads lay scattered in the same basic pattern as in the Iron Age, but we have already noticed that a more palatial villa-type farmstead was in existence at least from the third century to the fourth century AD. Perhaps only these people lived a very different lifestyle to that of the Iron Age. Outside the present centre of Bishop's Cleeve, developments have enabled us to add to the number of our already-known scattered farmsteads. The sites include one around the northern roundabout of the bypass, where the fourth-century AD pottery, including Samian Ware plus paving slabs and a small length of walling, all suggest a settlement. Another site 60m (65yds) to the north might have been connected to it. Its main features were pits with first- and second-century AD pottery. In 1988 another site was discovered on the south of Stoke Road opposite Lakeside. The pottery was mostly from the Severn Valley but there was also evidence of five separate vessels of Samian Ware. The site seems to have been occupied from the late first century to the third century AD. Such Samian

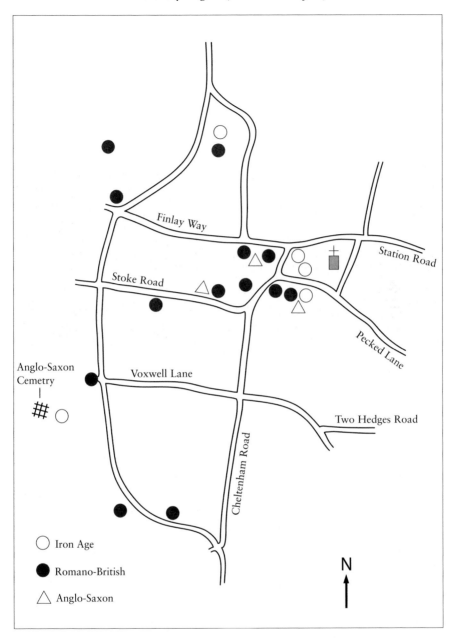

23 This sketch map summarises our increased knowledge of settlement resulting from the growth of Bishop's Cleeve. It particularly shows the importance of the investigations near the centre of the modern village and the dispersed nature of settlement in the Romano-British period

24 Archaeologists were disappointed that no significant finds were made when the Churchfields development took place on the old school site in 1988. This suggests it was never an early settlement site, unlike the areas on the eastern side of St Michael's. (T. Curr)

sherds are our only clues that some, at least, of the native British were trying to copy Roman ways at least with their possessions if not their homes. Near The Grange another site was found when the bypass was built. Here pottery from 12 different vessels was found, whilst further south near Field Farm more pottery from the late first century to the third century AD was discovered, together with parts of a roof tile and bits of a quartz sandstone quern. In 1997 several sherds of pottery were found in a trench at Cleeveway Manor. When these are added to the sites already known from earlier fieldwalking, there emerges a clear pattern of a 'well-populated Romano-British landscape of small dispersed agricultural settlements' (Home Farm report). In addition, individual pieces of Romano-British material, mostly pottery, indicate at least those areas which were being cultivated during this period as the broken vessels were thrown onto the manure heap and so found their way onto the arable land: near Homelands Farm north of Gotherington Lane; opposite Cleeveway Manor; and on the Grangefields school site. But the finds on Cleeve Hill at the Stables' Quarry, King's Beeches and Belas Knap are more likely to indicate

other uses: quarrying in the first two places and an interest in antiquity in the last.

Significant as these recent discoveries are, they only lead on to further unanswered questions about the Bishop's Cleeve area. Did any settlement extend under what is now the churchyard? Why did the archaeological investigations carried out before Churchfields was built immediately to the east of the churchyard draw a blank, when it lies so close to the historic centre? What was the relationship between the undiscovered large 'villa' and the smaller 'native' farmsteads to the north and west of it? Were the latter owner-occupied or tenanted as part of the large villa estate? Was there just one large estate? Certainly it seems that the nearness to some of the great Roman centres provided the market and stimulus to develop, but why does the pottery run out in the fourth century AD and a decline set in before the general decline of Roman influence a century later? Was this failure of commercial pottery a reflection of the creaking of the Roman Empire, or some more local conditions?

SO WHAT MIGHT IT ALL MEAN?

So finally, what was the experience of being alive in the years covered in this chapter; years which seem so remote to us, and yet years which once were the present for those who lived through them? The simplest answer would be that the people depended upon the land and the seasons – a thread of continuity which lasted into the twentieth century. Not until almost the end of the period can we clearly discern differentiated experiences of life in what later became known as Bishop's Cleeve. Our knowledge of Palaeolithic and Mesolithic societies is based on fragmentary finds. Certainly life was hard, hunting and collecting food with all its uncertainties, but certain times of the year brought greater prosperity, especially late summer and autumn when more plentiful supplies meant more time for resting and perhaps meeting other groups to share in ritual ceremonies. Their knowledge of how to exploit the natural world and how they made sense of it was passed down by word of mouth, so that it is now lost except for what we can infer from their flint tools.

The Neolithic revolution in farming tied people more closely to the land, even if their settlements were temporary and therefore almost impossible for archaeologists to find. Long barrows, such as Belas Knap, indicate a belief system that cannot now be really understood, although it seems certain that they and people in the succeeding Bronze Age took the power of their ancestors seriously. They might have been markers in the landscape and as the landscape filled up during the Bronze Age more markers developed, linear ditches and

round barrows. The hold of the Iron Age hillforts over our imagination has weakened in the last few years, as our thinking about their possible uses has developed, and they can now be seen as just one part of a well-developed landscape and they lost their importance even before the arrival of the Roman legions. Families continued to be dependent upon the produce of the land for their livelihood and so they were tied to it and the pattern of the seasons. Their timber-built houses provided warmth and shelter; they had elaborate field systems for controlling animals and they had developed a lightweight plough for the growing of their grain. They, too, celebrated the circle of the year by various ceremonies and worshipped gods and spirits which reflected the importance of the natural world around them. Some people such as smiths and priests must have held special places in society. The extended family groups and small tribes must have come together over many years so that by AD 43 our area came under the influence of the Dobunni.

The Roman Empire had a well-developed social structure, from the emperor to the slaves. Its influences can be traced here from the first century AD and by the third and fourth centuries AD those who lived in the vanished 'villa' enjoyed a luxurious lifestyle with central heating, fine wines and pottery imported from the south of France. By contrast, those living at Haymes were not so well-off, but they still enjoyed a more comfortable life than the bulk of the population living in their timber-built farmsteads which appear, archaeologically, little different from those of the Iron Age. Was it the sophisticated trading systems which allowed a few families to earn enough to purchase Samian pottery? It is most unlikely there were ever any Romans from Rome in Bishop's Cleeve, but some must have aspired to that way of life at least until the later fourth century AD. Throughout the period covered by this chapter life was short; average life expectancy was around 35, but this masks the fact that about half of all babies did not reach childhood. Those who reached middle and old age were fortunate if they did not end their lives in pain. The farming year with its physically demanding work still dominated; religion was based largely on the natural world. During the fourth century AD prosperity seems to have declined – what did the inhabitants of the villa do? Did they move to the towns or did they sink back into the humbler lifestyles of their neighbours or ancestors. With the final decline of Roman Britain in the fifth century AD changes did happen in Bishop's Cleeve. These will be taken up in the next chapter but readers whose main interest lies in Woodmancote will need to be patient for a while longer.

SOURCES AND FURTHER READING

Most of this chapter has been put together from my own observations and various archaeological reports. The County Archaeological Unit holds a record

of the county's sites and monuments, which can be consulted at Shire Hall by prior arrangement. For those not able to make a visit, there is a reasonable summary of unpublished work at http://194.66.65.187/index2.htm (type in 'Bishop's Cleeve'). Detailed reports have been produced in the *Transactions of the Bristol and Gloucestershire Archaeological Society*, notably volumes 104 (Haymes Farm), 116 (Home Farm), 117 (Gilder's Paddock) and 125 (Tesco). Two of the society's special reports focus on Bishop's Cleeve: number 1 (Stoke Road) and number 5 (21 Church Road). The Transactions have an annual review of archaeology in each volume, which describes minor excavations and observations. All the Transactions up to and including volume 120 (2002) are now online at www.bgas.org.uk/tbgas. The search engine allows Bishop's Cleeve and Woodmancote to be typed in and any relevant reports selected. The report on the King's Beeches excavations can be found in the *Proceedings of the Cotteswold Naturalists' Field Club* volume 15. There are detailed descriptions of the earthworks on Cleeve and Nottingham Hills in *Iron Age and Romano-British Monuments in the Gloucestershire Cotswolds* (RCHM 1976).

Books which have been helpful include Alan Saville's *Archaeology in Gloucestershire* (Cheltenham 1984), Stephen Yeates' *The Tribe of Witches* (Oxford 2008), N. Holbrook and J. Jurica (eds.) *Twenty-Five Years of Archaeology in Gloucestershire* (BGAS special report number 3), M. Ecclestone et al (ed) *The Land of the Dobunni* (Gloucester 2003) and T. Darvill *Long Barrows of the Cotswolds* (Stroud 2004). Francis Pryor's *Britain BC* (London 2003) provides an interesting personal account of prehistoric Britain. Tim Darvill's *Prehistoric Gloucestershire* (Gloucester 1987) and Alan McWhirr's *Roman Gloucestershire* (Gloucester 1981) are more local but older accounts.

A visit to the museums at Cirencester and Gloucester gives a good background to this period, especially focusing on Iron Age and Romano-British religion. Cheltenham Museum has on display some of the artefacts found in and around Bishop's Cleeve, including the display of the Bronze Age hoard found on Nottingham Hill.

2

SHAPING THE LANDSCAPE
(*c*.500-1086)

Fifteen hides of land to the minster at Cleeve and to the church of the blessed
archangel Michael which has been founded there.
Charter of Offa and Ealdred to the minster at Cleeve 777-779

SETTING THE SCENE

This chapter covers the years from the end of Romanised Britain to the
Domesday Book of 1086 – in popular shorthand, the Anglo-Saxon period.
It starts with two individuals: the first unknown but important in death; the
second known and important in life. And so we continue our journey with
another skeleton. This one is known as Burial 18. In 1969, when the sands and
gravels to the west of Bishop's Cleeve along Stoke Road were first exploited
on a large scale, a small Saxon cemetery with 26 burials was discovered just
to the north of Lower Farm. Originally excavated by Kenneth Brown of
Cheltenham Museum, a full report by Neil Holbrook did not appear until
2000. Burial 18 contained an adult female of unknown age who had been
carefully laid to rest on her back with her arms placed by her side. The bones
had later become disturbed but enough remained to show that she had been
about 1.57m (5ft 2in) tall, rather below the average height calculated from the
other skeletons. Apart from suffering from tooth decay, having lost four teeth,
she had been reasonably fit and healthy. In fact sometime during her life she
had broken her left arm above the elbow, but it had healed so well that the
archaeologists considered it had clearly received medical attention. She had
been buried in the clothes she had presumably worn in life because although
they had rotted, a metal brooch clasp still survived resting on her left shoulder
and 84 beads still lay across her breast. These were mostly of amber, a semi-
precious stone of yellow colour, which was a symbol for the sun and a good

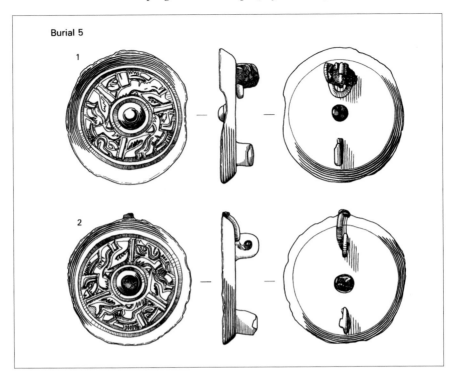

25 Two highly decorated saucer brooches which helped date the Saxon cemetery. (Cotswold Archaeology)

luck charm. The beads could have been placed there as a precious possession or for good fortune in the next world, in which case it might indicate she was not a Christian. Fragments from other burials indicated that wool and flax had been used for making the clothes. The archaeologists used the style of the brooch and other grave goods to draw the conclusion that this was a cemetery in use between *c.*525 and *c.*575 by people who were Saxons, or who had adopted a Saxon way of life.

In contrast, the second individual was a Christian and a man of some importance. Ealdred lived 200 years later than the person in Burial 18. Styled 'under-king of the Hwicce', he was one of three brothers who we know had made grants of land to churches in the south-west Midlands after 757. By 777 his brothers Eanberht and Uhtred had died, but Ealdred lived on for another decade. His Hwiccian kingdom had now become part of the larger kingdom of Mercia and Ealdred's grants were made with the approval of the much more powerful King Offa (king 756-796), remembered today for the dyke running along the Welsh border (*colour plate 6*). Our interest in Ealdred lies in the fact that in 777-779 he and Offa made a significant grant of land, the

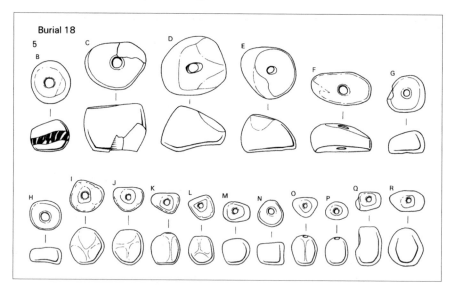

26 Beads from Burial 18. The originals can be seen in Cheltenham Museum. (Cotswold Archaeology)

profits from which were to support an existing 'minster' church at Cleeve. The Hwiccian rulers set up these churches, which were small communities where the members would not only pray for the founders and their families, but also spread or reinforce Christianity on their lands, spiritually by praying for the souls of their subjects and practically by offering them alms. The Latin for 'minster' is *monasterium*, which led earlier historians to believe that Cleeve's parish church of St Michael's was once a traditional medieval monastery with monks. This was not the case. We know that both men and women lived in minster communities and providing there was at least one priest to say mass, hear confessions and bury the dead, the other members could be lay people who would have served in the surrounding community. The great Anglo-Saxon historian the Venerable Bede, writing in 731, tells us that the princes of the Hwicce and their people had become Christian by the middle of the seventh century, which is before the setting up of the diocese based on the old Roman centre of Worcester in 680 to serve the spiritual needs of the whole Hwiccian kingdom. This did not mean that old pagan beliefs were left behind, for there is plenty of evidence to suggest they lay just below the surface. Modern thinking considers that St Michael the Archangel is a dedication which goes back to the earliest roots of Christianity in southern Britain, being used from the sixth century in Wales where we know Celtic Christianity had maintained a link with late Roman Christianity. It is most unusual to be recorded as early as 777-779 in England – what this might signify, we just don't know. Legend

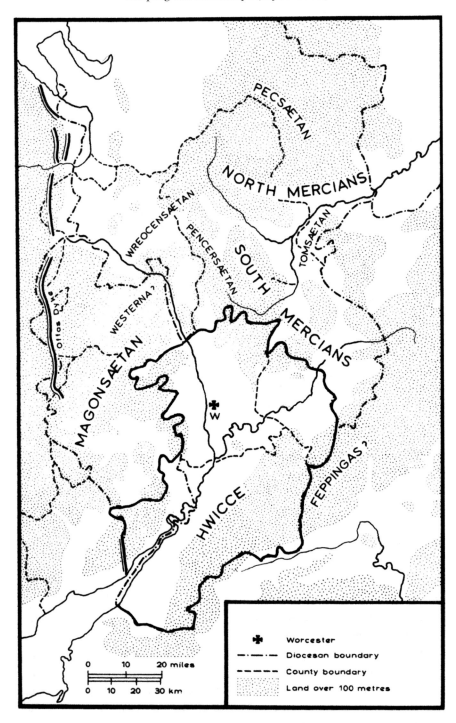

27 Map of the kingdom of the Hwicce. Based on Della Hooke's *The Anglo-Saxon Landscape, the Kingdom of the Hwicce* (Manchester 1985) p.7

has St Michael as the guide on the soul's journey to heaven and he came to be associated with existing burial places, so was there any link with the Romano-British graves found in nearby Gilder's Paddock? His name was also associated with churches standing on higher ground. At Cleeve did this mean the nearness to Cleeve Hill or the slight rising of the ground where the church actually stands? All this seems to mean that St Michael's was set up to look after the spiritual requirements of both the Hwiccian royalty and the local population who lived in a recognisable territory. This later became the ancient ecclesiastical parish of Bishop's Cleeve which survived into the nineteenth century.

THE IMPORTANCE OF THE MINSTER OF ST MICHAEL'S

Minsters gained their land from the royal family. We know that Ealdred's grant of 777-779 added 15 hides of land to an earlier grant of land, but we have few details of this earlier grant except it lay around St Michael's and that sufficient time had elapsed before 777-779 for people to realise it was insufficient to support the minster. Also it is likely to have been made by an ancestor of Ealdred. Originally a hide of land had been an area large enough to support one family for a year, but by now it seems to have become a unit of taxation without any fixed size. Some historians have tried to make the links between Romano-British landed estates and the new minster parishes, and it is tempting think that these two grants were based on the lands of the lost 'villa' in Cleeve and the excavated villa of Haymes, but there is no other evidence to support this and there is evidence suggesting it might be unlikely, to which we will return when we study the description of the boundaries. Similarly, there is a debate about the continuity of Christian beliefs from the Roman period and the possibility that St Michael's was built on an earlier Christian sacred site, especially as its dedication to the archangel represents an early origin. Again actual evidence of continuity of Christianity in the Severn Vale is lacking. Carolyn Heighway, who has a special interest in Anglo-Saxon Gloucestershire, wrote in *The Land of the Dobunni* that the area was not overwhelmed by Anglo-Saxon invasion and so it is reasonable to think that the people continued to be Christian and that the minster churches could have replaced earlier British churches rather than directly replacing pagan sites, but she readily admits that concrete archaeological and written evidence is missing. The speculation continues when we try to understand why the particular site for St Michael's was chosen, but if we try to answer this question, we can throw some light on how it became the central place of what later developed as the village of Bishop's Cleeve.

It is reassuring that we can be confident that St Michael's is the descendant of that original minster, although rebuilding means we have no idea what it might have looked like, except that it is likely to have been much smaller than the present church and perhaps built from timber at the time of Offa and Ealdred. John Blair of Oxford University is the national expert on minster churches. He has noted that there was a clear pattern to their location: they tended to be built in oval or rectangular enclosures on higher ground formed by islands of sands and gravels in areas of clay and surrounded by water courses. St Michael's, standing on an island of sands and gravels and with a rectangular precinct, originally mostly surrounded by water, fits all of this almost too well (*colour plate 7*). Its location also suggests that the land was not already occupied to any great extent because there was nothing preventing the choice of the ideal location. This might mean that Iron Age settlement brought to light in Gilder's Paddock and at 21 Church Road did not extend this far eastwards. Other evidence might support this view. When the St Michael's Hall site was investigated by archaeologists in 1987 only an undated ditch and two pits were found. From their report the excavators were obviously disappointed that a site so close to the church produced so little evidence. During building work at Cotland Priors in lower Station Road in 2004 archaeologists did find possible Iron Age ditches aligned with those at Gilder's Paddock, but nothing more. The ditches themselves would have silted and could no longer have been a significant feature, but it remains just possible the later Romano-British burials found by Charles Parry had given the site a particular significance which influenced the choice for the minster and its dedication to St Michael. In the end, however, we cannot be certain why this site was chosen for it's possible that the Iron Age occupation and choice for a minster reflected the same geographical advantages of an area of slightly higher and drier ground, largely surrounded by water, which made it attractive for occupation. There did not have to be a meaningful link between the two uses, in fact further evidence strengthens the view that this central area was not occupied at the time the minster was set up, as the 2004 excavations behind 21 Church Road, on the southern boundary of the precinct, failed to find any Romano-British or Saxon features, for although 19 sherds of mid-Saxon pottery were found there, the excavators considered they had come from somewhere else. And so there the evidence, at present, rests. Whatever might have happened we do know that from the eighth century at least, St Michael's became a central place and symbol of continuity for over 1000 years.

The members of the minster and their families lived within the enclosure, or 'precinct', where there would have been a variety of timber buildings, long since gone without a trace. Not only their houses, but also bake and brew

28 Houses at West Stow Anglo-Saxon village in Suffolk provide an indication of what houses in Bishop's Cleeve might have looked like. The earliest manor house of the church of Worcester might have looked like the building in the distance

houses, buildings for animals and barns for the corn, brought in by their parishioners as churchscot at Martinmas (11 November) as a tax on the grain they grew. Unlike today, the area was not at first used as a village graveyard, for only the priests and their families seem to have been buried in such places until the middle of the ninth century. It is not difficult to imagine other people moving to the edge of the precinct to sell their services as craftsmen, traders, labourers and even servants, so the settlement pattern possibly began to change; some of the scattered farmsteads were left to fall into ruin as the farmers and their families moved towards the main entrance of the precinct off what is now Church Road. We can only guess when this started for our evidence for people living in the surrounding farmsteads runs out in the later fourth and fifth centuries. We don't know if this was because they moved towards the minster or because the population shrank or even simply because we lack the evidence of occupation for nearly two centuries, as coins and pottery gave way to bartering, leather and wooden objects which leave no archaeological traces for us to find. By the time the church of Worcester took over the minster in the early ninth century it seems reasonable to suggest that Cleeve was already developing into a village rather than continuing as

an area of dispersed settlement. Did the villagers decide to make the change for their own advantage or were they influenced by their landlords? This is a question often asked when villages were formed in the later Saxon period. We will return to it later.

It must be obvious that this part of the story about the minster and its importance has been pieced together from written and landscape evidence which is tantalisingly fragmentary and so open to different interpretations. Coins and pottery, two key elements of the archaeological record, have largely disappeared. Also our earliest documents provide evidence of landscapes and territories within which the individual settlements existed and very little on the settlements themselves. Nevertheless, if we continue to put the archaeological and written evidence together we can make some observations and draw some tentative conclusions about the development of settlement in Cleeve in the six centuries from the decline of Romanised Britain to the Norman Conquest and in particular try to answer a question over which archaeologists and historians have argued for many years: was there a time between the end of Roman Britain in the fifth century and the setting up of the Anglo-Saxon kingdoms by the seventh century when settlements like Cleeve were abandoned and farmland reverted to woodland to be resettled later, or did settlement continue without a break? As we shall see, this depends upon the interpretation of very limited evidence. So let us restart our story with a more detailed examination of the pagan Saxon cemetery, placing it into its wider contexts of space and time.

IN SEARCH OF PEOPLE: THE ARCHAEOLOGICAL RECORD

Twenty six burials were excavated in 1969, but for unknown reasons some of the skeletons were lost and Neil Holbrook had only 20 to analyse for his report. It was impossible to tell the sex of all the skeletons, but calculating their approximate ages was more successful. Fifteen had been over 25 years old at death and five were younger; three being under ten – a low ratio of child deaths, perhaps indicating that they were generally a healthy population. On the other hand, just three of the people had lived longer than 45 years. Sixteen graves contained grave goods, amongst them were two spears, which were probably to signify the importance of the owner in this world and the next, and 196 beads, including the 84 amber beads found in Burial 18. Eight brooches were uncovered and from their styles it was possible for Neil to work out the cemetery had been in use *c.*525-*c.*575. The brooches are of a style linking these people to the upper Thames valley via the Avon valley; similar brooches found at Beckford in the 1950s support this theory. So who were these people?

The cemetery could represent a small community of 13 people buried over a period of 50 years, or a smaller community of nine people over 75 years. This might suggest settlement was still dispersed across the vale as the low numbers could represent an extended family group living in one farmstead. Ten burials towards the end of the cemetery's life had no grave goods. We will probably never know whether this was because of a lack of resources (so none would be 'wasted'), poverty of the individuals, or the impact of Christianity with its emphasis on an eternal life where possessions from this life are not needed. Were they incomers or locals who had adopted the incomers' ways? Andrew Reynolds of University College London has suggested they might be local people as he considers that incomers would have shown evidence of being prepared for struggles with spears and shields that were designed to be used. We shall probably never know for certain, but the commonly held idea or myth that warlike Saxon warriors hacked settlements out of the 'wildwood' and drove the remnants of an earlier population into the safety of the Welsh hills, seen across the Severn Vale, just didn't happen on any noteworthy scale. Neither were the local hillforts re-occupied for safety, as happened in some places in southern England.

When we turn to consider the wider context of the cemetery in Bishop's Cleeve, problems of evidence and interpretation continue. Carolyn Heighway has recently written about the period that,

> The (native) Gloucestershire British are invisible. Wherever they were we have every reason to suppose that in the sixth century, the vale at least was still under the rule of a British prince, its people still British-speaking and native born ... After c600AD every one in Gloucestershire becomes invisible, at least to archaeologists.

If the people buried in the cemetery represented one family over 50 or 75 years, where were all the other people in the area buried? These graves can only represent a fraction of the population for it is very unlikely the population of the area had shrunk to such small a number, although we do know from literature that (probably bubonic) plague hit Britain c.445 and c.549 and could have killed between a third and a half of the population as happened during the Black Death, but archaeologists have not yet found sound evidence to support this. In our area there might have been another small cemetery between the railway line and Gotherington Lane, but no trace now exists. Perhaps people were cremated, which leaves no record unless the ashes were placed in an urn and buried. All this means we can only conclude that we don't yet understand what happened to the remains of people who died at this time – another unanswered question for future archaeologists and historians

to investigate. However, if we now turn from the dead to the living, we find the archaeological evidence is more fruitful and so we can return to the Tesco site to continue our story.

We know the supermarket was built on land which in the Iron Age and Romano-British periods lay on the southern edge of small fields or paddocks. It seems the site continued to lie on the edge of the Anglo-Saxon settlement as the excavators found human activity, but could not be certain that they had discovered any houses. The river channels and marshy area continued to silt and be filled in by deliberately dumping waste. Fortunately for us part of the waste was broken pottery and the 230 sherds form the largest amount of Anglo-Saxon pottery so far found on one site in the village. Unfortunately, styles changed so slowly that the sherds could date from any time from the sixth to the eleventh centuries. Most were locally made, but some came from Charnwood Forest and the Warwickshire Avon areas. Some contained granite from an unknown source and as no granite occurs near Cleeve, this is more evidence for trading links with the wider world. Similar types of pottery were also found around Cleeve Hall, some of which could be more precisely dated to the sixth to eighth centuries. As this area lay on the edge of a settlement, it could further support the idea of a developing settlement along Church Road towards St Michael's church, but as in earlier periods we can only guess at the size of the population although it must have been larger than that suggested by the cemetery.

From the excavations it is clear that farming continued its crucial role as the backbone of the community. As far as can be judged from the evidence, people farmed in the same way as in the Iron Age, which is not that surprising as the need for food and the technology for producing it had changed little, if at all, although the plough could now cut deeper into the soil. Crops of wheat, barley, oats, rye and pulses continued to be grown, for food, drink and animal feed. Cattle and sheep were kept for dairy produce, working on the farms and for wool; some pigs were kept for their meat. Hedges of hawthorn and blackthorn defined the fields. There were possibly small areas of scrubby woodland, but the findings confirm there was no large-scale re-growth of woodland at the end of the Romano-British period as had happened in some places on the Cotswolds. Where the land remained damp, willow and poplar grew; the villagers also had access to oak, ash, maple and hazel, but it is likely they had to journey at least to the lower slopes of Cleeve Hill to find trees of any size in any numbers.

The evidence from the Stoke Road excavations reinforces this picture. Here were found five post holes, which the excavators in 1997 thought might be the remains of a temporary shelter or wind break, but which has been more recently re-interpreted as part of a circular dwelling about 4m (13ft) in diameter – the only possible Saxon house yet found, and which suggests people

29 The Stoke Road excavation site shortly after the topsoil had been removed

were still living at some distance away from St Michael's. The end of a strap made from copper in the ninth century was found here plus four sherds of Saxon pottery. Similar pottery was found during the Home Farm excavations but no evidence of buildings was found there. Some of this pottery has been dated to the sixth and seventh centuries, which indicates that people were living here about the time that people were being buried at Lower Farm, but whether the burials were connected to the Home Farm site is impossible to say. Had archaeological investigations occurred when other parts of Bishop's Cleeve were developed from the 1950s we might know more about Anglo-Saxon settlement, but the opportunities are now lost forever.

Taken together, all the evidence suggests that Cleeve was continuously inhabited during the 'Dark Ages' and the environmental evidence from the Tesco and Cleeve Hall sites indicates land use had not changed greatly from

the Bronze Age at least. Perhaps some land cleared at Haymes reverted to woodland, but the people needed to continue to farm in the vale to produce their food. Writing in 1999 Charles Parry remained tentative about the conclusions which could be made from the archaeology to support the idea of continuity:

> Bishop's Cleeve has been occupied since the later prehistoric period, and there is some reason to think that this occupation could have been continuous. However, the archaeological evidence is by no means conclusive and more work is required.

Five years later Peter Ellis and Roy King of Foundations Archaeology from Swindon, working at Cleeve Hall, were more convinced of continuity:

> At Bishop's Cleeve it is possible to build a sequence of continuity from Roman to the medieval period which would fit (the evidence) suggested by documentary and landscape studies and by excavation.

The weight of evidence seems now to support their view, although perhaps they have gone beyond the evidence in suggesting the estate attached to the Romano-British 'villa' formed the estate granted to the minster. In the end we have to ask, was it more likely that people stayed and farmed or that they moved away or died and they, or others, at an unknown later time returned to continue farming in the same way?

So a reasonable answer to the question of what might have happened in Cleeve in the fifth to eighth centuries is that people continued to live here because they were tied to the land to gain their food, using the land in the same way as the earlier inhabitants, even if the field boundaries themselves had changed. Some were moving towards the minster; some are likely to have still continued to live on the existing farmsteads, although they were perhaps being slowly abandoned, but to repeat Carolyn Heighway, people are now largely invisible as far as archaeology is concerned. It is quite possible that their way of life largely continued from the Iron Age as the Roman influence had been but a veneer on local life. People continued to live in timber buildings, but the supply of pottery from the Severn Valley, Malvern, Oxford and further afield dried up, replaced by perishable wood, leather and basket utensils which have left no trace and have caused archaeologists the problems explained above.

Such are the conclusions which can be drawn from the archaeology of the last 20 years. The evidence of the documentary record has been known for very much longer, although during the last two or three decades much of it has been subjected to a re-interpretation. In order to understand more fully

the grant of the land by Offa and Ealdred to the minster at Cleeve, we need to consider its context in the lands of the Hwicce. In doing this we might begin to understand how Cleeve gained its English name and how the Romano-British influence was swamped by the English.

IN SEARCH OF PEOPLE: THE WRITTEN RECORD

If the archaeological record speaks to us of the villagers, the written record speaks to us of their rulers. Steven Bassett of Birmingham University has studied the Hwicce intensively. He sees the kingdom being created from the bringing together of 'micro-kingdoms' which had possibly developed at the end of the Romano-British period after *c.*500. Della Hooke, another historian of the Hwicce from Birmingham University, suggests its British leaders intermarried with Saxon leaders and the Englishness stemming from these rulers triumphed over the Britishness of the local communities so that the language and culture were transformed. Although the Hwiccian princes seem to have ruled in their own right at first, after 700 they came increasingly under the influence of the Kings of Mercia; Ealdred was referred to as under-king and from *c.*800 the Hwiccian leaders were called only *ealdormen* (the equivalent of our earls). This last description appears in a document of 969, by which time Mercia itself had been merged into the kingdom of England dominated by its former southern rival of Wessex. Then sometime during the next 40 years the kingdom was divided into the shires of Gloucestershire, Worcestershire, part of south-west Warwickshire and Winchcombeshire, created as territories responsible for the defence of each county town. Winchcombeshire did not last long before being absorbed into Gloucestershire in 1017 but Steven Bassett considers its existence could well reflect a micro-kingdom around the original heartland of the Hwicce around the capital of Winchcombe. Cleeve came within that heartland, which could have stretched into the lower Severn Valley between the Cotswolds and the Malverns. Men from Cleeve would have served in the army, kept the walls of the royal centre of Winchcombe in good condition and repaired any local bridges (to allow the army to move quickly).

If we now focus on the documents related to the minster at Cleeve, light can be thrown upon the wider community and its surrounding territory over 1200 years ago, as long as we bear in mind the documents were written from the point of view of the rulers, so they can only indirectly tell us about the people themselves. On the other hand we are fortunate that the records survive at all, even if trying to understand them is something which has caused historians some difficulties. In setting up minsters the Hwiccian princes were not only showing their devotion to the Christian Church, but also increasing

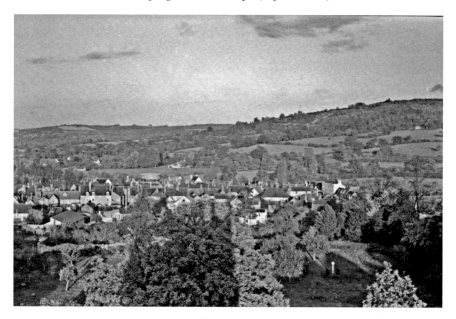

30 This view from Winchcombe church tower taken in 1964 looks out across the precinct of a Saxon minster, which later became the Benedictine abbey. The nineteenth-century cross was intended to mark the middle of the tower of the church, but a geophysical survey in 2006 found it stands several metres to the west (left in the view) of the actual crossing

their control over their subjects, so the minsters were well-endowed with land to provide the wealth and income needed to be successful. A minster had probably been founded in the Hwiccian capital at Winchcombe by the reign of King Offa in 757. But the town's close royal links would make it more likely that it was here the priests spent their time primarily praying for the Hwiccian royal family. It might even have provided a home for minor members of the royal family who would otherwise have been a drain on the family's resources. Other local minsters were at Evesham which had been set up by 706; Twyning by 740; Bredon by 773; Beckford and Cheltenham by 777; Bishop's Cleeve itself 777-779 and Deerhurst by 804. Of course the land still technically belonged to the royal family; it was only granted to provide income and support for the minster communities.

The charter detailing the grant was first studied in detail in 1935 by Dr Grundy of Oxford University who made an attempt to identify the places on a modern map, not totally accurately. He noted that two copies of the charter exist: the earlier one known by its number 246 in Birch's list of Saxon charters (*Cartularium Saxonicum*) and the second in an early eleventh-century collection of charters at Worcester called the *Liber Wigorniensis*. Although

historians can agree the details of the grant itself are likely to be those of the late eighth century, the dates of the boundary descriptions are more difficult to work out. Michael Hare, who has studied Saxon charters in the county in detail, thinks the first description is likely to have been written in the middle of the tenth century at the earliest; the second possibly two generations later.

If we now turn to the details, we are again grateful to Steven Bassett who has done more than anyone to steer a way through the Anglo-Saxon land grants in and around Cleeve and much of the following builds on his work. It is here we meet up again with Ealdred and his overlord Offa. In 777-779 in the presence of a number of witnesses they granted more land to support the existing minster at Cleeve. The introduction to the grant throws some light on Cleeve in the late eighth century. Steven's translation from the original Latin reads:

> I (i.e. Offa, King of Mercia) and Aldred, sub-king of the Hwicce, together grant, for the Lord Almighty's sake and the eternal health of our souls, fifteen hides of land, that is at the place called *Timbingctun*, to the monastery which is strictly called *aet Clife* and to the church of the blessed archangel Michael which has been founded there, giving this land freely into ecclesiastical possession. It is in fact that place lying under the cliff which in the old tongue is called *Wendlesclif* on the north side of the brook called *Tyrl*. It is adjacent to the land of the aforesaid monastery with its bounds.

Why did they do this?

> (On account of) these earthly royal trappings of rule which I (Offa) have received from the creator and bestower of all benefits (i.e. God), I should, for my soul's relief and the gaining of heavenly wealth, give something, however unworthy, to the Church for the profit of monastic liberty.

He was attempting to smooth his way to heaven by giving land to the minster, to allow it to carry out its work to pray to God for the royal families and spread or deepen Christianity in the area, presumably because the original grant was not sufficient, as we have noted. However, this grant of land was hardly 'unworthy' as it formed a substantial (and profitable) estate. We don't know the boundaries of this land grant because, as we have seen, the description now attached to the charter must have been drawn up at a later date. However, the grant was of 15 hides and in Domesday Book the entry for Cleeve states its size then was 30 hides and so it is possible that this grant doubled the minster's original landholding.

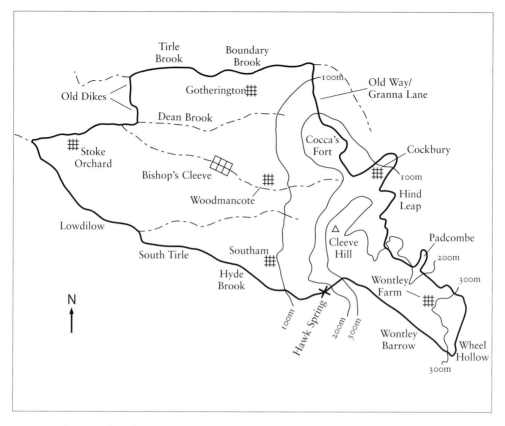

31 The area described in the boundary clauses of the *Timbingctun* charter

The charter is important in many ways. It contains the first recording of the place-name 'Cleeve', from the 'cliff' of Cleeve Hill; 'Bishop's' was added by 1243 to distinguish it from Cleeve Prior, north of Evesham, which was later held by the prior of Worcester. We obviously know the minster was at Cleeve but the area around which this new land grant was focussed was called *Timbingctun* below *Wendlesclif* on the north side of the *Tyrl*. This description best fits the area around the place we know as Southam, particularly as a similar charter for Deerhurst makes reference to the same tributary of the Swilgate as the *Tyrl*. This is Hyde Brook, which passes under the road to Cheltenham south of The Newlands (*colour plate 8*). *Wendlesclif* has provoked some debate amongst historians. Dr Grundy argued that it meant a steep slope of a quarry; Margaret Gelling, the expert on English place-names, writing in 1984, believed that *Wendel* was more likely to be a personal name, even a mythical one, literally meaning 'a wanderer'; either interpretation would fit its use here. Does the reference to 'in the old tongue'

suggest a translation from a British word known within memory and thus provide rare evidence that the British language was still being spoken here until the eighth century? *Timbingctun* probably means *Tymba*'s settlement or farmstead. He remains an unknown, or even another mythical, person. The geographical description places it near Southam but that name is first recorded in 991, because it was the southern settlement of the estate in relation to the main settlement of Cleeve.

So the grant of 777-779 brought together two estates: one *aet Clife*, the other called *Timbingctun*, which together became the long-lived ecclesiastical parish of Bishop's Cleeve, but within 50 years it's likely the minster and most of its land came into the hands of the church at Worcester, where it remained until 1561. We have no specific reason why this happened at Cleeve but generally at this time head minsters like that at Worcester became keen to take control of the minsters in their diocese because they were seen to be failing and in danger of passing out of the church's hands into the hands of lay lords. This takeover was an important event in the Saxon period so how did it affect the community of Cleeve?

THE TAKEOVER BY THE CHURCH AT WORCESTER

Ten of the 17 manors recorded in Domesday Book as belonging directly to the church at Worcester had originally been associated with minster churches. When it took over Cleeve it split off a generous portion of land to support the small minster community which continued to work in the area. At some time before 1086 this community had given way to a parish priest. And so began the long story of what became the rectory of Bishop's Cleeve, one of the richest in the whole country and certainly the richest in the diocese of Gloucester, which was formed in 1541 when the diocese of Worcester was split into two at the Reformation. It is a story we shall pick up in the next chapter.

Another significant impact on Cleeve resulting from the takeover was the building of a manor house where Cleeve Hall now stands. The church at Worcester needed a centre to look after its manor, and the bishop and his household would need somewhere to stay as they travelled around the large diocese. The excavations of 1998 showed that this area had been reorganised with new land boundaries about the time of the early ninth-century split, presumably after the marshland had been finally drained by new river channels, a modern equivalent of which still flows in a culvert by the side of Stoke Road. These changes could be interpreted as a deliberate act to find a site for the manor house outside the original enclosure around St Michael's, perhaps a recognition of the continuing importance of the minster in the eyes

of the new landlord at Worcester. The hall and its outbuildings would have been of timber. The first might have been a simple rectangular building; one at Cheddar built about this time was 23m (75ft) long and 6m (19ft 6in) wide; the one discovered at Holm Hill when the Tewkesbury Borough Council offices were built in the early 1970s extended to 40m (130ft). Then, as at Tewkesbury, it was perhaps rebuilt before the Norman Conquest as an aisled hall open to the roof. We think this happened because an investigation of the structure in 2001 discovered that when the present building was built c.1250 it seems to have been a copy in stone of an earlier timber building (*colour plate 9*). Excavations in the grounds of the hall in 2000 found traces of another timber building, probably an outbuilding within the manor complex. The bishop's manor house had an important impact on the shape of the village, giving it a second focus away from St Michael's, and perhaps further encouraging development along what is now Church Road, but there was no new development in its immediate vicinity until the thirteenth century.

During the late Saxon period, as the church helped people make sense of their lives by offering the sacraments and the rounds of services on Sundays and holy days, it also had an increasing impact on their daily lives in very practical ways. We have already noted that families had to pay churchscot to the priests; by c.900 they also had to pay churchbot for the maintenance of the church itself. Now they were also paying tithes (one tenth of the produce of the land). From c.850 the villagers had the right to be buried in the churchyard, unless they were regarded as criminals or other undesirables, but by c.1000 they had to make mortuary payments to reserve the ground for their own grave, in addition to payments for the last rites and the funeral. With the dues and money payable to the church at Worcester and even the pope in far away Rome, the peasants must have felt the power of the Church very strongly in their daily lives. This was, of course, balanced by the spiritual strengths it gave them. But under the veneer of Christianity an older world of pagan beliefs still existed. Bishop Wulfstan I (1003-16) criticised those who continued to worship wells and trees and stones and performed 'magic'. The boundary description attached to the *Timbingctun* charter includes one marker in Padcombe Bottom 'where an apple tree and maple tree have grown intertwined'. Stephen Yeates argues that intertwined trees had a sacred pagan significance. It is quite possible that was the reason it was chosen for a marker. As we shall see shortly, other sacred spots were also used in this way. Further letters from Bishop Wulfstan throw light on how churches in his diocese were being (mis)used. He condemned those who ate, drank and behaved 'foolishly', played 'disgracefully' and talked ' scurrilously' in God's house. Churches were being used as community meeting places, not surprisingly as they must have been the largest public building in the villages, as was St Michael's in Cleeve,

even if then it was smaller than today. Nor were all the priests fulfilling their duties: they had to refrain from 'idle speech' and bad behaviour in and around their church and from wearing weapons inside church, and stop being drunk and quarrelsome. In addition, they had to ensure no mouse droppings or dirt lay on the altar, which was to be kept clean and well covered. Criticism of the church for failing to meet its obligations recurs from time to time during our story; any golden age tends to disappear under closer scrutiny.

DIVIDING THE LAND FURTHER

We have 889 as the very latest date for St Peter's at Worcester taking over the minster's lands, because in that year the priests at Worcester granted to Bishop Werfrith, 'land of five hides at *Alchmunding tuun*, which formerly belonged to the minster at Cleeve.' It was to be held for three lives (his own and two heirs) before going back to the priests at Worcester, but the people who lived there had to continue to pay churchscot to the church at Cleeve 'as is right'. This is one of the lost place-names in the territory attached to Cleeve. Michael Hare thinks the settlement lay towards the southern boundary of the territory, for the land was further split between 899 and 904 when two hides were to belong to Prestbury for the rest of the lease. This new lease contained a reference to woodland, which might help to locate the land near Hyde Brook as it ran down Cleeve Hill into the vale between modern Southam and Prestbury. We have no further knowledge about *Alchmunding tuun*. The land attached to it eventually returned to the church at Worcester and so it seems the settlement became another 'lost' settlement, possibly a casualty of the movement towards a village at Cleeve, but this is speculation.

From Bishop Oswald's reign (961-92) three more charters survive which are relevant to Cleeve. In 967 he leased six hides at Stoke (Orchard), with the consent of King Edgar and his council, to his thegn (i.e. a lesser nobleman) Eadmer for three lives. In 969 four hides at *Saperton* were leased to Eadric, with the consent of the cathedral clergy, for three lives, free of all dues except churchscot, which presumably had be paid to the church at Cleeve as usual. Finally in 991 Oswald granted two hides at Southam to his brother Athelstan, again with the consent of the clergy and for three lives. Oswald was rather keen to grant land to his relatives; in all, one quarter of his grants went to them. The reasons for these grants are not clear, but one suggestion is that the church at Worcester needed more income to meet its payments to the king.

Two more charters survive from a later bishop, Bishop Lyfing (1038-46). One is a now-lost charter for five hides at Southam, granted to an unknown

32 St James' church at Stoke Orchard has been dated to *c*.1170, and about the time of the earliest surviving parts of St Michael's. It has remained small because the village also remained small. Inside, the wall paintings have survived much better than in St Michael's

person; this might or might not have included the two hides granted in 991. In 1045 a second charter repeats the terms of the 969 lease at *Sapertun*, but unfortunately the name of the recipient and the size of the holding are lost. In Domesday Book Southam's size was recorded as six hides, which could have been the five-hide estate plus one hide at Cockbury on Cleeve Hill. Because the 967 lease at Stoke had been granted with the permission of King Edgar and not of the church at Worcester, this hints that it might have been part of the earlier estate around Cleeve which had remained in royal (Hwiccian) hands when the rest had been granted in two stages to Cleeve minster. This might help to explain the reason its Domesday sub-tenants Bernard and Reginald refused to do service to St Mary's at Worcester for their manor. The place-name Stoke is usually considered to mean a secondary settlement, which in this case would fit with its relationship to Cleeve, with the mother church of St Michael responsible for the care of the church of St James at Stoke. We will return to this and the lost settlement of *Sapertun* in the next chapter but at this stage observant readers will again have noticed that the name Woodmancote has failed to appear in the written record.

33 The earliest architecture of the Church of the Ascension at Southam dates from the early eleventh century, although it was restored by Lord Ellenborough *c*.1862 after centuries of neglect. It formed part of the manorial complex, with manor house and barn, but it never became independent of St Michael's, unlike St James' in Stoke Orchard

This granting out of land was quite usual from the tenth century onwards. Over the next two centuries the lay people who gained the land often built churches for their own use and that of their peasants. In most cases this led to the splitting up of the large minster parishes into smaller parishes based on the new churches. This happened in neighbouring Cheltenham and Winchcombe but not in Cleeve. Chapels survive at Southam and Stoke Orchard and we know there was a now-vanished chapel in Gotherington by 1258, but none of these became parish churches of new, smaller parishes. Why did this not happen at Cleeve? It might have been because the Bishop of Worcester or the priest in Cleeve was so powerful or that the actual lands attached to these sub-manors were often so intermingled in the arable fields that it was too difficult to disentangle into separate parishes. John Blair has even suggested that the great rebuilding of parish churches in the eleventh and twelfth centuries saw the former minster churches elaborately decorated to reflect their earlier importance and continuing power over the community, quoting Blockley, another of Worcester's churches, as an example, but St Michael's also fits this

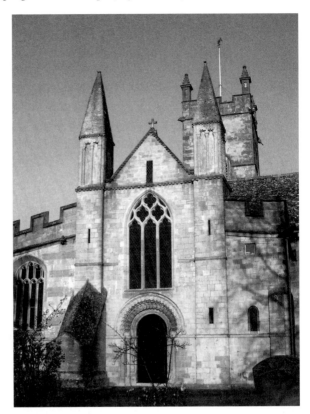

34 The door arch and
turrets at the west end
of St Michael's have
survived from the late
twelfth-century church

model. He also points out there had been an earlier rebuilding campaign *c.*1000 when stone came to replace timber, and he uses Odda's chapel at Deerhurst to support his argument, so there might well have been a stone church at Cleeve before the building of the present one began in the twelfth century.

A GLIMPSE INTO THE LATER SAXON LANDSCAPE

Finally we ought now to turn to gain a glimpse of the features of the countryside where these changes were taking place. As we have read we cannot be absolutely certain when the boundary descriptions were written down, except probably some time before the early eleventh century. The estate lay mostly between Hyde Brook in the south and Tirle Brook in the north; the use of natural boundaries is usually taken as indicating an early date for land units like these and we know, of course, that two existing areas were put together by the Offa and Ealdred's grant. In the west the boundary follows two 'old dykes' between the Dean Brook and the Tirle. This gives us

35 The boundary description starts here at Lowdilow Bridge. Today the Hyde Brook has nothing to suggest it has been a boundary for well over 1000 years

clear evidence for artificial boundaries dividing up land likely to be already set out as fields in the vale by the early eleventh century at the very latest. The boundary follows the Tirle eastward to the Meercombs ('the valley of the boundary'), where it bulges round a Romano-British 'villa' near the bottom of

36 This hedge marks the southern 'old dyke' which marks the western edge of the estate and links the more natural boundaries of Dean Brook and Tirle Brook

Granna Lane near Gotherington. This is the evidence that this Saxon land unit was not based on the two earlier Romano-British estates as here was another 'villa' within the boundaries and yet the boundary itself cuts so close to this 'villa' site that it must have cut through its lands and not followed the 'villa's'

37 'Hawk Spring' is a boundary marker as the boundary drops down from the crest of Cleeve Hill. From here the water flows into Hyde Brook which runs between Southam and Prestbury

own land boundary. The Saxon boundary then heads up Nottingham Hill and around Cocca's camp before reaching Hengist's headland at the watershed of the Avon and Severn by the Cheltenham to Winchcombe road. From here it drops down to Stony Cockbury and runs up onto Cleeve Hill above Postlip from where it cuts an indirect course via Padcombe Bottom to the eastern end of West Down and subsequently runs largely north-westwards to Hawk Spring – the source of Hyde Brook. Significantly, in the second version the boundary is written down in greater detail as it runs over Cleeve Hill, which supports the theory that by this time most of this large established open pasture, which had been previously shared by the surrounding communities of Winchcombe, Sevenhampton and Prestbury, had been successfully claimed by the people of Cleeve for their own exclusive use.

For a balanced farming economy any estate needed arable for crops; pasture for animals; meadow for hay; and woodland for building-timber, firewood and a host of domestic items and tools, as well as for pannage for pigs. The boundary description can expand what we know from the archaeology. Cleeve Hill was even then an important pasture resource but the open land was not just used for grazing, as two references to 'leaps' for deer suggest animals were also hunted there. The 'leaps' allowed them to leap on to the upland but not off it. Meadow might have lined the banks of the streams in the vale, as we know happened

38 The White Way is aptly named as it cuts across Cleeve Common. Its route is referred to in the boundary description as the old way/Granna Lane and Wheel Way

in later centuries, but there is reference to Woodpecker Meadow near West Wood on the far side of Cleeve Hill. All references to woodland are, as would be expected, away from the vale. There was a clearing frequented by wolves in *Watancomb* (Padcombe Bottom) and Sprog's clearing south-east of Wontley, and a hanging wood on the steep slope above Hawk Spring. Even today these parts continue to be amongst the most wooded in the area; for example, Queen's Wood runs by the side of the infant Hyde Brook. Trackways criss-crossed the upland: *Gwena Weg* (Granna Lane) from Gotherington climbs Nottingham Hill and crosses Cleeve Common as White Way and leaves the parish at *Weohles Heale* (Wheel Hollow) at the eastern end of West Down. *Hweogel Weg* (Wheel way) marked a route which leaves the common at Wheeler's Corner to drop down to Prestbury. How many walkers passing through Wontley Farm realise they are following *Wahlweg* (Strangers' Way), indicating that long-distance travellers cut across the eastern boundary of the parish on a north-south route between the Midlands and the south of England? For the modern archaeologist the bounds provide tantalising evidence for burial mounds. In the vale by Hyde Brook near Elmstone Hardwicke lay *Hleowede Hlaw* (now Lowdilow) and before the boundary reached Stoke Orchard it passed *Imma Beorge* (Imma's Barrow). Possible evidence for a long-destroyed long barrow in the vale was found in excavations near the Tirle Brook at Walton Cardiff in 2004-05 because

39 The straight line of the West Down boundary of Cleeve Common reflects the artificial boundary set out in the land charter. At least two vanished burial mounds lay along its line. The sheep are still pastured here as they have been perhaps since the Bronze Age

Tim Darvill has suggested that the best explanation for a pair of nearly parallel ditches over 30m (100ft) long is that they were ditches from which the material for the long barrow was taken, like those which just survive at Belas Knap. If this is correct, it is further evidence for people living in the vale in the Neolithic period. Up on the hill the present Southam parish boundary still follows the south-western edge of West Down and passes the site of *Antan Hlaw* (Wontley) and *Herrihtes Beorh* (Herriht's Barrow). It does seem as if the boundary sought out these sacred sites, perhaps to give it legitimacy by association with the ancestors, possibly many centuries before these descriptions were written down. Of course, it is just possible the boundary existed before the barrows were built and the barrows were sited on the boundary, but we can only speculate again here. Finally, we meet some personal names: Imma, Cocca, Hengest, Cippa, Pippa and Wat. Were these real people who were tenants of the church of Worcester or who had cleared woodland, or were they mythical figures called up to 'explain' landscape features, as Stephen Yeates thinks about Cocca? Again, we will probably never know for sure.

SO WHAT MIGHT IT ALL MEAN?

What does all this evidence tell us about Cleeve from the end of the Roman period to the Norman Conquest? Cleeve lay near the heartland of the Hwicce.

The archaeologists have told us that people continued to live near the Iron Age and Romano-British settlements but following a lifestyle which left behind few physical traces before the seventh century. We know of a small group of 'Saxon' settlers from the Lower Farm cemetery. On the Tesco site archaeologists think they found the southern edge of a settlement which might have begun to develop around a minster set up before 777-779 as people began to move there from their outlying farmsteads. When the church at Worcester took over the estate, leaving some land to support the minster, a second focus appeared with the building of a manorial complex on the site of Cleeve Hall and a village began to form between there and St Michael's church as people moved to live closer together. The lands originally granted to the minster developed into a long-lived ecclesiastical parish and although Southam, Stoke Orchard, *Sapertun* and Gotherington were split off into sub-manors held by lay people, they never became medieval parishes themselves. Yet there is still no record of Woodmancote, except that the charter boundary descriptions suggest clearings were being made in the extensive woodland by the end of the ninth century. People lived by growing crops and keeping animals and providing St Michael's and the church of Worcester with their work and produce. Quarrying was still taking place on Cleeve Hill providing some alternative economic activity to farming.

So to conclude, let us return to Ealdred, under-king of the Hwicce, and Burial 18. Ealdred was part of a line of rulers who were already losing their power to that of Mercia by the end of the eighth century. Perhaps Ealdred spent some of his time in Winchcombe; perhaps relatives formed part of the community of the minster in Cleeve; their lives were made comfortable by the taxes and produce claimed from their subjects. Providing he avoided the intrigues of power and remained alive, he and his heirs enjoyed the privilege of not having to work to keep themselves alive. They enjoyed some 'leisure time' long before it became an accepted concept for everyone. Not surprisingly, hunting seems to have been an important part of such activities. Their lives might not have been much longer than their subjects' but they were immeasurably easier.

The Christian descendants of the person known to us only as Burial 18 would have had similar experiences of the fundamentals of life as Ealdred did: the round of seasons; the comforts of the Church's year with its important festivals of Easter and Christmas plus the feast days of lesser festivals and saints long forgotten in a secular age. St Michael's stood as armour against the Devil and evil spirits, offering the people protection in this world and hope in the world to come, but pagan beliefs remained just below the surface. Yet the real concerns in their lives, which were on average still much shorter than our own, were to keep alive, raise their family and pay the Church its dues. Their lives were very similar because these inhabitants of Cleeve still depended upon farming, which had changed little from

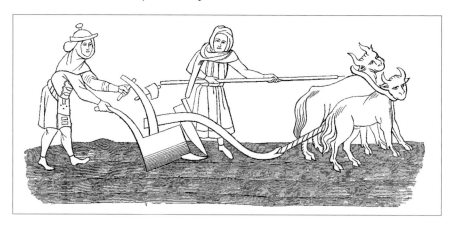

40 An early sixteenth-century drawing of a Saxon ploughman from Paul Lacroix's *Manners, Custom and Dress During the Middle Ages and During the Renaissance Period.* The two oxen represent a larger team. (EBook #10940)

the Iron Age. They were still dependent upon the weather and the harvest: wheat for bread; barley for brewing; butter, milk and cheese from cattle; milk and wool from sheep; and meat from pigs. Firewood came from the hedges or the woods on the hill slopes, which also provided wood for tools and timber for building their thatched houses, as any remaining Romano-British stone buildings had decayed or been destroyed. Some villagers had additional tasks for the community: shepherd, cowherd, swineherd and dairymaid; some worked for their lord as riding men to carry messages, and reeves who ruled the villagers on behalf of their lord; some were slaves of the church at Worcester, but it was the ploughman who symbolised the Saxon peasantry. In 1005 a monk at Canterbury called Aelfric wrote a textbook for learning Latin based on imaginary conversations with different people. It vividly describes the life of the slave ploughman,

> I work very hard. I go out at dawn, driving the oxen to the field, and I yoke them to the plough; however hard the winter I dare not stay at home for fear of my master; I have to plough a whole acre or more. I have to fill the oxen's cribs with hay, and give them water, and carry the dung outside. It is hard work because I am not a free man.

Villagers were tied to the land. They knew that power in the community lay at St Michael's and the manor house. As we move on we can discover more about the community at the end of this century by investigating the entry in William the Conqueror's great survey of England of 1086. The Domesday Book entry for Cleeve provides the subject for the next chapter and allows us to stop the story to focus on the first of two snapshots in time.

SOURCES AND FURTHER READING

Much of this chapter is based on my own fieldwork. Several of the books and articles detailed in Chapter One have again been useful including *The Tribe of Witches*, *Twenty Five Years of Archaeology in Gloucestershire* and *The Land of the Dobunni*. The same articles in the *Transactions of the Bristol and Gloucestershire Archaeological Society* have also been relevant. Neil Holbrook's report on the Anglo-Saxon cemetery appeared in volume 118.

Carolyn Heighway's *Anglo-Saxon Gloucestershire* (Gloucester 1987) remains the single most comprehensive survey of the county in this period. Della Hooke *The Anglo-Saxon Landscape: The Kingdom of the Hwicce* (Manchester 1985) deals with all aspects of the landscape, largely through the use of land charters. G.B. Grundy's *Saxon Charters and Field Names of Gloucestershire Part One* (Bristol 1935) has the only published version of the *Timbingctun* charter. My own *Cleeve Hill* (Stroud 1990) has a detailed discussion of the boundary across the hill and (ed) *Gotherington* (Stroud 1993) discusses the boundary in the vale, but the interpretation of the context of the charter has since been modified. Steven Bassett's most locally accessible writing is *The Origins of the Parishes of the Deerhurst area*, his 1997 Deerhurst lecture. A wider analysis can be found in his (ed) *The Origins of the Anglo-Saxon Kingdoms* (Leicester 1989) and P. Sims-William's *Literature and Religion in Western England* (Cambridge 1990). M. Gelling and A. Cole's *The Landscape of Placenames* (Stamford 2000) is the most recent work on the meaning of place-names. Finally, John Blair's two books which have been used are (ed) *The Minsters and Parish Churches* (Oxford 1988) and *The Church in Anglo-Saxon Society* (Oxford 2005).

3

SNAPSHOT ONE: DOMESDAY BOOK 1086

In TIBBLESTONE Hundred
The Church holds CLEEVE itself
Domesday Book 1086

THE DETAILS

At this stage in the book it might be useful to pause and reflect on how much we can learn from Domesday Book, and in particular to focus on the communities which existed within the boundaries described in the previous chapter. Behind the terse statements of the survey there lies much of interest.

It all started at Gloucester when King William I spent Christmas there in 1085. According to the Anglo-Saxon Chronicle he 'had a deep speech with his council and sent men all over England' to record and value his kingdom won at Hastings in 1066. Even though Domesday Book was compiled in the astonishingly short time of two years, William did not live to see it completed; dying from a nasty fall from his horse in September 1087. The entry for Cleeve follows the general formula. It reads in translation from the original Latin, based on the work of John Moore of Bristol University in 1982, as follows:

LAND OF THE CHURCH OF WORCESTER
IN TIBBLESTONE HUNDRED
The church itself held Cleeve. There 30 hides. In lordship are 3 ploughs.
16 villagers (villani), 19 smallholders (bordarii) with 16 ploughs.
There 8 slaves; 1 draught animal.
There a priest has 1 hide and 2 ploughs.
One riding man having 1 hide and 2 ploughs.
There a very small wood.

Of this manor's land Durand the Sheriff holds from the church 6 hides in Southam,
Ralph 4 hides in Sapletone, Thurstan son of Rolf 6 hides in Gotherington.
 In these lands are 8 ploughs in lordship; 22 villagers and 7 smallholders with 13
ploughs. There 20 slaves; three draught animals; a mill worth 12d; some meadow.
 Of this land Bernard and Reginald hold 7 hides in Stoke.
They refuse to do service to St Mary's.
 The value of the whole manor in the time of King Edward (i.e. 1066) £36.
Now £26 between them all.
Bishop Wulfstan holds this manor.

So what might all this mean? We can answer this question by breaking the entry down into its individual statements:

LAND OF THE CHURCH OF WORCESTER

Bishop Wulfstan holds this manor

We start our investigation by taking the opening and closing statements together, for they both refer to the church, which was the tenant-in-chief as it held the land directly from the king. Bishop Wulfstan was the second bishop to have that name in the eleventh century. Cleeve was one of the church's 17 demesne manors, controlled directly by the church and not sublet to tenants. We have already remarked that ten of the 17 manors had, like Cleeve, been acquired from minster churches. These included Bibury, Bredon and Withington. Others had been granted directly to the church as gifts e.g. Alvechurch and Kempsey, whilst some had been purchased. In the ninth century the church began to lease out lands to sub-tenants and it then sometimes found it difficult to reclaim the lands at the end of the lease. This became a serious problem in the eleventh century and in the south of the county, Sodbury, Tetbury and Woodchester were lost to the church. By 1086 the different manors taken together provided the church with a geographically varied estate: lowland and upland; wooded and open; heavy clay, sands and gravels. The whole designed to protect the church from the vagaries of the climate in any one year. Cleeve itself was a miniature version of the whole estate.

 When the diocese of Worcester had come into being in 680, the cathedral of St Peter's housed a community of priests who served in the outside world similar to those at Cleeve. Around 966 Bishop Oswald founded the abbey of St Mary for Benedictine monks, as part of the movement to reform the old minsters, which was sweeping the country. St Peter's and St Mary's stood side by side until St Peter's was abandoned and demolished when Bishop Wulfstan rebuilt St Mary's after 1084. Over time the large estate of the church of Worcester came to be split between the bishop and the monks of the abbey,

or priory, which as we have seen gave rise to the names of Bishop's Cleeve and Cleeve Prior north of Evesham.

Wulfstan, who started the rebuilding of St Mary's, was the only Anglo-Saxon bishop to survive the upheavals of the Norman Conquest. He was born in 1008 in the village of Long Itchington in Warwickshire. His parents were well-off and so religious that after his birth they both entered religious houses. As a young man Wulfstan first studied at Evesham Abbey and then at Peterborough. He became a priest in 1038 and came to St Peter's before entering the monastery of St Mary. William of Malmesbury, who wrote 100 years later, vividly recorded Wulfstan's motives for becoming a monk:

When he returned from Peterborough to his parents, a damsel of the neighbourhood set herself to make shipwreck of his modesty and tempt him to sinful pleasures. She would ever be pressing his hand, beckoning with her eyes, and tempting him with wanton gestures which foretell the death of virginity. But when Wulfstan's natural chastity made all her shameless desires vain, she still pursued him as now follows. The devil put it into her heart to approach him. She began to dance before Wulfstan with lascivious movements designed to take the eyes of a lover. And he, whom touches and glances had not moved, yielded to her seductive gestures, and panted with desire. But in a moment he came into a better mind, and burst into tears: and took flight into rough thickets and thorny places. And as he still pondered, and accused himself of many sins, sleep came upon him, and a miracle was seen ... Never from that day forth did any marvel of beauty attract his mind or his eye; and his sleep was never broken by ill dreams.

This good story is spoilt for us by the knowledge that it was a popular explanation of why men chose to become monks! Wulfstan became bishop in 1062 and set about rebuilding the cathedral in 1084. He died in 1095 at the advanced age of 87.

How did he survive the Conquest when all the other bishops were replaced? On the one hand he was a pragmatist; a wily politician who saw the key issues, especially the threat of rebellion, and ultimately sided with the Norman rulers. He quickly submitted to William in 1066 and although at first he objected to Lanfranc, the new Norman Archbishop of Canterbury, he soon made his peace with him. He also realised he had to get on with the Normans more generally because they replaced the Anglo-Saxon sub-tenants on the church's lands. His loyalty was shown when he was made governor of Worcester Castle against the Norman lords who ruled the borderlands of Wales when they came to attack the city in their revolt of 1088. He was already 80 years of age. However, he is chiefly remembered as the pious shepherd leading his

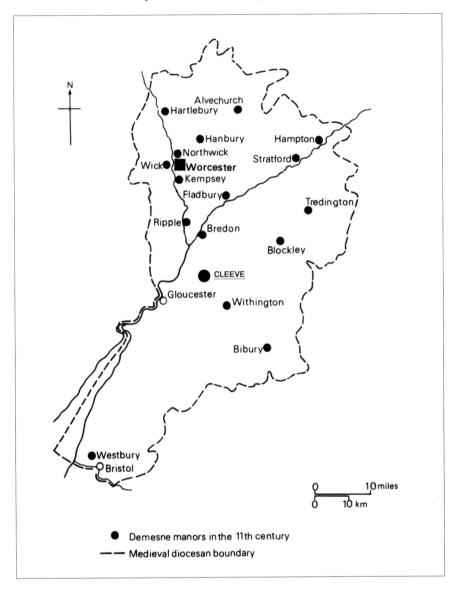

41 The main Domesday manors of the church at Worcester. Based on C. Dyer's *Lords and Peasants in a Changing Society* (Cambridge 1980) p.8

flock. He travelled round his diocese on horseback to preach to the people. He certainly campaigned against slavery and legend has him dying as he washed the feet of 12 poor men in the traditional Maundy Thursday ceremony, as illustrated in the millennium window in the cloisters of the cathedral. Again this appears to be a story created to emphasise his holiness, for his predecessor

81

Oswald is said to have left this world doing the same action. His holiness lived on; his tomb became a shrine for pilgrims and in 1203 he was declared a saint by Pope Innocent III when his feast day was fixed as 19 January. William of Malmesbury even records him curing a man of an illness in Bishop's Cleeve. Although this was an everyday type of miracle for medieval saints, the reference to the village indicates that Wulfstan must have visited it when he was bishop, staying at his manor house where the day-to-day administration of the manor lay in the hands of his officials – the bailiff, reeve and receiver of the rents. Wulfstan seems to have looked after his estates and people well. He provided a steady hand on the tiller in a time of change. Perhaps that was the secret of his survival.

IN TIBBLESTONE HUNDRED

The Tibblestone still stands at Teddington Hands crossroads, albeit not on its original site, having been 'lost' for over a century until found and re-erected in 1948 (*colour plate 10*). The hundred was an old division of a county, dating back to the tenth century and based on an area that in theory contained 100 families. The meeting place was often a prominent open-air feature. The Tibblestone is a prehistoric standing stone and there the hundredal court would meet. Its business included listening to royal proclamations and handing out justice to those accused of wrongdoing, especially theft. It was expected that all the freemen in the hundred would gather there once a month. At Domesday the Tibblestone hundred comprised the parish of Cleeve, together with Beckford and most of Ashton under Hill and Hinton to the north. By 1327 Cleeve had become separated to form its own hundred, which possibly illustrates the power of the bishop in wanting to gain closer control over his people. In 1086 it is very likely that the hundreds served as the basis for the collection of information for Domesday Book itself by the King's commissioners. Remarkably, the Tibblestone still stands today as a physical link to that great survey.

The church itself held Cleeve. There 30 hides. In lordship are 3 ploughs.

The whole manor was large. Westbury on Trym near Bristol with 50 hides was the only manor held by the church which was larger than Cleeve. The church at Worcester held Cleeve itself as a demesne manor; it had not sub-let it as Southam, *Sapletone* and Gotherington. Part of it was called the demesne, which was not even let out to the villagers because it was farmed to meet the needs of the bishop and his officials. This holding was extensive enough to provide work for three plough teams, but much smaller than the combined

demesnes of the sub-tenants in the three sub-manors. Historians have traditionally accepted that a demesne plough team could plough 100 acres (40ha) in one year. The main purpose of the demesne was to feed the bishop and his household, but even when cultivating only half the land in any one year – the two-field system where half the land would be left fallow for the animals to graze and manure it – there would have been a surplus to sell. The plough team comprised eight oxen as the heavy clays of the vale made hard work for the plough. The labour would have come from the slaves and from the villagers and smallholders owing labour services to St Mary's at Worcester under the watchful eye of the reeve; a villager who had the responsibility of making sure that the church of Worcester's demands on the inhabitants were met. The arable land was probably already arranged in strips in a ridge and furrow pattern which can be seen in surviving patches around the village even today, although it might have been replanned into the pattern we see during the two centuries after Domesday to provide for the increasing population. The demesne strips would have been scattered throughout the arable land intermingled with the strips of the villagers and smallholders.

16 villagers, 19 smallholders with 16 ploughs.
There 8 slaves; 1 draught animal.

Unfortunately Domesday Book recorded the names of manors and not settlements. By now, however, we can be reasonably sure that a village had been formed in Cleeve and we know that most of these people lived there, but a handful lived in Lower Gotherington clustered around the present Shutter Lane. Here was a small community of people who served the bishop. We know from later records that there was a cook, smith, swineherd and a beadle, whose task it was to summon people to attend the bishop on his visits (*colour plate 11*). It is also likely that some of their families lived in Woodmancote, although its name has not yet appeared in any known record. The reason we can suggest is that the villagers (villani) were probably the ancestors of the yardlanders of the later Middle Ages and most of these lived in Woodmancote. On the manor of Cleeve a yardland was about 24 acres (10ha) which is rather smaller than the traditional size in the West Midlands of 30 acres (12ha), although the size of an acre had not yet been standardised. The smallholders (bordarii) became the half-yardlanders and, possibly, cotlanders (literally a cottager with some land) who we know held six acres (2.5ha). A yardland provided enough food for one family with some to spare, but the small holders would have needed to supplement this by working for wages, especially at busy times of the farming year like ploughing and sowing, hay making and harvest. No doubt the invisible wives would add to the family income by

spinning, not just wool, but also flax and hemp, brewing ale, selling honey and eggs and other marketable products in the larger centres of Tewkesbury and Winchcombe, both within a day's journey on foot. The men worked communally. There were 16 villagers and 19 smallholders with 16 ploughs. A peasant plough would have been able to plough 50 acres (20ha) each year. If each villager could contribute the traditional half team of three or four oxen for each plough, then the smallholders would have needed to have kept an ox or two in order to make up 16 ploughteams. To us there is a paradox in this method of landholding, for the larger the holding, the more the peasant had to work for the lord as payment for it, and so the less time he had to work on his own holding. Conversely peasants with smaller holdings worked less for the lord, but their own holdings needed less time spent upon them. They must have needed to work on larger peasant holdings for wages to buy what they could not produce and so this, in turn, helped those with larger holdings to work them successfully. All the peasants were called customary tenants, because it was the custom to carry out these labour services. Nevertheless, however much work they had to do, their lives were still immeasurably freer than the lives of the slaves.

As we read at the end of the last chapter, the slaves were the property of the lord and owned nothing of their own 'except their stomachs' which they hoped to fill with the grain, meat and dairy produce supplied by the bishop. They were needed to work the bishop's demesne, for example, two slaves were needed for each plough team; one to drive the ox team and the other to hold the plough. It is not clear where the slaves came from or how they became enslaved but by the time of Domesday Book these slaves were probably born into slavery as the children of slaves themselves. Gloucestershire had an unusually high percentage of slaves: 25 per cent of the recorded population, but in Cleeve it was actually higher still, nearer 30 per cent. Yet the institution had died out by 1100. Bishop Wulfstan was an outspoken critic and he can be given credit for ending it on the church's estates. Although slavery could be seen as a purely moral issue, there were also powerful economic arguments for the abolition. By emancipating the slaves and providing them with small plots of land and the freedom to earn a living, the church would be able to charge them rent and demand labour services from them, as it already did from the villagers and smallholders. Of course these two motives for ending slavery were not necessarily mutually exclusive.

No one really knows why the draught animal (nor the three recorded later) was included. The most plausible reason rests in the mechanics of the making of Domesday Book. The final version was based upon very detailed original surveys, made so that 'not even an ox, nor a cow nor a swine was there left, that was not set down'. These earlier versions now only survive as

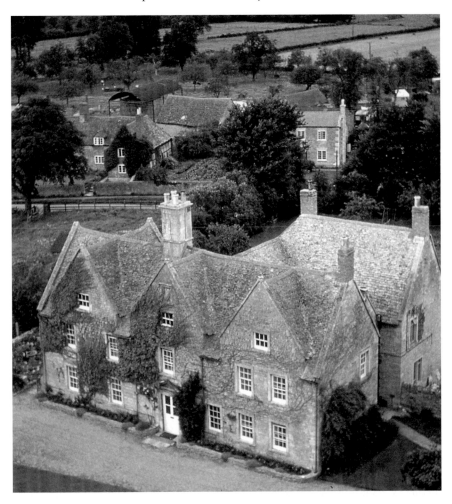

42 The Priory and, behind it to the left, Cleevelands Farm *c*.1960. This arrangement of priest's house and farm had probably been established by Domesday. (A. Evason)

the Little Domesday for Essex, Norfolk and Suffolk; all the rest seem to have been destroyed. For some unknown reason these four animals slipped through into the final version – and there the explanation must remain until a more convincing argument is put forward.

> There a priest has 1 hide and 2 ploughs.

This is where we can pick up the story of the minster from the last chapter. We have already read that when the church at Worcester took over the minster, probably in the early ninth century, it provided a substantial grant of land to

support the minster community and this ultimately became the rector's manor. Domesday records a priest with land, but it is not yet described as a manor. He is recorded because he had a substantial holding of over 100 acres (40ha) which would have needed at least four peasants to work it, if only to guide the ploughs. In many manors a priest is known to have been present but he was not recorded because the holding was much smaller. In addition to the profits of the produce of this land, he would have received the tithe of the produce of all the peasants, even down to the tenth egg; tithes had been made compulsory in the previous century. By the time of Domesday the mortuary payment had become established as the second most valuable possession when a parishioner died, usually an ox or horse. The most valuable possession went to the lord. So the priest was well-provided with money and produce, some of which he might have sold to further increase his income. From this he had to keep the chancel of St Michael's in good repair, for it was his responsibility, and to take care of the poor in his parish. As we shall find in the next chapter, he was also able to keep servants to keep his manor running. This entry in Domesday Book provides early evidence that the arrangements made by the church at Worcester, to provide priests to serve the people of Cleeve, were made on very generous terms.

This had an important effect later in the Middle Ages for the rector's manor was so rich that some became rector to enjoy the income, lived elsewhere and paid a small sum to a curate to carry out the priestly duties, but sometimes the spiritual care of the parishioners was neglected. The house now called The Priory in lower Station Road stands on what has probably always been the site of the priest's house, built within the minster precinct, unlike the manor house of the Bishops of Worcester. The first building would have been built of timber with its farm buildings across what is now Station Road. As we shall discover in the next chapter, this was certainly the rectory in the later Middle Ages. Perhaps it served as a catalyst for the development of the northern boundary of the minster precinct; an area which was to develop later as the place where the higher status villagers lived, and known as 'The Street'. Historians and archaeologists argue about the dates when villages were formed in the landscape. We have argued that a recognisable village was forming at Cleeve by the time of the early ninth-century split. Further evidence for this can be found in the later Middle Ages when the manorial records of both the bishop and the rector show that their tenants held their farms and land on identical terms. This strongly suggests that an existing settlement was split, rather than the bishop and rector getting together at a later date to make the terms of landholding identical in each manor. It also suggests the church of Worcester, the priest and the villagers themselves were all involved in the process.

One riding man having 1 hide and 2 ploughs.

Here was a similar holding with a similar value. Riding men took messages for the church and might accompany the bishop when he travelled in the area. There were 21 in total scattered across all the church's estates. He would have served as the means of communication between the bishop in Worcester and the peasants in Cleeve. The king granted land to a tenant-in-chief – the church of Worcester. The church in turn granted some of its land to sub-tenants such as Thurstan in Gotherington and to others, such as the priest and riding man. Their services and money would help St Mary's to meet its obligations to the crown, in this case supplying 50 knights to defend the kingdom, or the means to support them. For example, *c.*1170 Henry of Newmarket is recorded as holding Upper Gotherington from the Bishop of Worcester by providing him with half the costs of a knight. In 1299 Adam Haymes and his tenants held three yardlands 'by military service'. In their turn these tenants-in-chief and sub-tenants would expect labour services and money from the peasants in return for granting them their plots of land and protecting them. A fortunate few paid only money to their lord which gave them freedom from the labour services. They were known as free men. The peasants' lives were closely controlled by their lord, for in addition to their labour services peasants needed the lord's permission for all types of activities we take for granted – moving away, marrying, inheriting a deceased parent's farm holding. Add to this the dues to the rector, and it's not difficult to appreciate how tied the peasants were to the manor where they were born, and yet why some of them tried to escape.

This reference to the riding man has a further significance. It reminds us that the names in the Domesday survey were the names of manors and not villages. This riding man's holding has been conclusively identified as Moat Farm in Gotherington – it was not in Cleeve at all as it formed part of the settlement of Lower Gotherington. The Gotherington recorded in Domesday Book referred only to Upper Gotherington lying below the Manor House at the end of Manor Lane with its handful of outlying farms along Gretton Road: two manors, two settlements but one name.

There a very small wood.

This must refer to Bushcombe wood: 'the wood in the bishop's valley'. It still exists as coppice woodland which until the last century was divided into sections and cut regularly about every seven years in rotation to provide wood for furniture, handles for tools and household items, wattle for houses and hurdles, with the undergrowth taken for firewood and the nuts as pannage to feed the pigs. The annual spring carpet of bluebells indicates it has not been completely cleared of woodland since at least the Middle Ages (*colour plate*

43 Moat Farm in Gotherington represents the holding of the riding man recorded in Cleeve in Domesday Book

12). Yet the single reference to 'a very small wood' is rather a puzzle, for there must still have been large areas of woodland on the slopes of Nottingham and Cleeve Hills even though Woodmancote seems to have been developing as the trees were cleared along the lanes rising to the common pasture on the hilltops. A possible explanation is that only part of the extensive woodland lay on the bishop's demesne.

> *Of this manor's land Durand the Sheriff holds from the church 6 hides in Southam, Ralph 4 hides in Sapletone, Thurstan son of Rolf 6 hides in Gotherington.*
>
> *In these lands are 8 ploughs in lordship; 22 villagers and 7 smallholders with 13 ploughs. There 20 slaves; three draught animals; a mill worth 12d; some meadow.*

Frustratingly this entry combines three places, so we'll never know the individual details of each, except the names of the sub-tenants. As a result this part of the entry will be taken as one. We do know something about Durand and Thurstan but the name 'Ralph' appears 12 times in the Gloucestershire Domesday, so it's impossible to identify which one held *Sapletone*. The entry

for Stoke also creates a problem for 'Bernard' is a name which appears five times, whilst 'Reginald' appears nowhere else and so nothing further can be discovered about them. However, we do know something about Durand and so we can start with him. At the actual time the Domesday commissioners were collecting their information his brother Roger died and Durand took over from him as the sheriff of the county. The sheriff was the *shire-reeve* who was mainly responsible for looking after the shire for the king, particularly collecting the royal taxes and rents. One of his duties was to oversee the Domesday process. Durand was also constable of Gloucester Castle and owned four houses in the city. He remained sheriff until his death by 1101. Originally from Pîtres in Normandy, he had been well-rewarded by King William with 19 manors in the county – eight in Herefordshire, seven in Wiltshire plus Caldicot in South Wales. It was usual for the Conqueror to grant scattered manors to his followers to prevent any one of them creating a power base from which to challenge his royal authority. Not only was Durand a sub-tenant as here, but he was also a tenant-in-chief of the king, at Standish, where Domesday Book records three hides had been granted to him by William on the death of his brother Roger. He was obviously a wealthy individual but it is hardly likely that he lived in Southam. Interestingly the Domesday Book entry for Dyrham in the south of the county records that three hides had been granted by Durand the Sheriff to Saint Mary's Abbey, Pershore, then taken back by King William and given to Thurstan son of Rolf. Given Durand's recent appointment as sheriff, this must have been a very recent action indeed and it suggests that Durand and Thurstan were known to each other. Thurstan is thought to have been William's standard-bearer at the Battle of Hastings, for which he was also richly rewarded with manors in Gloucestershire, Somerset, Dorset, Herefordshire and South Wales. It's unlikely that he ever made more than a fleeting visit to his manor of Upper Gotherington.

It is frustrating for historians that the details of the three manors were combined. They totalled 800 acres (320ha) of demesne with 650 acres (260ha) in the hands of the 29 villagers and smallholders. The size of the villagers' holdings seems to have been the same as in Cleeve itself with the villagers each holding a yardland of about 24 acres (10ha) and the smallholders holding half a yardland at most. More of the ox teams would have been made up from the contributions of the villagers than in Cleeve itself. The slaves would have worked on the demesnes of Durand and the other sub-tenants and there were relatively more of them here than in Cleeve. By contrast there were fewer smallholders. Perhaps a dozen of the 20 slaves lived in a planned settlement below the manor house in Upper Gotherington. The mill would have been used by the villagers to grind their corn, as well as for grinding corn when

44 Gotherington Manor at Upper Gotherington represents the entry for Gotherington in Domesday Book

the bishop and his household visited. The miller took one sixteenth of the villagers' grain as his toll; always a source of great resentment as millers were everywhere considered dishonest, a belief reinforced by the caricature in Chaucer's *Canterbury Tales*. The tolls paid by the peasants meant it was worth 12*d* each year to the bishop. It would have been powered by water, as windmills did not appear until 1189, but unfortunately we do not know where it stood, although one possibility is along the Tirle Brook north of Gotherington.

Sapletone remains a mystery for it has disappeared completely, both as a name and a place. We have already noted that it was recorded as *Saperetun* in 969 as a four-hide holding granted by the bishop to his thegn Eadric for the length of three lives. A deed dated *c.*1300 suggests it might have been situated between Southam and Brockhampton. In 1986 Bernard Rawes noted a scatter of 'medieval pottery' to the south of Gambles Lane near the junction with New Road. Was it here, a small settlement at the edge of woodland and farmland, or was it west of Southam towards GE Aviation? It is just impossible to tell from our present state of knowledge.

Of this land Bernard and Reginald hold 7 hides in Stoke.
They refuse to do service to St Mary's.

One reason that Bernard and Reginald refused to do service to Saint Mary's at Worcester has been explained by Steven Bassett as a continuing reflection that this part of the Anglo-Saxon estate stayed in royal hands and was not granted to the minster church at Cleeve in the eighth century. An alternative explanation is that it was one of those landholdings which the church was finding difficult to reclaim at the end of the lease. Bernard was presumably the person who held the other part of Stoke Orchard directly from the king: a holding of almost three hides with one plough in demesne and four acres of meadow. Here were two manors in the same settlement possibly held by the same person. The pattern of landholding recorded in the Domesday Book could be very complicated.

The value of the whole manor in the time of King Edward (i.e. 1066) £36. Now £26 between them all.

Domesday Book never mentions Harold, defeated and killed at Hastings, as king because William never considered him to have been the lawful king. So the value is calculated from the time of Harold's predecessor, King Edward the Confessor. The ending of each entry with its value has led historians to conclude that the reason for the survey was taxation. The value of the Cleeve manor dropped which is quite usual, but the reasons are unknown. Perhaps it slipped in the upheaval of changed tenants, or because more paid in kind from the produce of the land rather than in money, but we cannot be certain.

SO WHAT MIGHT IT ALL MEAN?

What picture of Cleeve has been provided by this snapshot based on the entry in Domesday Book? The whole manor (and parish) was a large holding of 30 hides subdivided into the church of Worcester's demesne holding and the holdings of seven sub-tenants, ranging in size from one to seven hides. There were 35 peasant families in Cleeve and Lower Gotherington and 29 in Southam, *Sapletone*, Upper Gotherington and part of Stoke. It is very difficult to use these figures to calculate the total population, even if they themselves form an accurate count. However there might have been around 175 people in Cleeve and Lower Gotherington (and possibly Woodmancote) and 145 across the sub-manors. We know the riding man and priest must have had tenants not recorded in Domesday; at least four families, based on the size of their holding. The slaves added another eight individuals in Cleeve and 20 elsewhere but

it is impossible to know how many actual families this might represent. Society was clearly hierarchical or feudal. From the bishop at the top, who enjoyed all the privileges wealth and status could bring, to the slaves at the bottom, everyone continued to be dependant upon the produce of the land whether at several stages removed, as the bishop, or as the basis of daily life for the peasants. In the next chapter we shall see how society became more socially and economically diverse during the later Middle Ages, however we know by 1086 that peasants held different sized farm holdings. So some peasants had more land and therefore could live a more comfortable life than other peasants, who in turn enjoyed more freedom than the slaves, who remained the property of their lord.

Although Domesday Book has told us so much about the area it remains a very simple snapshot because features that had no value to St Mary's at Worcester were not recorded. There is no mention of the extensive woodland on the Cotswold scarp, nor of the extensive areas of pasture on Nottingham and Cleeve Hills, nor the patches of meadow in the vale. It does not tell us where the people lived, although we can be pretty certain that in Cleeve itself the farms and cottages were clustering around the minster precinct to the bishop's manor house; in Southam round the church, the present 'tithe barn' and the manor house (Pigeon House); at Stoke around the church; and at Gotherington around the manor house on the lower slopes of Nottingham Hill and around Shutter Lane. Indirect evidence suggests that Woodmancote might be developing as a dispersed woodland settlement strung out along the lanes leading up the Cotswold scarp. Unfortunately the eleventh-century timber buildings with thatched roofs have left no trace to help us find out more.

The total acreage of the whole ancient parish of Cleeve was 8667 acres (3509ha). If we exclude the area of Stoke for which we have no details in Domesday, we arrive at 7378 acres (2987ha). Using figures accepted by historians, the area of arable land for growing crops can be calculated as 2550 acres (1032ha) in 1086 or 35 per cent of the total land area. The rest was made up largely of pasture and woodland with some meadow. The areas of arable on the church of Worcester's other manors ranged from a quarter at Hanbury in Worcestershire to two-thirds at Tredington in Warwickshire. Cleeve came somewhere in the middle of the range. This meant there was plenty of room to expand its arable land as the population increased in the years after 1086. The expansion and contraction of the population in the later Middle Ages forms the subject of the next chapter and at last we see Woodmancote appearing in the written record.

SOURCES AND FURTHER READING

This chapter has been based upon my interpretation of the version of Domesday Book edited by John Moore, *Domesday Book: Gloucestershire* (Chichester 1982). Christopher Dyer has written on Bishop Wulfstan and his estates in J. Barrow and N.P. Brookes (eds.) *St Wulfstan and his World* (Aldershot 2005). There is also a helpful article on the Domesday Book tenants of Gloucestershire in the *Transactions of the Bristol and Gloucestershire Archaeological Society* volume 4. The English version of William of Malmesbury's *Life of St Wulstan* was reprinted by Llanerch publishers (Burnham on Sea, Somerset) in 1996.

4

THE BISHOP'S MANOR
(1086-1550)

He cannot sell his ox or horse without a licence. His son cannot leave, nor his daughter marry without a licence. He ought to come to the *fustale* and to the lord's ale, and he will give for himself and his wife 1d.
Some of the duties of a customary tenant, 1299.

COUNTING THE PEOPLE

The Bishop of Worcester was the lord of the manor of Bishop's Cleeve and Woodmancote from the early ninth century until 1561, after Henry VIII's dissolution of the cathedral priory in 1540. This chapter focuses on the years after 1086 when the surviving records of the Bishop of Worcester give us insights into how the people actually lived. They have been carefully studied by Professor Christopher Dyer of Leicester University and to these can now be added some of the recent archaeological discoveries made in the village. The overall picture which emerges is of a settlement where population grew until the early fourteenth century and then declined, largely as a result of the Black Death of 1348-49. This mirrors the national picture as historians have calculated the population of England rose from two and a half million at Domesday to six million in 1300; a figure not reached again until the late 1700s. Average life expectancy now seems to have been about 45; ten years more than during the Romano-British period.

During this period the evidence suggests that the population became more differentiated, with more villagers enjoying reasonably secure lives, especially from the mid fourteenth century. Historians can make such suggestions with the advantage of hindsight but we need to constantly remind ourselves that the villagers could only see their own lives and those of their neighbours, both near and far, and change was often difficult to recognise. Yet everyone

continued to hold a common interest in the land and its produce. Good or bad harvest; heavy wool yield or sheep foot rot; ample fruit or late frost – there was ultimately no escape from dependence on farming. It was the breaking of this link in the later twentieth century which has been the most important factor in cutting the modern villages off from their own past.

What we know about the number of tenants on the bishop's manor is shown by the following figures.

Tenants recorded on the bishop's manor

1086	c.1170	1299	1349	1474-75	1544	1545-6
45	83 (7)	102 (14)	61	53 (6)	52	39

There were perhaps five people in each tenant's family. There are difficulties with these figures, even assuming the bishop kept accurate records for accounting purposes. We mustn't forget that some tenants lived in Lower Gotherington – the figures in brackets give the best estimate of these. A tax list of 1327 recorded 39 tenants and with only 40 per cent likely to have been rich enough to pay the tax, the 1299 survey and 1327 taxation figures provide a very close match for the bishop's manor, but the community of Bishop's Cleeve also included the rector's manor, with ten tenants recorded in 1327 and 12 in 1479. In addition there are hints in the bishop's records that tenants sub-let. In the mid thirteenth century a Richard of Cleeve was recorded as having 21 smallholdings let to sub-tenants. These people would not appear in the bishop's records, or be rich enough to pay taxes, so the overall population could have been much higher. Such situations might also help to explain why 39 tenant families were recorded on the bishop's manor in 1545-46 but in 1551 a total population of the whole parish of approximately 800 could be calculated from the church's record of people taking communion and that figure does not necessarily include young children. We must never forget children might have formed 40 per cent of the population; a hidden minority.

EXPANDING THE FARMLAND

The economic basis of life in Bishop's Cleeve and Woodmancote continued to be agriculture and so a key question must be: How did it change after 1086? We begin with the bishop's demesne of 300 acres (120ha). We know he increased this by buying land and also from assarting; ploughing up land which had been woodland or pasture, so that by 1290 he needed four ploughs.

Yet a century later the demesne had shrunk to half that size because he had followed the fashion of renting some of it to his tenants. This meant they took the risks whilst he enjoyed their rents. However, through his manorial servants, he was still directly involved in farming because he owned four horses and 23 oxen. The bishop's strips lay scattered among his tenants' throughout the open fields stretching away in familiar ridge and furrow pattern to Gotherington in the north, to Southam in the south and to Stoke Orchard in the west. So what of his tenants – the villagers?

45 A light covering of snow picks out the ridge and furrow running high up the slope of Nottingham Hill, showing how medieval arable land expanded away from Woodmancote

We calculated that in 1086 approximately 35 per cent of the parish area was under plough but as the population grew so did the need for food and the arable land increased. The villagers also took part in assarting. The best evidence for this can be found in a survey dated c.1170 which records assarts totalling about 230 acres (100ha) carried out by nine people. This survey is also important as Woodmancote and Wontley are recorded for the first time. Fourteen people are recorded as having land in Woodmancote, although of course, they might have still lived in Bishop's Cleeve. At last we discover the names of some of the inhabitants: Sampson the priest (probably the curate), Ordmer the smith, Osbern the miller and Osbert son of Saret in Cleeve and Richard son of Tolus, Alfred Wynter and Alfred brother of *Safare* in Woodmancote. From such names we gain the first indication that Bishop's Cleeve was already developing a more varied social structure with a number of craftsmen. Most of the assarts were small in size, but a tenant from Cleeve by the name of Girold created a huge assart of 143 acres (60ha) 'with wood which remains to be assarted'. Presumably this refers to the wood on Bushcombe and so would locate the assart on the slopes of Nottingham Hill below Bushcombe Wood, where the small irregular fields have survived until today. Perhaps significantly part of this area formed a detached part of Bishop's Cleeve township within Woodmancote until 1883. Girold's total

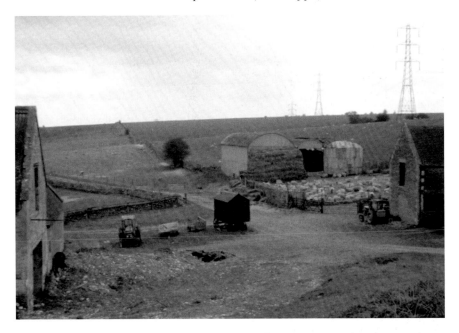

46 This photograph of Wontley taken in 1973 echoes its post-medieval use as sheep pasture. The shepherd was living in the traditional van in the centre of the picture. The track passing through represents 'Strangers' Way' recorded in the charter boundary

assarting extended to 178 acres (75ha). He achieved minor international fame by appearing in the Vatican archives when Bishop Roger wrote to the pope in 1174 wanting clarification about what happened to assarted land when the assarter died. The answer came that it could be let to the legal heirs in the same way as traditional landholdings. For his original half yardland of 12 acres (5ha) Girold paid 4d an acre rent; for his assart he paid only 1d an acre; an indication that his newly-broken land was not as fertile as his original holding and that the bishop wanted to encourage assarting as it would ultimately increase his overall income. So Girold's attempt to improve his situation happily coincided with the wishes of Bishop Roger. A valuable comment in this survey indicates that the land was still farmed on a two-field system. 'Field' at this time did not mean what it does today. It was the collective name for the strips lying in their ridges and furrows round the settlements. The small irregular fields on the slopes of both Cleeve and Nottingham Hills were called 'enclosures'.

And what of Wontley? Six half-yardlanders with their families lived on the other side of Cleeve Hill. Even here there was also a small assart extending to eight acres (3ha) in this most distant and inhospitable part of the manor. The

bishop would again have encouraged assarting to increase the income from his rents. Yet perhaps Wontley would not have appeared at all but for a century of warm weather from the mid twelfth century, which allowed farming here a chance to be successful.

By the late thirteenth century assarting was meeting with resistance because it increased pressure on other land uses. Fortunately, but atypically, Cleeve Common provided the peasants with a large area of permanent pasture to supplement the grazing of animals on the weeds of the fallow land and on the stubble after harvest. It was an important resource. In 1299 the bishop had 1000 sheep on the common in summer and 200 in winter. A century later the peasants themselves were pasturing three or four times that number, whilst the bishop's flock numbered over 600. Cattle and horses also grazed there. It seems that attempts to limit the number of animals any one person could place on the common ('stinting') were never really successful. Some evidence for this comes from 1538 when one yardland was said to have the right to graze 30 sheep on the common, but such stinting was generally ignored and in the mid nineteenth century was said never to have existed. Yet Cleeve Common was not the only permanent pasture the people could use. Pasture on Bushcombe, possibly Longwood Common, was worth 20s each year to the bishop in 1299 and we have already read how the area of the hillfort on Nottingham Hill remained shared common pasture until the enclosure of Gotherington in 1807.

Assarting also placed pressure on woodland; in the case of Girold we know this was Bushcombe Wood, but it was never cleared because it remained important to provide coppiced wood. Evidence for its importance comes from the court rolls. The value of the underwood (e.g. stakes cut from the coppiced trees) was worth 5s a year to the bishop in 1299. In 1491 the rector's servants illegally cut stakes from the wood and were fined 6d. However, trees for timber for buildings and large farm equipment were grown elsewhere. In 1413 timber from the manor was sold for 27s 2d. This would have been grown around the settlements or in West Wood near Wontley, which was first recorded in 1221. This was the most important place in the manor where trees for timber grew. Two woodwards lived at Wontley in 1299. It was worth £40 in 1440 and in 1505-06 money was spent on a fence around it to keep out the animals which were by then grazing on the abandoned open fields of the hamlet. In 1396-97 timber was brought from West Wood to repair the rector's buildings in Bishop's Cleeve. It is extremely likely that some of the surviving timber-framed houses in Bishop's Cleeve and Woodmancote were constructed with timber from West Wood. However, overall Bishop's Cleeve lacked good supplies of wood and timber. In 1396-97 the rector obtained firewood from both Alveley in Shropshire and Bewdley in Worcestershire. When the bishop

47 The wattles discovered in the walls of Laburnam Cottage in Church Road in 2007 probably came from Bushcombe Wood in the later Middle Ages

was building the present Tithe Barn in 1465, timber came from the grounds of his palace at Hartlebury. All this came down the River Severn to Tewkesbury.

As the arable land increased, pressure was placed not only on permanent pasture and woodland but also on meadow for growing hay. The largest area of meadow attached to Bishop's Cleeve was in fact at Bredon. How many travellers on the M5 motorway realise they are driving across Cleeve meadow as they cross the River Avon? In 1299 it was 53 acres (22ha) in size and worth 79s 6d to the bishop. The areas of meadow which could be found around Bishop's Cleeve and Woodmancote were very much smaller. *Finemede* on the parish boundary on the far side of Cleeve Hill was recorded again in 1251. In 1389 a mower was hired for four days at 4d a day to mow the meadow at Northenham, near the allotments along the bypass. *Mockmead* ('large meadow') lies between Southam and Woodmancote, still recognisable today by its oval shape lacking ridge and furrow. Millham means the meadow by the mill and the modern name Hisnam is a corruption of *Issenham*, but *Honeymede* can now no longer be located. Other references to small areas of meadow are too imprecise to locate them.

These examples of carrying timber from Hartlebury and hay from the meadow at Bredon show how the bishop's manors worked together. The trade in wool is probably the best example of this. The bishop's sheep farming was well-organised. Adult sheep were kept at Cleeve, Blockley and Bredon whilst

48 Pigs with their heads in feedbags from the end of the choir stalls in Little Malvern Priory. It was to nearby Welland that the pigs from Bishop's Cleeve came to be pastured

the lambs were born in the more sheltered low-lying manors of Fladbury, Kempsey and Hampton Lucy near Warwick. In early summer the sheep were taken to Blockley on the Cotswolds, which served as the nerve centre of the bishop's estate. Here they were sheared and the wool clip was then sold to merchants like William Grevel of nearby Chipping Campden, 'the flower of the wool merchants of all England'. In 1384 the wool of 3126 sheep was sold to him for £133, giving an income of over £80 for the bishop. We do know that in 1391 the wool of 314 sheep from Bishop's Cleeve brought the bishop £9 16s 4d but a reference to a William *Wolmonger* of Cleeve being sued for a broken contract in 1412 suggests that one peasant at least was acting as a middleman buying wool from the peasants and selling it locally at markets possibly in Tewkesbury, Winchcombe or Gloucester. He would have become richer than those peasants who depended solely on farming. In this case we know William held just six acres (2.5ha), so his wool dealings would have provided important extra income. This interdependence of manors is also reflected in the keeping of pigs. The bishop charged his tenants for putting their pigs to feed in Bushcombe wood. In 1413 this was worth 3s 9d but in 1468 only 1s 2d. At 1d a pig the numbers were small, but this was not likely to be the total number as most were driven (no easy task) along the roads and tracks to the woodland, now largely gone, at Welland near Malvern, over 20 miles (32km) away across the Severn. In 1389-90 370 piglets were born on the manor, far too many to find food in Bushcombe Wood.

STRUGGLING TO SURVIVE

In the second half of the fourteenth century after the Black Death, widespread economic and social change took place as the population shrank and farmsteads were abandoned. The bishops responded by demanding cash rentals rather than labour services. In 1371-72 all the bishop's customary tenants held by a mixture of labour services and cash payments; by 1393-94 almost half (46 per cent) held exclusively by cash payments. This blurred the distinction between the free tenants, who made up one third of the population and only ever paid a cash rent, and the two thirds who were the customary tenants. After 1395 the bishop leased out his demesne, which automatically cut the number of labour services he needed from the peasants who could now work for wages on the same land where they had previously performed their labour services. From c.1430 to c.1470 farming was in crisis with low prices for grain and wool. Three wet summers in a row from 1438 led to very poor grain yields and wide spread foot rot in sheep. In 1441 the tenants of Bishop's Cleeve joined a rent strike across the bishop's estate – it was probably a protest against their remaining labour services. Was the plea in 1445 to be exempt from taxes on account of a serious fire, metaphorically a smokescreen for the villagers' poverty? An enquiry called by Bishop John Carpenter in 1452-53 reported that he had already largely lost control of his free tenants and so had lost about £130 in annual rents; so much for the oft-quoted powerlessness of the medieval peasant. By 1475 perhaps 40 per cent of the farm holdings had been abandoned so the more enterprising peasants were able to increase their landholding by taking them over on more favourable terms as the bishop was only too happy to accept reduced rents rather than see the farmland abandoned and worthless. Interestingly, these were the years of the Wars of the Roses, with the important Battle of Tewkesbury taking place in 1471, but it was a concern of kingdom; the concerns of the peasantry of Bishop's Cleeve and Woodmancote were much more fundamental.

With this general background we can now turn to rescue just a few typical individuals from the dry parchment of the bishop's records and breathe new life into them. Even though all the villagers relied directly or indirectly on the land, their various economic positions created differentiated experiences. We can start by revisiting the survey of c.1170 which was of the same 30 hide area as Domesday Book, but it is much more specific about the people living in Bishop's Cleeve and Woodmancote. If Bishop's Cleeve had a more varied social structure, the larger farms tended to be in Woodmancote as most of the yardlanders lived there. Here were five freemen holding a yardland each and nine customary tenants also holding a yardland each. Three of the freemen of Woodmancote are described as riding men. We don't know exactly how much

49 A dairy maid in the fourteenth century, based on a drawing in the *Luttrell Psalter*. The milk would have been used mostly for producing butter and cheese

land the eight freemen in Bishop's Cleeve held, but there were no yardlanders, just six half-yardlanders. Unfortunately we don't know exactly how the other 35 smallholders and landless villagers were divided between Bishop's Cleeve, Woodmancote and Lower Gotherington. No one experienced an easy life. The holders of a yardland had to work on the lord's demesne three days in every week and plough, sow and harrow half an acre each day from Michaelmas (29 September) to Christmas, using their own horses, which indicates that some were wealthy enough to contribute horses to the communal teams rather than the more common oxen. At haymaking each yardland had to provide one man to mow and one to lift the hay and half a wagon to carry it from the meadows to the hayricks in the farmyards. At corn harvest each yardland had to provide one man for three days and two men for the fourth day in each week. They also had to carry wood and prepare malt for brewing ale when the bishop came to Bishop's Cleeve. Fortunately this was quite rare as some medieval bishops never stepped foot in the manor. There were also a number of smaller works and tolls to be paid. If work demanded two men, then those with no family help would have hired a labourer from the village. So who might these have been?

People looking for work would have been the descendants of the Domesday slaves who had become the six oxmen recorded *c.*1170 who had to work for

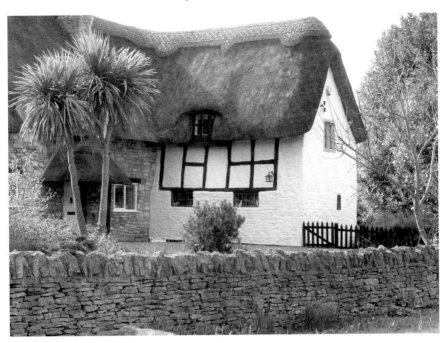

50 There is some debate whether King's Farm in Woodmancote is the King's Place of 1609 and before that the home of Robert King, but the surviving timber-framed wing could well date back to the later Middle Ages

the bishop every Monday and the eight *bracmen* who in return for a small plot of land had to work on manual tasks twice a week, with an extra day at harvest time Four cottars, who held a cottage each, performed the same services. The 13 bordars had to work once a week for their lord and two days a week at harvest time. The smaller the holding, the lower the labour services but the more critical the success in finding other work to survive. The oxmen were no longer slaves but their three acres alone would not have been enough to feed themselves and their families. Perhaps the swineherd, shepherd, smith and the two keepers of the lord's wood at Wontley came from these smaller landholders.

In his book *Standards of Living in the Later Middle Ages* Professor Christopher Dyer chose to illustrate the lives of the medieval villagers by breathing life into three different types of customary tenant listed in the 1299 survey. Robert King was one of the nine customary yardlanders who lived in Woodmancote. His 24 acres (10ha) of land was made up of strips lying scattered in the open fields. He paid for this in labour services, working on the lord's demesne by ploughing, sowing, harvesting and threshing the lord's corn, all of which paid his annual rent of 8*s*. He also had to contribute horses or

oxen to make up a ploughteam of six or eight animals. In any one year Robert would have planted 12 acres. Half was sown with barley for making bread and brewing, a third was wheat, mostly to sell for cash, and the rest probably oats and rye, beans and peas, as they had been for over 1000 years. In bad times he would not have harvested as much seed as he had planted; in good years he would perhaps have gathered four times the seed sown. In addition to any oxen or horses, on average he is likely to have owned two cows, 13 sheep and a pig. The cows were much smaller than today's standing about 1m 35cm (4ft 6in) to the shoulder and giving only a tenth of the modern milk yield, most of which went into making butter and cheese. Milk (and fleece) came from sheep which stood 60cm (2ft) to the shoulder. The pig would have been eaten and any ox too old to work, but not the horses which were more highly valued. The excavations at 21 Church Road in 2004 uncovered two almost complete horse skeletons showing they had been buried with some care. Both were about 12 when they died and one had evidence for a hard life as a beast of burden, although their size was only that of a modern small pony. At this time oxen were generally used for the heavy task of ploughing but horses for carting and harrowing.

Robert would have had a vegetable plot and there is evidence that flax and hemp were grown to sell. His wife Edith, like the other wives, would have sold eggs from the chickens, spun wool and flax, brewed ale and made honey to add to the family income, taking them to the local markets. Robert needed cash for his outgoings: paying workers at haymaking and harvest, repairing the house and farm implements, buying horse shoes, tar for treating diseases in the sheep, salt and herrings and paying the bishop's tolls and the king's taxes. At a time when wages were 2*d* a day at harvest and 1*d* a day during the rest of the year, Robert could have enjoyed a surplus of cash, estimated as £1 in a good year, which would have been spent on clothes, furniture and other domestic items. He would have lived like the king in his name, but in bad years he would have struggled and Edith's earnings would have been crucial. This would have happened in the early 1290s as harvest yields were down by 20 per cent and royal taxes were heavy. There were also natural highs and lows in his life cycle. Assuming he had taken on the holding when his father died, he had to pay a heriot, such as an ox worth ten shillings, to the bishop and also a mortuary payment to the rector, which might have been another ox. Then there were the burial fees and a payment (entry fine) just to take over the holding, so it is not surprising he is likely to have started life as a tenant in debt. The situation would have been worse if he and Edith had young children to feed and clothe. However once the children grew up they would to be able to work and so contribute to the family economy as Robert would not have had to pay any workers, but later when they left home and Robert grew older, he would have

51 The cruck discovered in Laburnam Cottage makes the cottage one of five known later medieval buildings in Bishop's Cleeve built around a pair of curved timbers which reach from floor to roof. They are seen here passing through the upper floor. It is extremely likely that Laburnam Cottage was the home of a half-yardlander. (P. Badham)

been increasingly dependent upon hired workmen and in the end he might have had to give up his holding to another tenant, possibly one of his children, to support himself and his wife. In this particular case we know that when Robert died Edith took over the holding, but we do not know how she managed.

If Robert the yardlander lived on the edge of poverty in some years, then Henry Bennett with half a yardland lived an even more precarious existence, even if the demands of the bishop were less and his cash rent was only 4s. Professor Dyer has calculated the cash surplus from his farming to be 2s or 3s a year. The work of his wife and family would therefore have been crucial, as Henry would know he might run up debts at any time. His smaller holding would need less of his time and therefore allow him to spend time working for wages to supplement his income. Any years of poor weather would not only have decreased the yield but would have also lessened the opportunities for earning wages from people like Robert King. 1294 was particularly bad, for exceptional rain ruined the harvest and wheat prices soared; a year's supply cost 12s, four to six times his annual profit. We know Henry lived in Bishop's

Cleeve; one of eight half-yardlanders and 14 cotlanders listed in 1299. Another three half-yardlanders and 13 cotlanders lived in Woodmancote so the cotlanders were by far the most numerous type of villager at this time. They each held six acres (2.5ha) and so they would have been very dependent upon other income (*colour plate 13*). They owed labour services worth 3*s* a year and many seem to have been employed as ploughmen; others were possibly craftsmen. Their lives would have been even poorer than the half-yardlander, but not as poor as the 13 Mondaymen who paid 12*d* for their three acres (1ha). Most lived in Bishop's Cleeve near the church. John *le Gavisare's* crops would not even have met the needs of a wife and three children. He might have had a single cow to provide dairy produce. Working for an average of 1½*d* a day, John would have needed to work for 130 days to pay the rent and buy the food he could not grow on his one and a half acres, but would there have been enough demand in the area to satisfy all those looking for work? The bishop, the rector and the yardlanders would all have needed labour, but especially in bad years it might not have been enough to employ all those looking for work. John would certainly have had to go further afield, if only to Southam and Brockhampton, but possibly Cheltenham and Winchcombe. His wife's contribution would have been much more crucial than Edith King's. Taking a craft would have been another solution for helping John avoid poverty. Perhaps it's no coincidence, then, that a community of craftsmen emerged in Bishop's Cleeve rather than Woodmancote. Some of these villagers would have worked in the quarries on Cleeve and Nottingham Hills. Very little written evidence survives about the quarrying. This is unfortunate because it must have been on a considerable scale. From the fifteenth century at least, the abbot of Winchcombe was renting Postlip quarry from the bishop for the very small rent of 6*d* per annum. Arthur Price, an expert on Cotswold stone and its history, considers stone from Cleeve Hill was not only used in St Michael's and the bishop's manor house from the twelfth century onwards but also much of Tewkesbury Abbey was built from it and perhaps many of the local parish churches. Haulage would have provided more work for the villagers. In addition we know that in 1529 the bishop's tenants in Cleeve had to provide five wagonloads of stone per yardland for the repair of the local roads.

FAILING TO SURVIVE

If the Black Death carried off a third of the population of Bishop's Cleeve and Woodmancote, its impact on the outlying communities brought about the final stage of the movement from dispersed to nucleated settlements which had begun almost 1000 years before. *Sapletone* of Domesday Book

has, of course, disappeared so completely that its location is unknown. Of the rest, Wontley was the largest of the settlements which disappeared. Its size increased from six tenants in *c.*1170 to eight in 1299 but it seems to have been abandoned by 1372-3 when it was said the tenants were unable to pay taxes and rents 'because of death' and the bishop was renting the lands out for 10s a year; by 1393-4 the rent had fallen to 6s a year, but in 1472, by enclosing the former open fields with a ditch and a bank (to keep the animals from straying), the bishop was able to rent the land to two merchants from Winchcombe, for sheep grazing, for the vastly increased annual rental of £6 13s 4d. The crumbling nineteenth-century buildings remind us that farming at Wontley, on the edge of the manor at a height of nearly 300m (1000ft) has never been really successful. The medieval village itself lay to the west of these farm buildings and can be identified by a scatter of pottery. The lack of evidence for building materials seems to indicate that the medieval houses and farm buildings must have all been timber-framed with thatched roofs.

The former hamlet of Wick is much more accessible, lying above Woodmancote on the north side of Stockwell Lane. 'Wickfield' survives in the name of the lane running from the hillfort on Nottingham Hill to the golf clubhouse on Cleeve Hill. The name, meaning an outlying farm, gives a clue to its origin: an area of expansion out of Woodmancote. There were never more than two dwellings. Our first clear record of its existence lies in the survey of 1299, but we don't know when it was founded. In 1299 Walter held a cotland, with a furlong (i.e. a group of strips), a grove and an assart. The grove was known as Wickfield coppice in 1503 and still stands to the north-west of the deserted settlement. We know the other tenant was called Matthew. He also held a cotland with an additional two and a half acres (1ha) which lay in the lord's hands. According to the 1327 tax list John and Peter lived there. In 1462 John Fowler was brought to the bishop's court because his house had fallen down. In 1475 it was recorded as an empty toft, so the settlement had been abandoned and the land was being worked from Woodmancote.

Cockbury and Haymes were also abandoned during these years. They lay in Southam manor, but still in the ecclesiastical parish of Bishop's Cleeve. Cockbury (still reflecting the old name for Nottingham Hill hillfort) lies on the edge of Cleeve Common. It was first recorded in the *c.*1170 survey and it paid tax with its neighbour Wontley in 1327, when there might have been four or five families living there. In 1340 it pleaded, together with Wontley, that it had been destroyed by robbers and the fields lay uncultivated, which might have meant it was already deserted, but this was a not uncommon way of trying to avoid the king's taxes. Cockbury Court now stands on the eastern edge of the former hamlet; some of its architectural features date to the early seventeenth century by which time the hamlet is likely to have been abandoned.

52 These earthworks at Wick are the remains of a farmyard. The camera is pointing north-east towards Wickfield Lane on Nottingham Hill

In 1299 Haymes was held from the bishop by Adam of Haymes who held three yardlands 'with his joint tenants' by military service. This probably means that Haymes was one of the sub-manors created by the Bishop of Worcester to fulfil his military obligations to the king. Adam remains a strong candidate for the effigy of the cross-legged knight in the south transept of St Michael's. However the family most associated with Haymes was the Loringe family. They were certainly living in the area in 1389 when John Loringe bought the rector's tithe corn of Gotherington for £16. In 1413 he or another John was summoned to the bishop's court because he had blocked Haymes Lane with 'branches of thorns'. However in 1451 a Thomas Water held the three yardlands 'once held by Adam of Haymes', so it is not absolutely clear when Haymes came to the Loringe family, but they held Haymes until 1717. What sort of settlement existed in the later Middle Ages is impossible to say. In fact, nowhere are we given any clues as to the size of the settlement. All that is left are a few house platforms surviving to the south of Haymes Farm.

Finally, before leaving the deserted medieval settlements in the parish, there exists a tantalising reference in the bishop's court roll for May 1414, when William Poulton stands accused of having blocked a ditch at *Neweland*. Is this a reference to the Newlands, a hamlet which stood until the 1960s at the crossroads outside the GE Aviation complex, and the name of which lives on in the name of the playing fields there? The name had probably been given

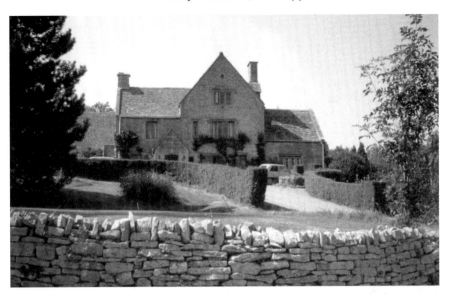

53 The lower mill in Stockwell Lane in Woodmancote in 1965. It is the only surviving mill building. There must have been an earlier mill at Millham ('mill meadow') to the north of Bishop's Cleeve, but this was recorded as out of use in the survey of c.1170

c.1300 as settlement expanded in the parish. Here are more questions for which we will probably never know the answer.

INCREASING PROSPERITY

We have now considered the four types of customary tenants and how their experiences had become more varied, or differentiated, compared to the simpler social structure of villager and smallholder in Domesday Book. However as we have noted, they were never the only type of people living in Bishop's Cleeve and Woodmancote. The great landholders, the Earls of Gloucester and Hereford and the abbot of Tewkesbury all held land but probably never visited. At the top of the pyramid of village society came Adam of Haymes and Thomas Ede who held their land by providing for a knight, which the bishop had to contribute to the royal army. Next came the free tenants; 30 in number in 1299. They held their land from the bishop solely by cash payments and, not being subject to labour services, enjoyed a higher status than the customary tenants, despite some of the freeholdings being smaller than customary holdings. So although Matilda Chapman held only a farmstead and three acres (1ha) and was potentially economically

109

worse off than the customary yardlanders, she enjoyed a higher social status as a free tenant. Sometimes we find tenants holding both free and customary land. William Usher of Woodmancote had a yardland for which he and Thomas Ede paid four shillings to be freed from taking the bishop's messages as riding men. He also held another yardland with his wife Juliana for which he paid 14s 1d annually; it had once been customary land with labour services attached. He held a third yardland for eight shillings on the same customary terms as Robert King. William serves as a good example of how complicated land holding arrangements could be and also how much freedom some tenants enjoyed to build up their land to improve their economic position. In the 1327 taxation William paid 12s 1¼d, considerably more than the Woodmancote average of just over 4s. No doubt he paid other villagers to fulfil his labour services to the bishop and also employed them on his land. William's 'engrossing' as it was called was not that unusual from the fourteenth century onwards. Between 1327 and 1343 Thomas of Amersham, a free tenant, obtained nearly 20 acres (8ha) of land through 16 different transactions. Even some of the cotlanders were engrossing. The 1299 survey records that eight of them had added up to four acres (1.5ha) to their original six acres (2.5ha); John *Droys* had also added a further two and three quarter acres (1ha). So the enterprising tenants were exploiting an active land market without reference to the bishop. No wonder the richer peasants were getting richer.

Unfortunately no records survive to tell us of the immediate impact of the Black Death and other fourteenth-century epidemics on the community, but a survey taken in 1475 does catch the longer-term impact. It gives a quite different picture to that of 1299. The 53 tenants listed included five women. Not a single surname survived from 1299 and although at that time surnames were not always inherited, support for a complete change of families comes from the observation that only ten tenants in 1475 had inherited their holding from someone of the same surname and only three, all in Woodmancote, were said to have inherited from their father. Lack of personal mobility in the Middle Ages is another modern folk myth. That the villages had shrunk is clear from other entries; 39 messuages (the term used for a farm complex) were listed, but there were 27 tofts (a plot where a messuage used to stand) because when a tenant was not replaced and the holding added to the holding of another tenant, the farm buildings were usually not needed. This process led to larger farms. Twenty eight tenants had had holdings of six acres (2.5ha) or smaller in 1299; by 1475 this figure had reduced to just ten. Many had become attached to larger holdings, so for example, John Webb of Woodmancote held both a yardland (rent 20s a year) and a Mondayland (rent 1s 6d) which he might have used as the home for his farm labourer.

Professor Dyer has recalculated the economic position of Robert King, Henry Bennett and John *le Gavisare* as it might have been in 1475. In 1475 William Newman of Woodmancote held a yardland, as had Robert King in 1299. Yields of grain were generally 20 per cent higher, and with more land put down to pasture he was able to keep more animals than Robert, but prices of grain and any labour he bought in were more expensive, as was any farm equipment he needed, so in the end he was only slightly more wealthy than Robert. Yet his family's life generally was more secure as the demands from the king and the bishop had declined and there were fewer bad harvests. Robert Smith, the half-yardlander, would have similarly been better off than Henry Bennett, partly because of the sale of his larger number of animals. Yet the greatest change was at the bottom, where John Gamell junior with a cottage and plot of land now earned 4d a day, which meant he could buy enough wheat for his family with only 75 days' employment. There was now more of a cushion between his family and absolute poverty and there were fewer villagers like him and all must have been better off regarding their farming because by 1475 a three-field rotation had replaced the older two-field rotation which meant that only a third of the land was now left fallow in any one year.

One of the best buildings to show this increasing prosperity is Old Farm at the bottom of Station Road. It mirrors in timber the design of Cleeve Hall. Who might have had the means and the desire to build such a pretentious farmstead? The evidence points to Thomas Yardington, father and son. The Yardingtons' own family holding was recorded in 1475 as a mere cotland, yet from 1471 to 1525 Thomas senior leased the 400 acre (160ha) demesne from the bishop. He moved up village society serving as reeve and bailiff, and as a juror in the manor court. When the demesne was granted to his son Thomas in 1541, his son was described as a yeoman – a term of status. We know the names of 13 people who rented the bishop's demesnes across the whole of the West Midlands and the Yardingtons were the only ones of peasant origin; no wonder then that it is reasonable to suggest that Old Farm might have been their statement that they had made good in their own village.

The survey of 1475 provides more evidence of the broad distinctions emerging between Woodmancote and Bishop's Cleeve. In the former there now existed nine yardland, two half-yardland and nine six-acre holdings. In the latter there were still no yardland holdings but 11 half-yardland and 18 six-acre holdings. Those of three acres (1ha) had almost disappeared as separate holdings, becoming attached to larger holdings, as in the example of John Webb above. As Woodmancote had been developed later it had perhaps offered greater opportunities for larger holdings to be formed

54 Old Farm in the floods of 27 July 2007. The water reverted to its medieval course along Station Road where it probably ran through the rector's fishponds

compared to Bishop's Cleeve, which had experienced greater sub-division of long-established holdings to accommodate its population growth. Evidence to support this view of Woodmancote is provided by the 1475 survey which records 37 pieces of *forlet* land; new land often forming

55 The Wynyards in Butts Lane in Woodmancote could well reflect the wine-
growing area on the bishop's manor, which was recorded in 1475

small plots on the edge of cultivation which a tenant held only during his
or her lifetime. Several are said to be under Bushcombe at *le Breche*, in
the vicinity of Breeches or Butts Lane on the lower slopes of Nottingham
Hill and also near Girold's twelfth-century assart. One is recorded as a
vineyard which name is still in existence today. Not all *forlet* land lay
below the hill. One piece lay at Irish Butts, near Cheltenham North rugby
ground on Stoke Road. Was this a small patch of land that had not been
brought under cultivation until later than most, as might have happened
at the Newlands? A small clue appears in the 1299 survey when John Irish
held half a yardland and one parcel of land called No Man's Land (i.e.
disputed land) for which he paid the bishop 2*d* compared to 4*s* for the
half yardland.

We have seen that by 1475 the distinction between free and customary tenant
was becoming blurred. Many customary tenants paid money rent instead of
performing labour services, and several tried to claim they were freemen. This
can be illustrated by tracing the holding of William Usher. This land was held
by John Sewell in 1475, paying the bishop 28*s* 2*d* each year. John himself had
also profited from the decline in population, for in May 1462 he had also
taken a messuage and six acres (2.5ha) of land called Gamell's Place 'lying
under Bushcombe'. He was obviously an aggressive engrosser for he appears
several times in the bishop's courts in the 1460s as he tried to privatise his

56 'Under Bushcombe'. The area of assarting below Bushcombe Wood saw John Sewell attempt to privatise the land in the fifteenth century, tobacco-growing in the seventeenth century, and it was where Benjamin Slack collected his first census return in 1851. The Wynyards lies just off to the right of this view

lands by putting a fence around them. This meant they would no longer be part of the open fields for grazing the villagers' animals. In 1469 he was faced with a fine of 40s so he agreed to remove the fences. In 1490 either he or his son was described in the court roll as a free tenant so that the customary land inherited from William Usher's holding was now indistinguishable from free land. In fact, by then only seven customary tenants still owed labour services for the bishop and these amounted to a combined total of 20 days in the year, at either hay or corn harvest. Even they probably now paid a sum of money instead so most families had therefore profited in some way from the slackening of the bishop's control.

So how had all this affected the annual value of Bishop's Cleeve and Woodmancote to the bishop? It rose from £5 0s 8d c.1170, when labour services were much more important, to £26 8s 5d in 1299 and £35 1s 5d in 1475 despite the number of recorded tenants falling from 102 to 53. Christopher Dyer records that the income from the whole bishopric rose from about £300 in 1161 to £892 in 1290, chiefly through expansion and better use of the farmland, then dropping slightly by 1475 but the 1475 survey came at a bad time for the peasants, for grain and wool prices were low and they found difficulty in paying their rents; a situation which lasted until the 1480s. We know from other sources that Bishop's Cleeve manor had dropped £10 in value over the previous 20 years as rents had been reduced. This fixing of rents was one of the activities which took place in the bishop's court which all tenants were expected to attend, or be fined. Records of the courts survive from 1412 to 1515 and they can also provide us with insights into how the

community functioned towards the end of the Middle Ages. We can now turn to them to examine more closely the lives of the villagers, even if through the eyes of the bishop.

LIVING AS A COMMUNITY

The increased opportunities for building up wealth from engrossing came at a price. When holdings were amalgamated and buildings allowed to fall into ruin, not only did this create an unattractive environment for the villagers but it was likely to work against any efforts of the bishop to re-let the holdings in future. During these 100 years frequent orders were made to repair ruinous buildings or pay a heavy fine. Lack of a reference to the repairs being completed might suggest they had been repaired – or that the bishop had given up. There was probably a mixture of both these outcomes. In the first entry, in October 1412, it was the bishop's sheepcote, where he put his flock of sheep for winter, which was declared ruinous. We know it stood near Cleeve Hall and that it had still not been repaired by the following summer. In April 1462 another sheepcote, that of engrosser John Sewell, was in disrepair. During the fifteenth century references to ruins generally become more numerous; five holdings in Woodmancote in October 1419; seven in Bishop's Cleeve in April 1491; five 'badly ruinous' in Bishop's Cleeve in October 1505, when three lay ruined and an unnamed number 'badly ruined' in Woodmancote. It is impossible to locate the individual buildings but some of the toft boundaries survived to be recorded on nineteenth-century maps (*colour plate 14*). Despite fines and threats of fines, the bishop fought a losing battle to keep the buildings in good repair because there weren't the tenants to need them. The remains of woodworm and death-watch beetle found during the excavations at Stoke Road are clear reminders of the problems in keeping timber-framed houses in good repair.

The case of John Sewell, brought before the court for blocking off his land, shows how personal gain could be at odds with community well-being. Other anti-community actions were repeatedly brought to court; blocking public pathways, failing to keep water courses clear and overburdening the land with grazing animals. In 1413 the ditches at Linworth, Millhamend and the King's Way in Woodmancote were ordered to be cleared. In the declining days of Wick in 1451 John Fowler was ordered to remove his fences which blocked *Wykeman's* lane. In 1462 the whole community was ordered to repair Breeches Lane. Even the rector was not immune from such demands. Richard Ewen had been the bishop's surveyor and receiver of rents, yet in 1450 he was ordered to repair the ditch below his rectory close, probably on the line of Station Road. In 1491 one of his successors was fined 40s for overburdening the common

pasture with his animals and there are regular orders to the villagers to keep their animals out of the arable fields and the meadows until after harvest. These orders became much more common after 1460 as the tight manorial control began to loosen. In May 1469, all the villagers of Bishop's Cleeve and Woodmancote were forbidden to put their horses and cattle to pasture between Hisnam and Cleeve unless tethered by a rope. Similar orders were still being made in the early sixteenth century; in 1504 no sheep were allowed on the wheat field stubble until Martinmas (11 November) so the cattle would have the first grazing. Communal farming also meant that there existed a danger of animals roaming onto the growing crops because the large open fields could only temporarily be subdivided by fences and hurdles. In April 1413 John Dolling's cattle caused 13s 4d damage to Hugh Walker's peas and beans. Consequently a close eye was kept on stray animals and their capture was recorded regularly throughout the court rolls. In October 1450 no one seems to have claimed a stray pig with five piglets nor 14 stray sheep, which remained in the hands of the farmer lessee of the bishop's demesne.

The courts also tried to ensure standards amongst the traders and craftsmen. Agnes Baker was a miller. As we have read, Millers symbolised dishonesty, so it is no surprise to find that she was fined 4d in May 1414 for taking too much grain for her toll. John Read and Richard Smith were fined 2d each for the same offence in 1462. At this time there were probably the two watermills in Stockwell Lane and a windmill in Southam field, although they were said to be ruinous in 1475, so people either bought their bread or ground their grain by hand quern. Agnes also brewed ale, for we find in October 1412 she was fined three times for selling poor quality and/or false measure. Brewing ale was a popular way to provide some income and we might suspect Agnes was a widow who needed such income to supplement her profits from milling. In November 1413 no fewer that 14 people were fined for selling short measure. We also find references in the fifteenth century to villagers selling basic commodities to other villagers – the origins of the village shop. Not only were bread and ale sold but also candles and meat. In 1396-97 John Southbrook was paid 4s 6d to re-roof four shops on the rector's manor. They were probably near the present site of the war memorial because this area was later known as Cheapside i.e. a place for trading. Such trading, of course, provided a valuable alternative to farming for people with little or no land.

Although life was generally well-ordered, acts of violence and theft against individuals did arise. These are the type of court cases with which we are most familiar today. The court of October 1461 sent Simon *Beke* to prison in Gloucester for theft, and goods worth 10s were seized from him by the sheriff, including one horse and a brass pot. In May 1469 Agnes Saunders was declared a common gossip, disturber of the peace and thief, for she had stolen malt from

57 The architectural details of Cockbury Court suggest it was built in the seventeenth century, possibly on or near the site of the medieval hamlet

her neighbour. She was fined 4d and bound to keep the peace for the surety of 3s 4d. Two cases of personal violence were recorded in April 1491: John Shepherd, one of the rector's servants, was fined 3d for hitting Thomas Taylor with a sheep crook and John Hicks was fined 6d for hitting a servant of the bishop's steward with a stick so that 'he drew blood'. In May 1504 nine tenants were together accused of stabbings and fined from 4d to 20d; unfortunately the rolls do not record any more details. The worst case took place in April 1462 when Richard Smith and his sons John and Thomas came to the court and assaulted the steward himself. It seems this Richard might have been the same Richard who had a record of anti-social behaviour as a tenant at Hampton Lucy; in 1451 he had illegally ploughed up the bishop's demesne. They were fined the enormous sum of £100 but they could never have hoped to pay this and had to be pardoned by the bishop. However, this was exceptional and the overall impression from the court rolls is that social controls were strong enough to allow the community to get on with its daily living, despite the bishop's control loosening in the second half of the fifteenth century.

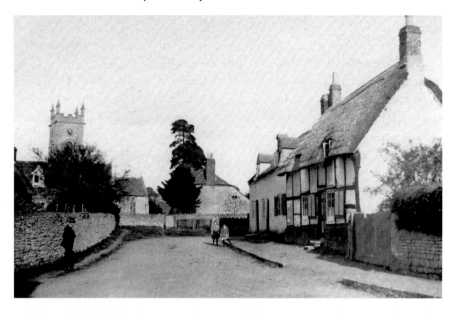

58 'Cheapside' in the early twentieth century. The war memorial now stands on the site of the houses

THE RECTOR'S MANOR

But the bishop's manor was not the only manor in Bishop's Cleeve. We must not forget the rector's manor which had its origins in the grant of land to the minster by the church of Worcester in the early ninth century. Although much smaller, it was legally distinct from the bishop's manor, although its tenants formed part of the one village. In addition to the payments directly related to his work as priest, John Brian enjoyed an annual income from his manor of £94 in 1389-90; the slater who was in the same year repairing the chancel roof with slates brought down from Cleeve Hill, at a daily wage of 3*d*, would have to have worked for 25 years to earn the same amount – and he was a skilled craftsman. The rectory was worth £133 a century later, mostly from the sale of the tithes and so it was a valuable prize, being worth more than double the bishop's profits from his manor at that time. However, we must not think of the rector as a part of the community. He enjoyed the vast income and from it often paid a chaplain or curate to carry out the services. We have already met Sampson the priest, but not the rector, recorded in *c*.1170. John Shepherd 'chaplain of the parish' received 8*s* 6*d* in 1396-97 for serving from Palm Sunday to Michaelmas (29 September), but it seems he was also allowed the lesser tithes – from animals and their produce, fruit and some crops, which he could sell; William Baldwin, the rector's shepherd, received 10*s* for

the same period. The rector also had to make sure Stoke Orchard was served by a priest. In 1296-97 the 'chaplain of Stoke' was paid 26s 8d. Ten years earlier Bishop Giffard had himself unsuccessfully canvassed the pope to be granted the rectory of Bishop's Cleeve so he could recoup some of the costs of providing for 56 knights for Edward I's war in Wales. He had more success in 1291 when Pope Honorius IV allowed him to use most of the income from the parish to pay for the food for his table during his lifetime, yet Bishop Giffard had had to pay over £103 in expenses to his ambassador, Adam of Filby (Norfolk) and £200 to the pope's secretary to win the case! Bishops had a large number of servants and retainers, so the food bill must have been a large drain on the bishop's resources. As a result of this case, Peter of Leicester, appointed by the bishop as vicar of Bishop's Cleeve in 1291, needed other finances. He was already amply rewarded as rector of Preston Bagot and Budbrooke in Warwickshire, but more importantly, he was also steward of the Bishop of Worcester's estate and since 1290 Baron of the Exchequer in national government, so his time in Bishop's Cleeve was limited to say the least. This was not an isolated case. Nicholas Bubwith (1403-15) was Lord Privy Seal (1405-06), Lord High Treasurer (1407-08) and successively Bishop of London, then Salisbury and finally Bath and Wells. Richard Ewen was rector in 1447-48, but he was already the receiver of the rentals of the bishop's estate. When he left the diocese in 1448 to be surveyor for the Bishop of Winchester, there were loud complaints that he had not passed on to Bishop John Carpenter all the money he had collected from the bishop's tenants, but no court case was ever brought. How the villagers regarded their economic loss through tithes, through mortuary dues and other payments in return for the spiritual comforts of the sacraments and hopes for heaven from a low-paid curate representing an absentee rector enjoying a lavish lifestyle, is unfortunately not recorded. Were such feelings of alienation behind the biggest recorded robbery of the Middle Ages in the turbulent last year of the reign of Richard II? The rectory was raided in 1399 and £24 in cash was taken, £29 in stock, including four horses, 18 oxen, one hundred and nine pigs and 23 piglets, with fish 'still to be valued'. It still remains an unsolved crime.

In every respect the rector's manor was a cut-down version of the bishop's manor. The rector had a demesne recorded as more than 86 acres (36ha) in 1589. There was a substantial rectory farm with barns, a granary to store the grain, a byre for cattle, stable, pigsty and sheepcote. They were all timber-framed and thatched and must have stood to the north and east of the rectory house. A walled garden, orchard and close led down to three fishponds on the line of the present Station Road. Then there were over 90 acres (38ha) of customary land, rented out to 12 tenants in 20 separate holdings in 1479; 14 of the 20 holdings in 1479 were four acres (1½ha) or smaller. Of the rest four

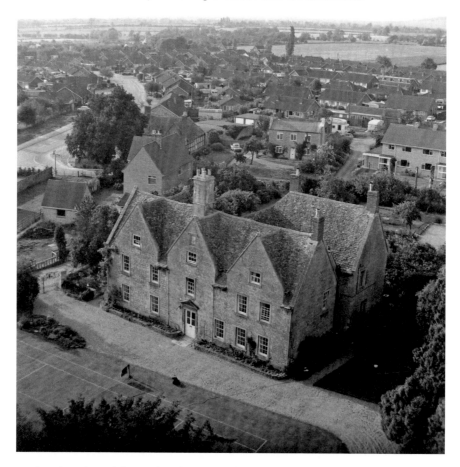

59 Another view of the medieval rectory (The Priory) taken in 1972 which now also shows the development of the Cleeveview estate

were half-yardlanders and only one a yardlander, so presumably most of the tenants needed other work. Several of the tenants were the rector's servants. In 1397 John Brian employed Richard Haymes, who was his steward and auditor, plus a bailiff who ran the manor, three carters, a swineherd and shepherd, a dairymaid and a hayward, who looked after hedges and fences, not forgetting the clerk who kept his accounts in order. In 1418 John Bromsgrove spent 9s on 6yds (5.5m) of red and green cloth for their tunics. He also bought green cloth for the chaplain and striped blue cloth for the bailiff. They must have cut a lively sight as they went through the village on their daily business.

Details of the rectors' lifestyles when resident in Bishop's Cleeve can be recreated from their accounts. In this case it is John Brian (1374-1403), who seems from his accounts to have been mostly resident in Bishop's Cleeve.

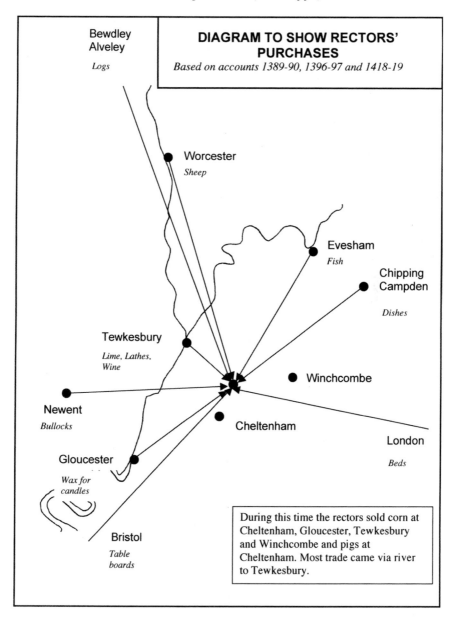

**DIAGRAM TO SHOW RECTORS'
PURCHASES**
Based on accounts 1389-90, 1396-97 and 1418-19

Bewdley
Alveley

Logs

Worcester
Sheep

Evesham
Fish

Chipping
Campden

Dishes

Tewkesbury
*Lime, Lathes,
Wine*

Winchcombe

Newent
Bullocks

Cheltenham

London
Beds

Gloucester
*Wax for
candles*

Bristol
*Table
boards*

During this time the rectors sold corn at
Cheltenham, Gloucester, Tewkesbury
and Winchcombe and pigs at
Cheltenham. Most trade came via river
to Tewkesbury.

60 This map shows where some of the rector's purchases were made. It shows the importance of the River Severn for carrying the items to Tewkesbury, from where they were carried to Bishop's Cleeve by road

Seventeen dishes, two stools and two pails were bought at Chipping Campden in 1392-93. Wax for candles was bought in Gloucester; wine was bought regularly in Tewkesbury and Gloucester; in 1392-93 the rector paid the almoner

of Tewkesbury Abbey 2*d* for delivering 120 gallons of wine in one consignment! Yet the previous year a workman was paid 4*d* for a day's work pruning the vines in the rectory garden. In 1396-97 beds came from London and 24 blankets were bought, but we don't know where; in 1398-99 18*s* were spent on oil for lamps. Vegetables came from the rectory garden and fruit from what was traditionally known as the Cherry Orchard immediately to the west of The Priory. Other indications of the rectors' comfortable life style are references to a brewhouse, bakehouse, a building for sifting flour, a detached kitchen and soap for washing tablecloths and towels. This was a life immeasurably richer than that lived by the richest parishioners. It is to their food and drink that we now turn.

EATING AND DRINKING

Obviously the food and drink of the villagers was very similar across the different types of villager from yardlander to cottager. Recent archaeological investigations have confirmed the main findings of Professor Dyer from the documents. The villagers' staple diet was based on the fruits of the field; wheat and rye for bread, barley for brewing ale and small quantities of oats for ale and cooking. Peas and beans were grown for making pottage with other vegetables and herbs, including cabbage, onions, leeks and garlic. Elderberries and hazelnuts were gathered from the hedges to supplement their diet. Animals were kept for a variety of reasons. The archaeological excavations in Stoke Road not only increased our knowledge of the Roman period, but brought to light new and important discoveries from the Middle Ages. Over half the number of bones identified came from sheep. Most were three or four years old and so had probably been kept for wool, reinforcing the documentary evidence for the importance of the wool trade, then eaten as meat and their skins used for soft leather items like gloves, but three younger sheep had obviously been killed for their meat. Pigs had been killed for food. There were few cattle bones and the bones of horses and dogs suggested they had only been used as farm animals. Deer and game had been hunted. A complication in interpreting these finds is that much of the pottery found there, from as far away as Malvern, Oxfordshire, Buckinghamshire, Bristol and Wiltshire, was of high quality, suggested this area might have been used as a dumping ground for the waste from the manor house. The typical diet of the villager would be considered largely vegetarian or even vegan in today's language. The remains of charred seeds, and the more important evidence of waterlogged plant remains (the largest assemblage to be found in Gloucestershire) show from the surviving seeds that both arable and pasture land lay close by; buttercup, dock, nettle and orache were the most common grassland weeds. Most of the pottery found in this area can be dated from the middle of the thirteenth century to the late fourteenth century. At 21 Church

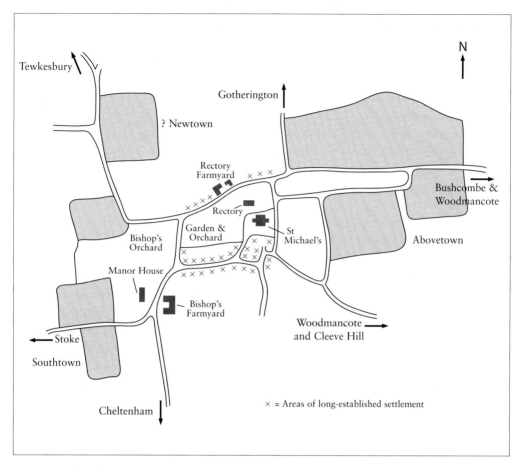

61 This sketch map shows the possible layout of Bishop's Cleve *c.*1300 with its historic core and three areas of expansion. It is based upon archaeological evidence and the 1839 Tithe map

Road most of the pottery came from the mid twelfth to mid thirteenth centuries. By relating such archaeological evidence to the written record, it becomes possible to suggest the shape and extent of Bishop's Cleeve in the later Middle Ages.

THE SHAPE OF THE COMMUNITIES

By the end of the Saxon period the two focal points in the village had become established: the church and the rector's manorial complex to the north and east, and the Bishop of Worcester's manorial complex to the south and west. Both sites had extensive farm buildings of which the Tithe Barn and re-used

dovecote and stables at Cleeve Hall are the most obvious survivors. The plots along Church Road were small and some were irregular, evidence of piecemeal development and sub-division. Some of the half-yardlanders recorded in 1299 might have been living on the south side of Church Road. Some of the rector's servants might have occupied the small plots at the war memorial end of Church Road. Little evidence for medieval occupation came from the Tesco site, suggesting it represented the gardens and paddocks of the houses fronting Church Road. What had happened to the central area, which had been the minster precinct? Most of it seems to have remained in the rector's hands but a clear boundary still runs from the entrance to the churchyard westwards down behind the Church Road plots to Gilder's Paddock. It is not beyond the bounds of possibility that this marked a medieval division of the former minster precinct, with land taken for the bishop's tenants for their plots facing onto Church Road. The archaeological investigations at 21 Church Road found only pits and ditches and low-status 'cooking pot' pottery. This lack of evidence for medieval farmsteads might confirm this area as one of cottages with gardens. The finds were similar to those in Stoke Road dating from the eleventh century with occupation at least to the fourteenth century. West of 21 Church Road, it's possible the farmsteads of the half-yardlanders began to appear. It is also possible that the freemen and yardlanders, if any, lived along the King's Way or The Street, now Station Road, along the northern boundary of the former precinct and, significantly, away from the bishop's manorial complex. Here stands Old Farm and by the nineteenth century many of the higher status inhabitants of Bishop's Cleeve lived here, still reflected today in houses like Southfields and the Old Manor House.

Away from this central core there appear to be three areas of expansion. Christopher Dyer sees the excavated plots along Stoke Road as plots of the three-acre Mondaymen. The dating of the pottery supports his hypothesis as the pottery fades out in the late fourteenth century when we know that only two out of eight recorded Mondaylands were still separately tenanted. This seems to have been called 'Southtown' in the bishop's records. There are enough references to cotlanders living 'above town' (*Bovetoun*), with the occasional Mondayman and cottager, to hypothesise that there was another extension towards Woodmancote, focused around a green between what is now Station Road and Priory Lane. Interestingly the houses here are at right angles to the road, unlike in the centre of the village, perhaps to maximise the number of plots as the village expanded (*colour plate 13*). There is some evidence that some of the plots both here and in Southtown belonged to the rectory manor. This eastward extension is captured as mostly empty plots on the Tithe Map. We know that in 1475 seven plots here were recorded as empty. Thirdly, fragments of cooking pots still lying on what were the long-

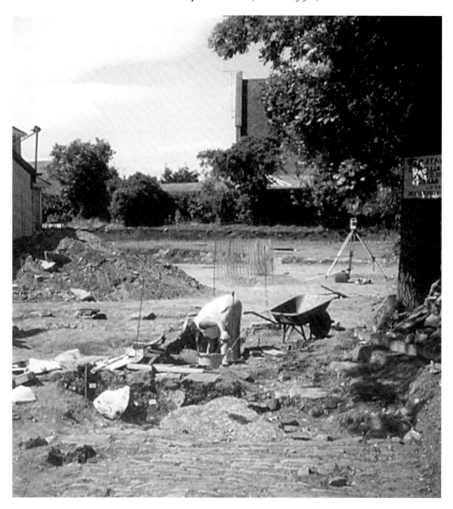

62 The wall crossing the middle of this photograph of the excavations behind 21 Church Road in 2004 emphasises the change in level which could indicate the division of the former minster precinct between rector and bishop. The cobbled surface in the foreground is probably seventeenth century

disused hearths of abandoned houses were found opposite the entrance to Cleeveway Manor when Willow Park estate was being developed. This might have been another medieval extension from the core settlement at the far end of the bishop's garden and orchards, away from his manor house. This area was known as New Town by the nineteenth century, but we don't know if this name was in use in the Middle Ages because the archaeological evidence is so far inconclusive. In 2004 late medieval boundary ditches, suggesting farmsteads were not too far away, were found at Cleeveway

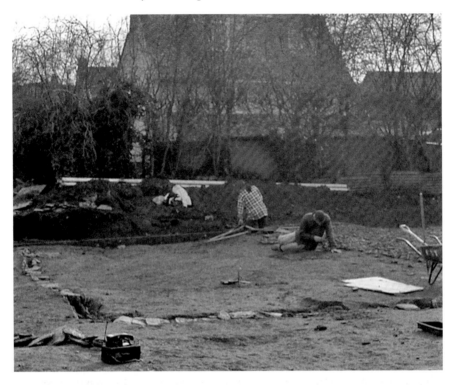

63 This view of the Stoke Road excavation shows a drain which is the best evidence that people were living here in the thirteenth and fourteenth centuries before the plots were abandoned as the population fell

Manor, but a little further north, near Malvern View, only the ridge and furrow of the medieval strips was found in 2001. Interestingly, there is no evidence for medieval settlement immediately to the east of the churchyard, where St Michael's Hall now stands; an area which also lacks prehistoric features.

In Woodmancote there were no regular patterns of settlement, as would be expected from a settlement taken from woodland. It focused on The Green and stretched up Bushcombe, Stockwell and Gambles Lanes, with the evidence of high quality timber framing, still recognisable in places like Box Farm and The Manor, suggesting the richer yardlanders were more numerous in Stockwell Lane. Perhaps The Green and the lower part of Stockwell Lane were the first part to be developed, lying on the direct route from Bishop's Cleeve up the scarp to the hill. It's then not difficult to imagine the first clearing here with the same process taking place along Bushcombe and Gambles Lanes. All we know for certain is that development had taken place by c.1170, although we have seen it was possibly already forming by 1086. Now let us move from the

community to consider the place of the church in controlling that community by offering the people earthly comfort and hope for heaven.

THE CHURCH IN THE COMMUNITY

St Michael's, whose tower still dominates the village, provides the link to this lost world. We can start by considering how its appearance was different from that of today. We have already read how the earliest visible stonework dates from the late twelfth century. It must have replaced an earlier building, of which there is no visible trace. As the population's grew, so did the building, especially in the early fourteenth century, when both aisles were enlarged. The chancel was also enlarged in the early fourteenth century, probably replacing a shorter chancel with a rounded east end. This is likely to have taken place after Walter Gammel, rector 1273-86 and also Bishop of Salisbury 1284-86, left £40 for that purpose. In the south aisle new windows were inserted in the later fifteenth century, which seems to have been the time when every alternate column in the nave was removed, possibly to give more light. The different styles give St Michael's its distinctive appearance and yet the interior of the church during the Middle Ages looked very different from today. A clue to some of the medieval decoration survives in a blocked window in the south transept (*colour plate 15*). Only remnants survive elsewhere, the most obvious being the painting of St Christopher on the north wall, probably dating from the late fifteenth century. Heavily decorated wooden screens divided the church into sections; one across the chancel arch (the rood screen); one separating the south aisle from the nave and one around the altar in the north aisle, where the channel for the end of the screen can still be seen in the north wall. They were removed in the sixteenth-century Reformation (*colour plate 16*). The lime wash which covered the external walls was only removed in 1893. The present tower replaced a shorter tower and spire which collapsed in 1696. It cost £700 and took four years to rebuild.

Yet although the physical structure of the medieval parish church remains, the way it was used, as with Belas Knap long barrow, has long since vanished. In the Middle Ages the church was the villagers' weapon against the Devil and the evil spirits 'that fly about in the air as thick as motes (specks) in the sun.' Dates were fixed not as days and months, but in relation to the church's festivals and holy days; some 50 of them during the year, when no work was done but mass attended and the rest of the day spent at leisure. There were another 30 or so fast days when no meat should be eaten, even if the villagers had had the means to acquire some.

The experience of going to church was nothing less than theatrical. Every Sunday before mass the priest led his congregation around the church,

64 Hidden in the shadow on the north side of St Michael's are clues to its original form. A blocked doorway and scar of a sloping roof indicate how narrow the twelfth-century aisle was. Remnants of the limewash which covered the exterior until the late nineteenth century can also be seen

sprinkling the altars with holy water. Latin was the language of the church, which added to the mystery of faith as the villagers could not understand it. Most of this disappeared at the Reformation leaving simpler services in English and only Christmas, Easter and Pentecost with a few biblical saints' days were left. Gone were the prayers to the saints like St Appolonia who cured toothache. Gone was the last great celebration of Christmas, Candlemas, on the first day of February, when every parishioner was expected to process around the church carrying a sacred candle. As the flames reflected the bright colours of the walls, the effect must have been awe-inspiring and emphasised the mystery of faith. The candles were blessed and taken home to ward off the Devil in all his forms. People no longer walked barefoot to kiss the cross on Good Friday. When death seemed only a tap on the shoulder away, people were terrified of dying without a priest to give them absolution (hence the importance of at least a curate living in the parish), but they were comforted by the knowledge that their presence continued in the lighted candles they had paid for and the masses sung for their soul in the side chapels, which meant they remained part of the community even after death. Such are the glimpses into the devotional life of the mediaeval peasant; one not wholly appreciated if we just study the architecture of St Michael's, fascinating as that might be. And yet behind this devotional life another world of paganism mixed with disrespect lived on. In 1240, a century and a half after Bishop Wulfstan's

1 Bishop's Cleeve and Woodmancote from Cleeve Hill

2 The King's Beeches above the Rising Sun. The stone in the foreground marks the boundary between the medieval manors of Bishop's Cleeve and Southam as it ran across the common

3 The platform in the foreground is the site of the undefended Iron Age settlement. The stables in the background are a reminder of the association of horses with the common, which goes back to Cheltenham races held towards West Down 1818-42

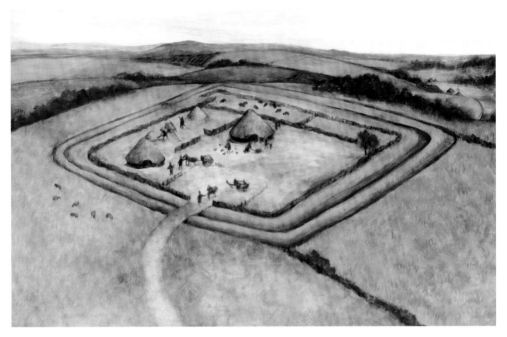

4 The features found at Dean's Lea in 2006 were interpreted as an Iron Age farmstead. (Birmingham Archaeology)

5 Twenty-first-century living at Dean's Lea provides a stark contrast to the Iron Age

6 King Offa as represented on Offa's Dyke path and based on coin evidence

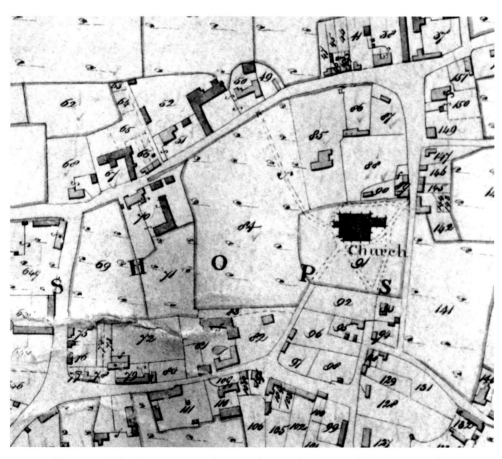

7 The 1839 Tithe Map captures the central area of Bishop's Cleeve, the site of the minster precinct. (Gloucestershire Archives)

8 Cleeve Hill above Southam appears to be the obvious location of *Wendlesclif* from the description in the charter

9 Cleeve Hall, the former Bishop of Worcester's manor house, was built *c.*1250 and then rebuilt in the seventeenth and nineteenth centuries, but it stands on the site of at least one earlier hall made of timber

Above left: 10 The Tibblestone today

Above right: 11 Church Walk off Shutter Lane survives as one of a number of narrow paths between the medieval timber-framed houses of Lower Gotherington

Above: 12 The bluebells in Bushcombe Wood provide evidence that the wood dates back to at least the Middle Ages

13 69 Station Road is one of the few remaining cottages standing side-on to the road, reflecting the arrangements at the medieval 'Abovetown'. It is very likely to have started life as the home of a cotlander. Note the original-style windows along the side

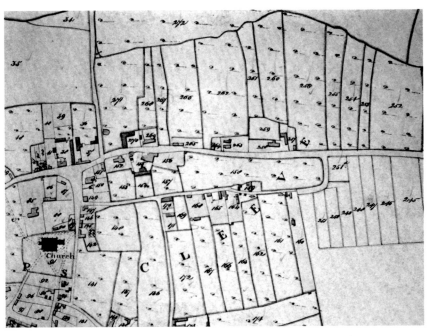

14 The remnants of medieval 'Abovetown' taken from the 1839 Tithe map. By this time many tofts had been amalgamated (e.g. 266) and post-medieval houses have appeared (e.g. 269). (Gloucestershire Archives)

15 The blocked window in the south transept of St Michael's gives an idea of the earliest internal decoration which no longer exists. (St Michael's church)

16 There is much of interest in this photograph of the north aisle in St Michael's. The stonework above the pillars indicates where two arches were made into one and the original 'dog-tooth' decoration chiselled away, possibly in the fifteenth century. On the far wall are the remnants of a medieval wall painting and the channel for a timber upright to support a frame to make a chapel around an altar. This was swept away during the Reformation. (St Michael's church)

17 The earliest reference to the squatter settlement on Cleeve Common, which became Nutter's Wood, was 1693. It has been continuously inhabited since at least 1812

18 Station Road looking down past the Old Manor House to the former Cleevelands Farm. The oldest part of the manor house, partly hidden by the tree, probably dates to the fifteenth century as it is another building containing crucks. The former Cleevelands Farm contains five crucks

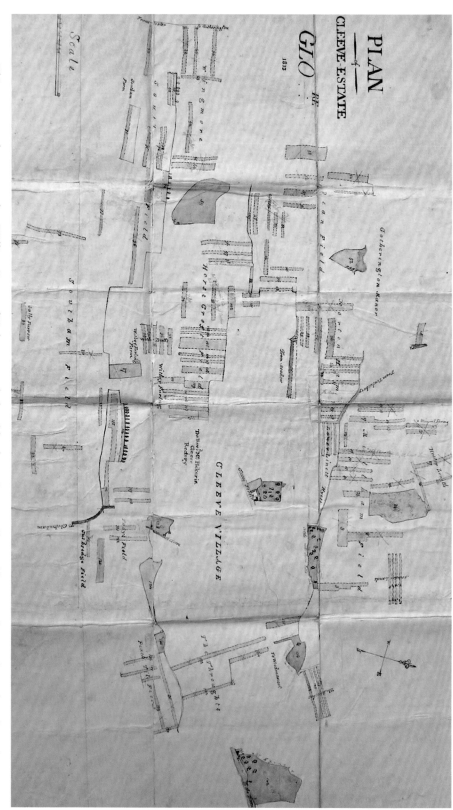

19 This map was drawn up when William Byam of Tetbury was declared bankrupt in 1813. It provides a good example to show how the village was surrounded by the strips in the openfields. (Gloucestershire Archives)

Above left: 20 Gotherington Fields Farm was created at enclosure in 1807 for the rector of Bishop's Cleeve

Above right: 21 These fragments are all that survive today from the stained glass of the medieval windows of St Michael's which were destroyed at the Reformation. (St Michael's)

Above: 22 The police station of 1851

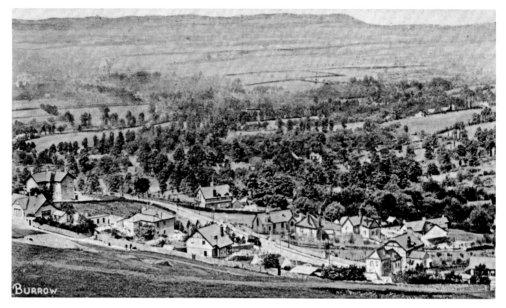

23 This postcard has been heavily tinted, but it shows well the resort nature of the new community on Cleeve Hill. It was posted in 1906

24 Four phases of building illustrate the story of Church Road. 29 Church Road is a traditional timber-framed house dating from the fifteenth century. Stone-built Greyholme dates from at least the early eighteenth century. The redbrick extension to 29 is made from machine-made bricks, which in the early years of the twentieth century began to change the character of Church Road. In more recent times the garage of Greyholme has been built in keeping with the house

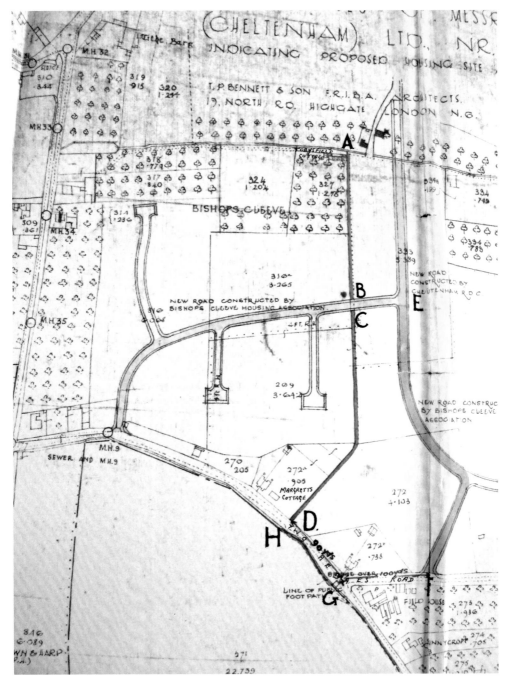

25 This is how the modern village began. The map outlines the first housing on Smiths' estate. Note the dotted line that marked the boundary between Bishop's Cleeve and Woodmancote parishes. (Gloucestershire Archives)

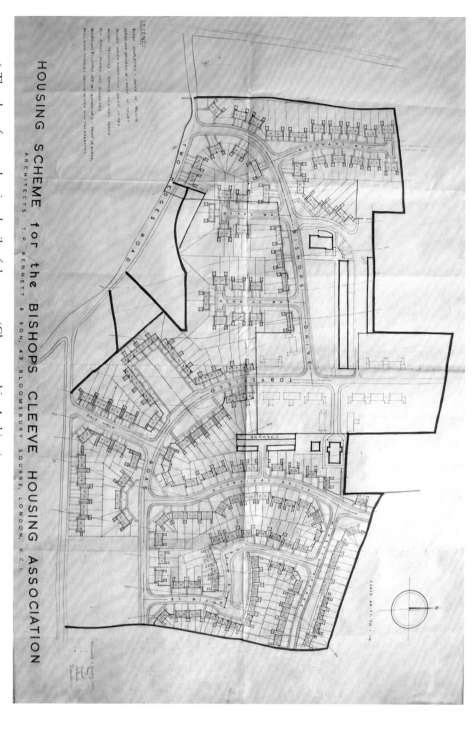

HOUSING SCHEME for the BISHOPS CLEEVE HOUSING ASSOCIATION

ARCHITECTS: T.P. BENNETT & SON, 43 BLOOMSBURY SQUARE, LONDON, W.C.1.

26 The plan of 1951 showing details of the estate. (Gloucestershire Archives)

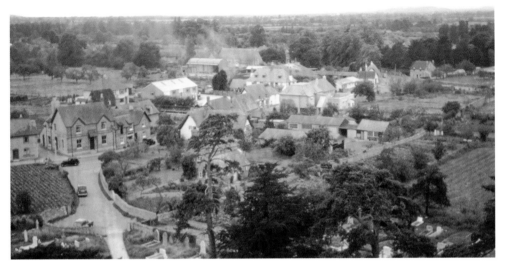

27 A view from St Michael's tower taken *c.*1960 shows Church Road with the workshops in Tarling's Yard to the right and Oldacres' Mill towards the middle. (A. Evason)

28 This second view was taken in 1966 and shows the gradual development of the Church Road area. Compare the growth of Oldacres' site with the earlier view

29 This barn was the last obvious remnant of the village's long agricultural history. It looked totally out of place by the time it was demolished in 2008 to make way for new parish council offices in Church Road

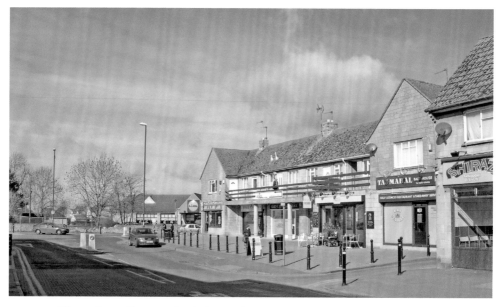

30 These shops illustrate the findings of the 2008 report; they could be in any town

instructions, we find Bishop Walter Cantilupe instructing his priests to guide their parishioners away from soothsayers, fortune tellers and the worship of springs; this last possibly a survival from the Iron Age. He ordered the priests themselves to stop playing dice, drinking to excess and attending wrestling matches. Three hundred years later we find John Basse, the curate, writing to the rector, John Claymond of Corpus Christi College in Oxford, that he is overworked, but having little impact on the lives of his parishioners.

The second focus of the medieval village was the bishop's manor house, which, of course, represented another aspect of the impact of the church on village life. The existing Cleeve Hall was probably built when Bishop Godfrey Giffard was enlarging his demesne lands in Cleeve. The excavations of 1998 and 2002 located what the archaeologists thought might have been a limekiln used for making mortar for building the stone walls which replaced the earlier timber walls. The main hall was open to the roof; a southern wing at right angles to it (as now) provided private quarters, but at the northern end the wing for servants and keeping the food and drink stood parallel to the road. About 200 years later the northern end was changed to match the southern wing and so it largely remained until it passed out of the hands of the bishop in 1561. The southern wing containing the private rooms was used by the bishop. Bishop Giffard (1268-1301) visited Cleeve as he travelled round his diocese. During his episcopate seven men from Cleeve became priests which was the easiest method for peasants to move up a considerable distance in this world. Bishop Adam de Orleton (1327-33) stayed two weeks in April 1328, when he granted the rector, Nicholas de Cobham, a licence to be absent to study for three years. Adam's successor Simon de Montacute (1333-37) is recorded as visiting twice. On his first visit in November 1335 he preached on the text, 'The good shepherd gives his life for his sheep'. During his episcopate a Richard of Wontley was appointed to be abbot of St Augustine's in Bristol, the present cathedral. After 1400 there were a number of bishops who did not even visit Worcester, let alone Bishop's Cleeve; between 1499 and 1535 two were Italian. Thus for most of its life, the manor house would have been used only by the steward and other officers who held court there, but nevertheless it served as a powerful symbol of power in this world and the next and it dominated this end of the village. In front of it lay the farmyard with its sheepcote, pigsties, granary, kiln (for drying grain) and hayricks and dominated by the bishop's barn, built in the late fifteenth century, shortened in 1886-87, and converted to a village hall in 1956. Its medieval origins are best seen in its roof timbers, although they were much altered in 1956. The dovecot and stables stood on the other side of the manor house. In its own way the bishop's complex must have been as impressive as the church, churchyard and rectory at the other end of the settlement and some of the peasants lived metaphorically trapped between them.

65 The bishop's barn in use. The rector, Benjamin Hemming, sits in front and so the photograph can be dated to between 1883 and 1895. (E. Powell)

SO WHAT MIGHT IT ALL MEAN?

Although everyone ultimately shared the same experiences of the farming seasons and harvests, by the early sixteenth century peasant society in Bishop's Cleeve and Woodmancote had become more differentiated with the gap between the richest and the poorest peasants increasing, although the poor were not quite so poor and there were fewer of them compared to the thirteenth century. As the villagers gained more freedom, less wealth was given away to support the bishop and rector so there was more to spend on themselves. Except for the bishop on his very occasional visits, no one could match the lifestyle of the rector when resident. The villagers were tied directly or indirectly to the land and the size of their holding remained a key factor in providing comfort, although some of those with smaller plots in Bishop's Cleeve were turning to crafts and trades to increase their income and for a fortunate few men, the church offered an escape from their poverty. There was a surprising amount of personal mobility as families moved in and out of the community. People fell into or moved out of poverty according to the time of their lives; young

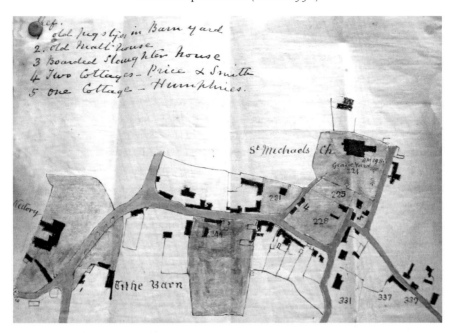

Ref.
1. old pig styes in Barn yard
2. old Malt house
3 Boarded slaughter house
4 Two Cottages – Price & Smith
5 one Cottage – Humphries.

St Michaels Ch.

Tithe Barn

66 This map of 1890, showing church property to be demolished, captures the last stage of the farmyard which accompanied the Tithe Barn and possibly still reflected the arrangement of the Middle Ages when it belonged to the Bishop of Worcester. (Gloucestershire Archives)

children were a liability but older children, who could work, were an asset. What is clear is that a combination of natural phenomena – plagues and bad weather leading to famine which thinned the population – and the entrepreneurship of individuals in building up their own holdings, by taking over vacant holdings as the bishop's influence declined in the later years, meant that overall life improved for the ordinary villagers. Today this is best evidenced in the surviving examples of the houses of the period as they were now better built and kept in better repair. The church gave meaning to people's lives, but there were undercurrents of paganism and indifference. The bishop's influence as lord of the manor had already declined by the time the Crown took over as lord in 1561. The manor then passed through several owners who sold plots off to enterprising villagers and it declined as an institution and became just a large farm. The rector's manor also became just a large farm. The villagers now had more opportunity to control their own lives. We will find out in the next chapter how Bishop's Cleeve and Woodmancote developed without a controlling lord of the manor.

SOURCES AND FURTHER READING

The two key books for this period are Christopher Dyer's *Lords and Peasants in a Changing Society* (Cambridge 1980) and *Standards of Living in the Later Middle Ages* (Cambridge 1989). E.B. Fryde: *Peasants and Landlords in Later Medieval England* (Stroud 1999) also contains some valuable references to Bishop's Cleeve. I have also continued to use the archaeological reports in *Transactions of the Bristol and Gloucestershire Archaeological Society* which have been identified in previous chapters. Eunice Powell's guide to and history of St Michael's parish church (available at the church) has proved very useful. Arthur Price's *Cheltenham Stone* (Cotteswold Naturalists' Field Club 2007) is essential to understand the working of stone on the Cotswolds.

The records of the Bishop of Worcester are in the Worcestershire Record Office and those for the rectory belong to Corpus Christi College Oxford. I am very grateful to Professor Dyer for making his transcripts available. The *Hockaday Abstracts* volumes for Bishop's Cleeve in Gloucestershire Archives contain copies of records relating to the church which are held in the national records.

5

THE TRADITIONAL FARMING COMMUNITY (1550-1850)

The fertility of this parish is very great and on the summit of Cleeve Clouds, the parishioners possess a common right of pasturage for sheep, over several hundred acres.

S.Y. Griffiths, *A New Historical Description of Cheltenham and its Vicinity*, 1826

COUNTING THE PEOPLE

This next stage in our story is marked at either end by two of the three most important sudden changes to have affected Bishop's Cleeve and Woodmancote. The first started in 1549 when the villagers' traditional religious beliefs were revolutionised by the English Reformation and the second occurred by 1847 when the villagers' traditional methods of farming came to an end as the medieval openfields were enclosed into the familiar fields of today. The arrival of Smiths' Industries in the mid twentieth century was the third. Unlike slow change, which is easier for the historian to see, these changes had a clear impact at the time.

In 1598 Richard Owen, the curate of Bishop's Cleeve sat down, put quill to parchment and wrote:

The Register booke containinge all Christ(e)ninges wedinges and burialls ffrom the year of our Lord god one thousand ffive hundred sixtie and three wrytten by me Richard Owen Clerke Curat Cleeve in the yeare of our Lord god 1598.

What was he doing? Queen Elizabeth I's parliament had ordered all parish priests to 'keep a fair book' of baptisms, marriages and burials. Such records had been kept haphazardly for the last 60 years and Richard must have spent

many hours carefully copying up the records he could find. He approached his task meticulously as we can learn from this outburst of exasperation:

> The names that were between the thirteenth day of January 1585 (1586 to us) and the xxviiith day of October 1587 were regestered in the old register booke in such confused sort that I am not able to set them downe in anie good sort.

His book and its successors are today kept safe in the Gloucestershire Archives and they provide a basis for understanding the community during these three centuries. However, in the early years not every priest was as conscientious as Richard. There are gaps between 1616-20 and around the time of the civil war (1642-49) especially 1649-60 when Oliver Cromwell's government made registration a civil responsibility. No burials were recorded between1645 and 1650. In addition, for historians they are only really useful when individuals lived their whole lives in the same parish and few did, as we have already seen in the Middle Ages.

Alice Willis is the first name in the registers, being baptised on 18 April 1563. Nine years later, on 12 November 1572, her mother Agnes was buried; her father Thomas must have moved away from the parish as his name does not feature again. There is no mention of Alice being married, but there is a burial entry for Alice Willis of Woodmancote on 1 May 1597. If this was our Alice, she must have been somewhere over 34 years of age. The next person to be baptised was John Hobbes, son of Thomas but no mother's name is given; not at all unusual. No John Hobbes appears in the marriage register, but he could have been any one (or none) of four John Hobb(e)s buried between 1604 and 1652. There are only two names out of the nineteen on the first page which we can follow with some certainty. On 16 July 1563 Edward Smythe was baptised. On 3 May 1589, 26 years later, he married Alice Smith, who must have been from another parish. In September 1592 daughter Alice was baptised; in April 1596 Katheryn, and in July 1599 Thomas. Edward was buried on 18 April 1631, aged about 67 and Alice could have been the widow from the almshouse buried on 11 December 1640. All their children must have moved away. The second name which can be followed is Joanne Hawkes, baptised on 20 August 1563 and married on 22 November 1584 to Edmund Webb, another incomer. In September 1585 their son Christopher was baptised; in July 1592 Susanna; in February 1599 Alice and in November 1599 another son Anthony, who died in 1661 in Gotherington. Joanne is likely to have been the Joan Webb, who was buried on 20 January 1638, aged about 75, but there is no further trace of her husband Edmund. The parish registers are full of such frustrations but they do record some of the distinctive family names which have unbroken associations with the parish of Bishop's Cleeve: Ballinger (first recorded in 1589), Barnes

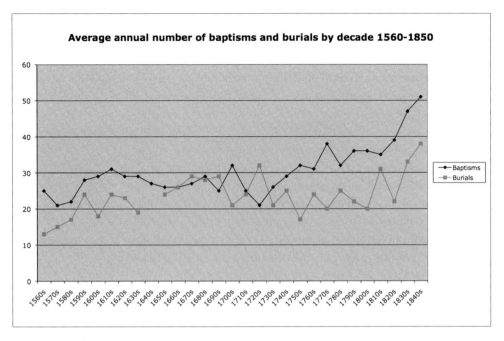

Average annual number of baptisms and burials by decade 1560-1850

67 Graph to show averages of baptisms and burials, 1560-1850

(1571), Cresswell (1592), Hobbs (1566), Holder (1573), Leech (1580), Tarling (1563) and Webb (1584). Of course some of these names might have been in Bishop's Cleeve before the first registrations in 1563. Those names first recorded in the seventeenth century probably relate to families who first appeared during that century: Kitchen (1683), Surman (1623) and Wasley (1664).

We know there are gaps in the registers. At other times we can suspect under recording; three burials in 1698 but 26 in 1697 and 24 in 1699. Exceptionally high numbers of burials should be accurate: 45 in 1604; 40 in 1624; 57 in 1675; 45 in 1711 and over 50 in each year 1727-29; all being about twice the norm. We know that the deaths in 1604 and 1624 are likely to have come from the plague. High corn prices and very hot weather possibly affected the numbers in 1675. In 1727-29 there was a dramatic increase in deaths nationally. Historians think it was caused by a severe outbreak of influenza in 1727 and food shortages in 1728, which weakened resistance to further infections in 1729. Significantly each year of high mortality except the last was then followed by large numbers of baptisms. Apart from such inconsistencies, we also do not know how many people slipped through the net and were not baptised or buried at St Michael's. However, it seems their numbers were always small. The only means of estimating their numbers comes from the records of dissenters or nonconformists. In 1676 there were said to be 37

nonconformists compared to 749 conformists in the whole parish. Quakers met at Stoke Orchard from at least 1654 to 1785. In 1672, the house of Joshua Head in Bishop's Cleeve was registered for Congregationalists. Other licences were granted in 1689 and 1811 but neither of these, nor any later chapels had their own burial ground, except the Quakers in Stoke Orchard.

Although we cannot use the registers to calculate the size of the population, we can at least estimate whether the population was rising or falling and by how much. This does depend on the reasonable assumption that migration into and out of the parish was largely equal. The graph shows how there was a natural rate of population increase throughout the whole period with the exception of the second half of the seventeenth century, when recorded burials exceeded recorded baptisms. It also shows that the population was increasing more rapidly and in a more sustained way from the second half of the eighteenth century, which we would expect from the national situation, as the trends towards an industrial revolution accelerated. But what was the actual size of the population? Until 1801 we depend upon tax and church records, but none of them was created to count accurately the whole population. Church censuses counted those who took communion; counting for taxation meant identifying those well-off enough to pay tax. Historians have worked hard to turn such figures into a count of the total population. Using their methods, the table below gives in rounded numbers the population of the whole parish at different times. It also includes the more precise figures from the 1801 and 1851 censuses.

The population of England grew during these years from about 3 million to 17 million. By 1851 Bishop's Cleeve was growing more slowly than the national population.

Date	Approximate size
1550	850
1600	800
1670	900
1710	900
1770	1200
1801	1355
1851	2117

These figures fit with the trends seen in the graph, and they remind us again that the Bishop of Worcester's tenants were never more than a proportion of the population in Bishop's Cleeve and Woodmancote, let alone the whole parish. Between 1664 and 1764 the baptism registers recorded where the parents actually lived and so we can use this to estimate the relative size of the settlements within the parish. The following table is based on the details of 2488 baptisms:

	Number	% of parish total
Bishop's Cleeve	813	32.7
Gotherington	650	26.1
Woodmancote	508	20.4
Southam and Brockhampton	335	13.5
Stoke Orchard	182	7.3
TOTALS	**2488**	100

Figures calculated from the census of 1851 show similar percentages. Bishop's Cleeve clearly remained the largest settlement but Gotherington's relative size had shrunk:

	Number	% of parish total
Bishop's Cleeve	745	35.2
Woodmancote	432	20.4
Gotherington	424	20.0
Southam and Brockhampton	290	13.7
Stoke Orchard	226	10.7
TOTALS	**2117**	100

So now that we have an idea of the size of the population, we can investigate the registers for what they can tell us about the key events of life. We shall start with marriage.

LIVING TOGETHER

Not until 25 March 1754 were marriages kept in a separate register. This was the result of Hardwicke's important Marriage Act of 1753. Before the act couples were not required by law to go to church to be married. As long as the groom was at least 14 years old and the bride 12 years old, not closely related nor already in a marriage, and as long as they agreed to be married, not even witnesses were required. Sometimes a 'celebrator' would create a certificate, but this was not a legal document. Such irregular or clandestine marriages totalled around half of all marriages in the early eighteenth century and they were held to be as valid as marriages made in church. One reason Hardwicke's act was passed to avoid the problems created when the marriage was disputed by one of the two partners.

But why was this marriage act also important for historians? All marriages now had to take place in the parish church by publishing banns or by obtaining a licence (not until 1837 was civil registration introduced). The marriage had to take place in front of witnesses and be recorded in the register. So it is not

surprising there was an immediate impact on the number of marriages in St Michael's. From an average of three marriages per year in the 1740s, the number shot to ten per year in the 1750s and reached an average of 12 per year in the 1770s before settling to an average of ten by the mid nineteenth century. This means the registers only become reliable for the number of marriages after 1750 but what else can they tell us? Between 1665 and 1710 the place of residence of both the bride and groom was recorded, so for 45 years it is possible to examine how far (mostly) young men and women travelled to meet their spouse. Only half (104 or 54 per cent) of the 192 individuals married someone from their own village. Another 15 (8 per cent) married within the parish of Bishop's Cleeve, but someone from a different village within it. Of the remaining marriages most were between one spouse from Bishop's Cleeve and the other from the surrounding parishes. Twenty six spouses (14 per cent) came from inside a radius of five miles including from Cheltenham and Winchcombe, so 75 per cent of couples lived within five miles of each other or, to put it another way, within a two hour walk. Yet there were some exceptions. In 1672, Mary Hobbs of Southam married Edward Hunt from Worcester; in 1674 Thomas Fluck of Stoke Orchard married Martha Bayot from Hillingdon. Interestingly in these pre-Hardwicke days, 13 couples (7 per cent) were not living in the parish of Bishop's Cleeve at all. Perhaps their close family disapproved of the marriage.

Many local studies have used marriage registers to study the age of the spouses and whether they were able to sign their names. Unfortunately the marriage registers for Bishop's Cleeve do not contain any information about their ages and so we have to rely on the national figures. Between c.1600 and c.1750 the average ages were 26 for the bride and 28 for the groom. By the mid nineteenth century this had fallen to 24 and 26 respectively. However, the Bishop's Cleeve registers are more useful when we examine whether the bride and groom were able to sign their names; a very simple measure of literacy. Between 1754 and 1763 there were 86 weddings: 41 (48 per cent) grooms and 23 (27 per cent) brides signed their names. Between 1828 and 1837 (the last decade for which such evidence is available) 49 grooms and 48 brides out of 100 individuals could sign their name. The proportions had become much more equal, possibly reflecting better education for women. But being able to sign one's name was only a simple measure of literacy, and anyway many more people could read than write. So where might they have learnt? Evidence is very scarce: a Sunday School for 150 children in 1818, and a number of small private day schools recorded at various times, for example four such schools in Woodmancote were educating 37 boys and 16 girls in 1818. In 1874 it was said that the chancel of St Michael's church had been used as a school and, of course, so had its porch room. Only in 1845 did the rector, William Lawrence Townsend, together with a number of subscribers and the National Society (of the Church of England) provide a school

68 The walls of the porch room at St Michael's provide clear evidence of its use as a school. They seem to have been painted in 1818. (E. Powell)

and school master's house to educate all the local children, not only to read and write, but also to receive the teachings of the church and to accept their position in life and respect their elders, especially the rector himself. It is no coincidence

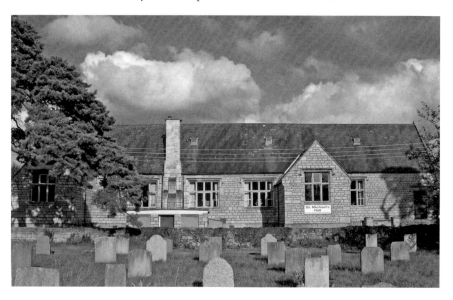

69 St Michael's Hall is the former National School built in 1847. The original building was enlarged at its southern end in 1905

that the only view out of the building for the scholars at their desks was towards the church across the road. Yet schooling was neither compulsory nor free until the very end of the nineteenth century and it comes as no surprise that 32 per cent of under 13 year olds in Bishop's Cleeve and 54 per cent in Woodmancote were not attending school at the time of a school census in 1846.

It was expected that children were born to parents who were married. But what about children born outside marriage? These children can be identified when only the name of the mother was entered in the register, or sometimes they were described as 'natural' or 'base'. On the whole, such children were generally small in number, reinforcing the importance of the institution of marriage in this period. From the mid sixteenth century the numbers tend to rise slightly and then fall to a low in the mid seventeenth century. They then tend to rise again until the early Victorian period. Between 1655 and 1670 there were only three years when even one such infant was baptised. In 1814 11 out of 48 baptisms (23 per cent) were of children born to single mothers. The figures mirror national trends. Nationally in the 1680s fewer than one in ten children was born to single mothers; in the 1820s over one in four. Of course we don't know whether all such children born in the parish were baptised, but it seems that such children were accepted into the community, which contrasted strongly with the general attitude that people who had sexual relations outside marriage must be brought before a church court and made to do a public penance. What

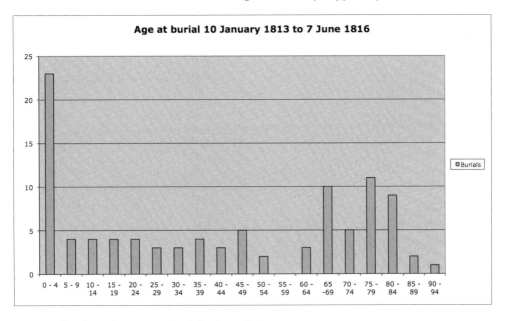

70 Graph to show age at burial, 1813-1816

is remarkable is that so few occasions are recorded, which perhaps suggests that such activities were not worth persecuting or prosecuting. Just two mid-sixteenth-century examples from Bishop's Cleeve will give an idea of the public humiliation for the unfortunate couples. In 1551 Thomas Byglyn and his wife Elizabeth were ordered to do 'public penance on five festival days in St Michaels with their bare bodies, hands and feet during homily (the sermon) and on two market days in the market place in Gloucester' to restore their marriage after their adultery. In the next year, William Garne junior, having committed fornication with Julia Grinning was ordered to stand in Bishop's Cleeve church in his shirt, bareheaded and barefoot, reciting his fault and then repeating it in Gloucester, Tewkesbury and Cheltenham in succeeding weeks. As the only way he could have reached these places was by foot, the punishment must have been intended to have a deterrent effect. The last recorded cases were in 1793, but there had been only six in the previous 50 years. By then the local magistrates had generally taken over by issuing maintenance orders for financial support against the fathers in order to prevent the mother and child being a charge on the parish poor rates. The issue had become one of finance rather than morals.

Twenty three such maintenance orders survive from 1755 to 1828. They must represent just the tip of an iceberg, for it seems to have been only the disputed claims which ended up in court. Usually the father agreed to pay a lump sum or regular smaller sums. In May 1755 Thomas Wills of the Rose and

Crown in Cheltenham High Street was ordered to pay Margaret Bannister of Bishop's Cleeve for the maintenance of their daughter. He disputed this, but his appeal at the County Court at Gloucester was turned down the following January. In August and October 1814 we find Anthony Webb, described as a labourer from Bishop's Cleeve, being ordered to pay maintenance first to Hannah Leys for Emma, then to Anne Reeve for another child. We might wonder what stories lay behind these bare statements.

Our final look at the registers gives us some indication of how long people lived. Unfortunately we have figures for only three years but they show that if children survived the first four years of childhood, they could expect to live to a reasonable old age even compared to our standards. So where did they live their lives? We can now turn to the buildings which survive to help us understand more about the community during these three centuries.

THE VILLAGERS' HOUSES

'The Great Rebuilding' from the mid sixteenth century led to many medieval farmhouses being improved by the insertion of an upper floor into the main open hall and by the building of a fireplace and chimney to give greater flexibility of use and privacy. Bishop's Cleeve and Woodmancote were no exceptions. Old Farm in Station Road must be the best example. But Cleveland's Farm (now 23 and 25 Station Rd), Laburnam Cottage in Church Road and 29 Church Road opposite, and the old part of The Manor in Woodmancote were also improved in this way.

Until the early nineteenth century the houses of the cottagers and labourers were timber-framed and thatched, but because they were tenanted on rents so low that the landlord could not afford to maintain them properly, many have disappeared in the post-war development; The Old Post Office at The Green in Woodmancote was demolished within living memory. A possible survivor is Church Cottage in School Road. By the early nineteenth century cottages were being built or completely rebuilt in stone, represented by Woodbine Cottage in Bushcombe Lane, Field House along Cheltenham Road and The Old Mill House in School Road (with its 1817 date stone). Sunnyside along Rising Sun Lane dates from 1793 and is possibly the earliest surviving house on Cleeve Hill. The cost of transporting free stone from the hill was expensive, and so hindered its use for housing. In 1708 four loads of stone were worth £2 at the quarry but carrying them down to Bishop's Cleeve cost £8, therefore it's not surprising that in the early nineteenth century brick houses like Home Farm, Albion Cottage and Malvern View also began to appear in Bishop's Cleeve – made from clay dug from pits along Stoke Road.

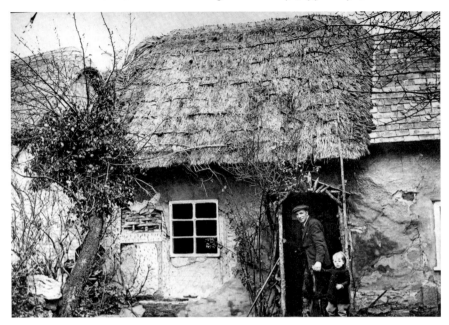

71 The old Woodmancote Post Office was probably a labourer's cottage declared unfit as a dwelling and demolished shortly after this photograph was taken in 1948. (T. Curr)

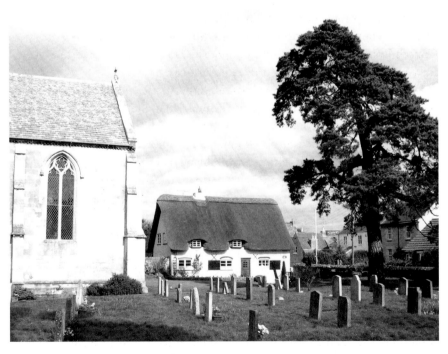

72 Church Cottage is likely to have been built in the churchyard after the Reformation for holding church ales which were important fund-raising activities for the parish

73 Albion Cottage on Evesham Road, with nearby Malvern View, are the only houses with a Regency porch modelled on those in Cheltenham

Near the lake which was formed from the clay digging, still stands 'Dog Kennel Row', built by Richard Slaney before 1838 for the workers at his brickworks. It provides the only example of nineteenth-century industrial housing in Bishop's Cleeve. Population growth led to the re-occupation of plots long abandoned in the later Middle Ages. Some can be seen along Evesham Road, Priory Lane and Station Road. In other places people were claiming squatters' rights by building houses on public land. The best example is Nutter's Wood on the Southam part of Cleeve Common, first recorded in 1693 and continuously settled since 1812 when the Hawkers, who worked the quarries, claimed squatters' rights (*colour plate 17*). Earlier examples (now gone) were Bird's Cottage and Bentley's Cottage alongside Gambles Lane which seemed to date from the late sixteenth century. Rose Cottage in Stoke Road and Mistletoe Cottage on Cheltenham Road provide good examples of houses built on the margin of a public highway from the eighteenth century onwards.

Larger houses, the houses of the descendants of the half-yardlanders and yardlanders survive in greater numbers. They became the homes of the larger tenant farmers and the owner-occupiers. The King's Head and Royal Oak in Church Road, Willow Cottage in Stoke Road and The Old Thatched Cottage

74 Slaney's Row or Dog Kennel Row is the only example of nineteenth-century industrial housing in Bishop's Cleeve

at The Green in Woodmancote remain largely in their timber-framed form, at least at the front. Some people had been able to rebuild or enlarge using Cleeve Hill stone in the seventeenth and eighteenth century: Cleeveland Cottage in Evesham Road, Owls End House in Station Road, Home Farm and The Manor in Woodmancote all have earlier timber-framed origins. Other houses were built, or rebuilt wholly of stone, destroying any earlier buildings. Many have fashionable features on gable walls, doors and windows indicating some farmers were relatively well off and profiting from rising prices. Good examples from the late seventeenth century include Cleeveway Manor, Eversfield House in Station Road, Greyholme in Church Road and Rose Farm and Southam Farm in Woodmancote. The Priory in Station Road was also built, or very extensively rebuilt at this time. Its life as the rectory came to an end in October 1624 when the rector Timothy Gates bought the former bishop's manor from Giles Broadway for £3000, leaving The Priory in a ruinous state. Fifty years later, William Nicholson, a rector who was also Bishop of Gloucester, modernised the former bishop's manor house. The main roof was raised, the central part divided into two, a floor inserted to create an upstairs and a new porch added. This carries the date 1667 to remind everybody. Yet by 1711 the north wing, the

75 Rose Cottage stands at an angle to Stoke Road – evidence that it was built as a squatter cottage on the margin of the road, probably in the early nineteenth century, using bricks from nearby Slaney's brickworks

servants' quarters, was declared 'ruinous' and 'altogether useless' and permission was given for it to be demolished. Some outhouses, including a brewhouse, were demolished, but the north wing survived. In the early nineteenth century, new windows were inserted and its present appearance created. About this time Southfield and the Old Manor House along Station Road were built or rebuilt (*colour plate 18*). At both these periods rising prices meant more wealth for the producers. Yet again others from this time have disappeared. A blocked entrance still stands at Gilder's corner as testimony to Rose Villa and Egremont stood until 1993 on the site of Aston House in the centre of the village.

INSIDE THE VILLAGERS' HOUSES

Today, of course, these historic houses have been modernised to provide comfortable homes, but how different were they in the past? Over 300 wills

and 60 probate inventories (a list of possessions drawn up on death) from Bishop's Cleeve and Woodmancote survive in the diocesan record office in Gloucestershire Archives. As long as we remember they favour the better off over the poor and that many people might have given away most of their possessions as they became older, they allow us a glimpse inside people's homes.

Richard Hobbs of Woodmancote died in 1691, aged about 80. His inventory gives a valuable glimpse inside the house (possibly Home Farm) of a comfortable farmer. It was large and well-furnished by the standards of the day with the hall i.e. living room, kitchen and a brewhouse on the ground floor, with three bedrooms on the first floor and an attic above. The most valuable domestic items were found in the kitchen; they were his brass and pewterware valued at £4 9s 8d. Seven barrels of ale lay in the brewhouse. In the hall stood a trestle table, six chairs, two stools and a bench. The main bedroom over the hall contained a four-poster bed, with blankets, covers and pillows and with a truckle bed underneath. It was the best furnished of all the rooms with firedogs (for a fire), two chests, one cupboard and a coffer, four leather chairs and four other chairs. The three other bedrooms had little more than a bed, but the attic had a cheese press; attics and bedrooms were the usual place for storing cheeses. Furnishings were sparse, and our idea of comfort did not exist. Furniture was made of wood; tableware mostly from brass and pewter; clothes were of wool and linen and very occasionally of silk. Walls were wood-panelled or lime-washed; floors were of stone or a mixture of beaten mud and animal blood. What is remarkable is that furniture and furnishings changed little during three centuries. When Samuel Cherington gave up his lease on Wingmore Farm in 1813 his furnishings were almost identical to Richard's. His kitchen was the best-furnished room with 'an excellent thirty-hour clock and case' but his brewhouse was considerably larger than Richard's containing 14 hogsheads (barrels containing 52.5 gallons [237 litres] each). His equipment and animals suggest that arable was more important than pasture on his farm in the vale. Although pewter and brassware would be bought at local markets, most of the furniture was made by local craftsmen and handed down through the generations. Only in the later nineteenth century did mass-produced commercially available furniture and fittings bring greater variety and comforts.

These documents show how the mixed farming tradition, which can be dated back to the Bronze Age, was still largely recognisable into the first half of the nineteenth century. The will of Richard Smith of Brockhampton who died in 1554 is the earliest which survives. From it we learn that he used oxen to plough, for he left all the gear associated with ploughing to his eldest son Edward, together with his crops and several hives of bees. As he left no animals

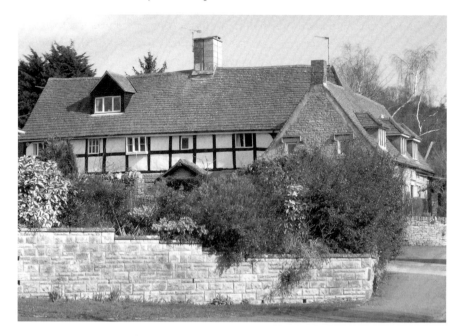

76 Home Farm in Stockwell Lane seems to be one of the buildings extensively remodelled during the 'Great Rebuilding'. It was the home of a branch of the Hobbs family for many years and is fully discussed in chapter 17 of Hugh Denham's book on Woodmancote

it would seem that this Richard, like Richard Hobbs, had stepped back from active farming by the time of his death. From the 1564 will of Richard Southall, who now had the Sewells' holding in Woodmancote (later The Manor), we learn that six oxen made a ploughteam. Samuel Cherington still owned one ox in 1813 but he had 11 horses. Wheat was sown in the winter, barley (mostly for brewing), peas and beans (mostly for animals) were sown in the spring in a three-course rotation, but now other crops were recorded. There were brief adventures in growing tobacco and flax (for linen) to give employment to the poor in the first half of the seventeenth century. The scale here was less than that at Winchcombe, but scattered plots along Butts Lane on Nottingham Hill and the lower slopes of Cleeve Hill were used. It seems that tobacco growing took place on any scale only in 1619. Joan Thirsk of Oxford University argues the local gentry introduced it in an attempt to give work to the poor, and make a good profit for themselves. Yet the methods meant fencing off areas of the common arable land, which offended other local people to such an extent that they took the matter into their own hands and broke down the fences. The villagers maintained the land must be open to all. Professor Thirsk calculated that up to a third of the population in Bishop's Cleeve and Woodmancote

could have been employed in the summer harvesting but it was immediately banned by the government to prevent competition with the newly-founded American colony of Virginia, where the local gentry names of Broadway (from Postlip and Bishop's Cleeve) and Loringe (Haymes) could be found in the late seventeenth century. A memory of the tobacco-growing episode persists in the name of the Tobacco Barn standing in the fields off Stockwell Lane, although there is no evidence it was ever used as such. Other recorded crops include clover, grown to enrich the soil, in Woodmancote in 1758 and John Kear was obviously growing enough garlic when he died in 1694 for it to be recorded with the wheat and vetches in his barn.

In addition to oxen and horses, sheep and goats, cattle, pigs and poultry were kept, just as in the Middle Ages. They were essential for keeping the arable land fertile as well as providing food and drink, wool and leather. Attempts to limit the number of animals on Cleeve Common continued to be ignored. Consequently, it seems to have been largely a free for all and a cause of much friction between the farmers of Bishop's Cleeve and Woodmancote against the farmers of Southam. Each accused the other side of allowing its animals to trespass across the marked manorial boundary running across the common. Court cases rumbled on from the late fifteenth century into the seventeenth century without any satisfactory conclusion until the problem faded with the decline of the manorial system in the nineteenth century.

The wills and inventories confirm that farmers' wealth lay more in their farms than in their homes and it's clear that widows could continue to play as important a role in farming as their husbands had done. Farmers were wealthier or poorer, largely depending upon the size of their farm and the resultant size of harvest and numbers of animals, but all farmers continued to be bound together by the same basic concerns as the weather, corn prices, animal diseases and the need to make a profit. When John Barnes died in 1728, his estate was valued at £18 2s 6d; William Rayers of Haymes died the same year and his estate was worth £440 11s 6d but the differences were only of degree. William just had more of everything John possessed: more personal possessions and furniture, more crops, horses, cows and calves, sheep and farm equipment and even 800 cheeses in the loft. As in the Middle Ages agricultural labourers, with perhaps a small plot of land, depended on the fortunes of farmers such as William Rayers, as did the few craftsmen and shopkeepers. In a rare will from a shopkeeper, when William Morgan, grocer, died in 1802 he was able to bequeath nearly £1000 in money to his children. Labourers earning 1s a day might wonder how a grocer could become so rich.

The inventories also tell us that many ordinary people seem to have dealt in a sophisticated money market. James Smith who died in 1580 was owed nearly £24 from various people as far away as Ashleworth and Evesham – possibly because he had sold them cattle on credit. Such debts could mask the

real wealth of individuals: in 1732 William Collett's estate was valued at £17 8s 7d of which £14 10s lay in debts owed to him. Wills and inventories can be used to provide evidence of occupations, for example we learn from the will of Richard Tichett, who died in 1593, that he had been a weaver of wool and linen. A century later in 1689 Mary Bussell of Woodmancote owned six pounds of yarn at her death. These references support the existence of a small textile industry in Woodmancote, reinforced by reference to three weavers in 1608. But how did most people earn a living?

EARNING A LIVING

We can start by reminding ourselves that in the later Middle Ages we found communities tied to the land (and the bishop or rector) with the larger (and therefore rather richer) farms in Woodmancote, whilst the numerically larger farming community in Bishop's Cleeve generally had smaller farms but more craftsmen and traders. This pattern continued until the early twentieth century. Dependence upon agriculture remained the glue which bound the communities together. Our first glimpse into the occupations after 1550 lies in a list of able-bodied men under the age of 60, whose names appear in a muster roll of 1608 as men being fit to defend King James I and his country from invasion. This is where we found reference to the three Woodmancote weavers. Seventy-five men are named in Bishop's Cleeve. Nine men were recorded as yeomen – farmers who owned their own land. Then there were 24 husbandmen, a more general term for farmer, especially tenant farmers, and 20 servants; 15 of the servants worked for the rector. Eight labourers were the next largest category, followed by four shoemakers, three tailors, two blacksmiths with two apprentices and a single representative of a butcher, a joiner and a tanner. In Woodmancote 21 men were listed; two yeomen, six husbandmen, four labourers, three servants and the three weavers, and then one tiler, one carpenter, and one shoemaker. The weavers no doubt wove the thread spun by their wives, who still largely remain hidden from sight and we have to assume they continued their home- and farm-based activities as in the Middle Ages, supplemented by supporting (with their children) the menfolk by hoeing weeds, removing stones from ploughed fields and driving birds away from the sown seeds.

We should not be surprised this general pattern continued. In 1754-57 the occupation of the bridegroom was recorded in the registers: one yeoman, two husbandmen, 13 labourers, two shoemakers and a single example of a carpenter, blacksmith, butcher and cooper (barrel maker). But we must not forget that quarrying on Cleeve Hill and Nottingham Hill continued to

77 The blacksmith: one of a number of engravings made by W.H. Pyne in 1802 to illustrate country life

provide a number of people with a living through quarrying and hauling the stone. From 1832 Henry Gaskins paid Lord Ellenborough £20 a year for a licence to work the Cleeve Cloud quarries. When he came to sell up in 1842 he had built a limekiln (without permission) and was £30 in arrears. Although quarrying took place over a long time period it has unfortunately left little record except the quarries themselves.

CHANGING AGRICULTURE

So the overall picture is clear. Agriculture remained the basis of economy and society; its world was a world of muscle power – human and animal, supplemented by wind and water. The medieval peasant returning in a time machine after 300 or so years would have noticed much that was familiar – the open fields in the vale with their ridge and furrow, the enclosed fields on the hill slopes, the meadows and woods, and the permanent pasture on Cleeve Hill itself. However, if he or she had travelled to the far side of the hill, they would have noticed a major change at Wontley Farm. Here, nearly half

of West Wood had been chopped down in the late 1820s by the farmer, John Price, in an attempt to expand the farmland to make the farm viable, but like the medieval peasants before him he failed and when he sold the farm in 1833 he received £500 less than he had paid for it. There had been other landscape changes, but none quite so dramatic. Some of the small arable fields on the slopes of Cleeve and Nottingham Hills had been converted to permanent pasture, but they kept their medieval shape.

However, between 1550 and 1850 subtle changes were taking place to make the fields more productive. Sometime between 1603 and 1617 a dispute reached the Court of Chancery in London, and from the case, we learn that from 'tyme out of mind' the villagers of Bishop's Cleeve and Woodmancote had operated a three-field system in which the arable lands were divided into three large areas, called Home, Middle and Wingmore Fields. The small medieval enclosures on the slopes of Cleeve and Nottingham Hills were still linked to one of the larger fields as they had been in the Middle Ages. Because the community had recently gone over to a four-course rotation, although we have to guess that clover and root crops might have been grown in the fourth year, the Chancery case had arisen because Robert Keer, Henry Guy and John Smith of Woodmancote stuck to the old three-field system in their enclosures. This meant their enclosures were not fallow at the same time as the open fields and this caused friction and annoyance to the rest of the farming community. Unfortunately we don't know the outcome of the case, but it sheds light on developments in farming at a time when the general view is that out-dated medieval methods remained unchanged. This was not wholly the case. As early as 1675 land in the vale had been put down to pasture near Wingmore Farm and enclosed by hedges. By the early nineteenth century temporary fences were being put up in the open fields to grow peas and beans. There were complaints that 'enclosures' had appeared on Millham Field in 1823 and at The Throughts and Crowfield in 1835. By that date the open fields had been divided into five 'fields' to give even more flexibility for growing crops: Dean, Horsecast, Millham, Southam and Wingmore, but there continued to be a considerable amount of intermingling of the villagers' strips in the land between Bishop's Cleeve, Woodmancote and Southam. Echoes of this still survive today: Southam Fields Farm stands beside the Bishop's Cleeve bypass; and Woodmancote Farm in Gambles Lane stands in Southam parish.

From the middle of the eighteenth century we have a better understanding of how the farming system worked because a handful of maps survive. The oldest is a map of Haymes of 1731 which shows the land as a mixture of old enclosed fields and strips, not only in the vale but also surprisingly high up on the scarp slope. A map of the combined Haymes and Bishop's Cleeve manors of 1778 confirms this pattern and shows the strips near the centre of Bishop's

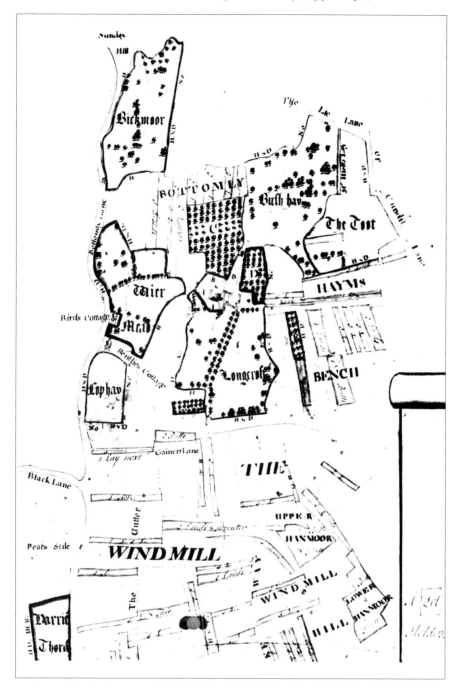

78 This map of 1731 of part of the Haymes Estate shows both strips in the open fields and some of the enclosures on the hill slope. The two early encroachments of Birds and Bentlies cottages can just be made out along Gambles Lane. (Gloucestershire Archives)

Cleeve with a very simple, but puzzling, road plan. The Old Manor House is described as 'a good farmhouse stone and slate' (see *81*). The map of the Bishop's Cleeve lands of Thomas Byam of Tetbury, drawn up on his death in 1813, reminds us that not all owners were local (*colour plate 19*). For people like Thomas Byam, land was an investment wherever it might be, although in his case it was not successful for he had gone bankrupt. But by 1813 the enclosure movement was sweeping through the Midlands and this open-field farming was regarded as inefficient and old-fashioned but let us pause briefly to consider the nature of traditional agriculture in its final years before the enclosure movement reached Bishop's Cleeve and Woodmancote in 1833.

Parliamentary figures from 1801 confirm what we already know about the crops grown in Bishop's Cleeve and Woodmancote. Wheat was the most popular (703 acres [293ha]), then barley (562 acres [234ha]) and beans (130 acres [54ha]) with much smaller areas of turnips and rape (16 acres [7ha]), peas (9 acres [4ha]) and oats (6 acres [2.5ha]). We know about farming practices because the famous agricultural observer William Marshall visited the lower Severn Vale in 1788 writing up his observations as *The Rural Economy of Gloucestershire*. If we allow for his strong bias in favour of agricultural improvement, he provides details of farming which we might otherwise not know. He criticised some of the methods used in Bishop's Cleeve and Woodmancote: ridge and furrow suited pasture because flooding in the furrows in autumn and winter meant it was not suitable for winter-sown wheat. The need to keep sheep on the fallow field meant that ploughing never properly cleared the weeds and therefore the ground never properly cleaned before its next crop. This meant crops had to be hoed as much as three times before harvest, but this did provide women and children with much needed work to keep the poor rate down and reduce the farmers' wage bill, for they were generally paid only half a man's wage. Hay and grain harvests continued to be vitally important, as can be seen from the labourers' rewards. They were either paid 3s a day with drink, or 1s a day with full board – a meat breakfast, lunch of bread and cheese eaten in the field, six to eight quarts of drink during the day, and a further quart with a hot supper at the end of it. Is the myth that farm workers were always drunk actually justified?

Marshall favoured the four-course rotation already used in Bishop's Cleeve. He wrote that peas and beans (vetch) not only returned nitrogen to the soil and allowed easy weeding, but could be readily sold not only to innkeepers for horse fodder, but also to middlemen who sent them to Bristol to be used as food for slaves on the notorious Middle Passage to the Americas; an unexpected local connection with the slave trade. Sheep, wrote Marshall, are not well suited to the Vale, for many had died of rot during the wet summer of 1782, but cattle were 'the natural inhabitants of a vale country'. Gloucester provided the chief

local cattle market every Saturday. Breeding the traditional Gloucestershires with Herefords was improving their fattening properties. Dairymaids worked from first light to bedtime making butter all the year round and cheeses in the summer to be sold in markets at Gloucester, Cheltenham, Tewkesbury and Evesham. Pigs complemented the cattle, feeding on field beans and the whey left over in the cheese-making process. The Gloucestershire pig was tall, long and white and much of the bacon was sent to the Stroudwater woollen valleys. Finally he informs us that if animal manure was insufficient to keep the fields fertile then 'night soil' from Tewkesbury's alleys' earth closets could always be bought for 2s a ton.

Marshall is important because he catches farming at a time of change. The changes can be seen as the response to the rising population of the country leading to greater demand, better prices for farmers and therefore higher rents for landlords. Enclosure enabled a farmer's land to be consolidated and he could more easily experiment to improve his crops at a time when mechanisation was having little impact. Enclosure created the fieldscape which is familiar today and which ultimately enabled Bishop's Cleeve to expand in the second half of the twentieth century, as the individual fields created at enclosure could be sold by individual farmers for development. Bishop's Cleeve was one of the last enclosures in the county, which can probably be explained by the very large number of landholders who jealously wanted to protect their rights to Cleeve Common.

The first stirrings for enclosure occurred on 30 October 1833 at a time when the movement had already nearly run its course across the English Midlands. The signatures of the rector William Lawrence Townsend and Lord Ellenborough headed the list of 25 names. The rector's enthusiasm might just have been stirred by the creation of the 280 acre (117ha) Gotherington Fields Farm in 1807 in lieu of the tithes of Gotherington, and in the knowledge that he would be entitled to a fifth of all the arable land in Bishop's Cleeve and Woodmancote for the same reason (*colour plate 20*). This new farm became Glebe Farm in Stoke Road. Also as part of the enclosure process the tithes were changed to money payments which alone came to be worth £1048 a year. However, less than a month later the application was postponed. Possibly this was related to the reassurances demanded by the absentee lord of the manor of Bishop's Cleeve and Haymes, John Somerset Packington, Tory MP for Droitwich, who feared losing his few remaining rights, particularly the right to quarry stone on Cleeve Hill, and his insistence that Lord Ellenborough's manor of Southam was but a sub-manor of his own of Bishop's Cleeve. Ironically his manor was indistinguishable from a large farm, but Lord Ellenborough was attempting to run Southam manor as if it were still a medieval manor, with a manor court. Unfortunately there is no record of his lordship's

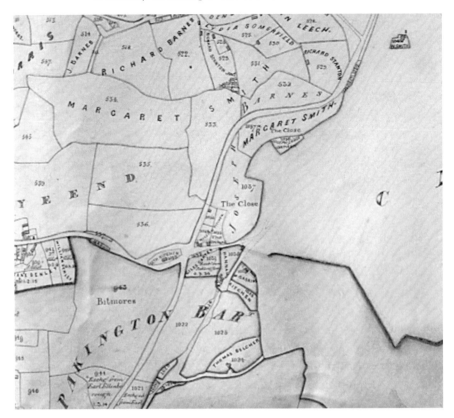

79 The 1847 Enclosure Map shows the boundary between Bishop's Cleeve and Southam with uncertainty as it reaches the common. It also shows the old route of the turnpike road as it comes from Southam before reaching the common. By 1847 it had already been narrowed by encroachments. (Gloucestershire Archives)

reaction. Perhaps the proposers also realised that a large number of people needed to be contacted before enclosure could go ahead, and so it was not until 6 January 1838 that we find 112 out of the 148 registered landowners had signed the agreement. Richard Hall of Cirencester was appointed as the enclosure commissioner to organise the changes. Messrs Griffiths and Pruen of Cheltenham acted as solicitors for the villagers; they both had property interests in Bishop's Cleeve.

All the freeholders had to submit a claim to land, not only so they would be awarded new plots to replace their scattered strips, but, more importantly, so they would maintain their right to put animals on Cleeve Common. The process was complicated because many owners lived outside the parish; the last claim came from a William Yeend who lived in Little Comberton near Pershore. Because the process took so long, it is impossible to work out when

80 Hay harvest: another of Pyne's scenes illustrating the need for many workers at such an important time

the new fields actually replaced the medieval strips. The first draft for the enclosure was completed by 1838 but the act of parliament was not passed until 1847. On 24 October 1840 Richard Hall put up a notice on the door of St Michael's stating that all common rights had been extinguished, i.e. the fields were no longer 'open', but in 1843 a small area of land which Lord Ellenborough sold to the Birmingham and Gloucester Railway Company for £23 still lay in strips. Enclosure cost £1226 3s 9d and although the rector and the two Lords of the Manor bore the brunt, no one escaped, as the costs fell proportional to the amount of land owned by each individual. In this way nearly 1000 years of communal farming ended quite suddenly in the 1840s.

THE REFORMATION

We must now retrace our steps in time. Enclosure brought fundamental change. The other great change is more difficult for the modern secular mind to grasp, for it is the impact of the religious Reformation in the mid sixteenth century. In the words of Eamon Duffy, one of its historians, it 'stripped away the familiar and beloved observances' that had given people in the Middle Ages comfort in this world and hope in the next. The Reformation, starting in the years of King Henry VIII and running into the reign of Queen Elizabeth I, moved people away from the 'superstitions' of traditional Catholic beliefs and practices, which emphasised the community of the church under the leadership of the priest, to the simpler faith of the reformed Church, which emphasised the individual's response to God for salvation in the life to come.

It also provides an early example where the people's way of life was affected by factors from outside the local community, especially from London – a theme which now becomes increasingly important.

There is plenty of evidence for traditional religious beliefs in the parish before the Reformation. When William Hobbs the elder of Southam made his will in 1542, he left money for the altars of Our Lady, All Saints, St Catherine and St Nicolas, all in the church of St Michael's. He also left £4 13s 4d for 'an honest priest' to sing mass for the souls of himself and his parents for a whole year. When Joanna Stevens of Woodmancote made her will three years later, she left 4d for the upkeep of each light (candle) before the altar, before the rood and in the porch. Yet only three years after this we know from an enquiry early in the reign of young King Edward VI that money to pay for these candles, a third of which came from rents paid for church lands (Widow's Acre and Rope Ground) was worth 9s 6d each year and had been converted 'within the last five years' into more practical help for the poor. William and Joanna must have seen the world was changing, but they stuck to the old ways. It was changing because in 1534 King Henry VIII had made himself supreme head of the church in England, replacing the Pope. In 1538, he instructed that every church should have a Bible in English, so all could understand the word of God for themselves. He also ordered a reduction in the number of saints' days and holy days and from 1549 the prayer book had to be in English.

Two years later John Hooper became the bishop of the new diocese of Gloucester, formed when the diocese of Worcester was split into two. His memorial stands outside the west gate of the cathedral precinct near where he was burnt at the stake in 1555. He was a committed reformer and so he instructed all his clergy to preach only from the Bible and to reject 'old Superstitions and Papisticall Doctrine', ridding the churches of 'images, relics, holy bread, candles, creeping to the cross'. He ordered all wooden screens in churches to be removed, leaving no dark corners where any forbidden ceremony could continue. St Michael's was suddenly taking on its present internal form, for we can assume there was wholehearted approval from the rector, Dr John Parkhurst, a reforming scholar of Oxford University. This is why only fragments of wall painting and a few pieces of stained glass survive (colour plates 16 and 21). In his first year Bishop John enquired into the state of the 311 parishes in his new diocese. He was horrified that only a quarter of the priests were 'fully competent'; ten did not even know the words of the Lord's Prayer and 30 did not know how it got its name, but John Parkhurst gained full marks, 'Mr John Parkhurst, rector, found very learned and answered learnedly to all the articles (questions)'. That is not to say, of course, he took a regular active part in church life. He was also chaplain to the Duke of Suffolk and rector of Pimperne in Dorset. No doubt he enjoyed his

vast income of around £500, but at least he had in place a curate, 'Sir' Symon Baker, who also answered competently, reciting the Ten Commandments 'fairly well' and knowing that the Lord's Prayer came from St Matthew's gospel chapter eleven. Stoke Orchard was recorded separately with its own minister, Thomas Dodimede, also being 'found learned and able to answer all the articles'. Bishop Hooper needed competent priests to convince doubting parishioners to accept the changes.

The reforms lasted until 1553 when Queen Mary, King Henry VIII's elder daughter by his first wife Catherine of Aragon, succeeded her sickly younger brother Edward to the throne. Mary was a traditional Catholic and immediately set about restoring the old ways. Churchwardens throughout the country were ordered to restore the traditional trappings of the church. We have no idea how far this happened in St Michael's, but the small amount of evidence suggests the rood screen, candles and altar movables were restored, but not the paintings, glass or the other wooden screens. John Parkhurst fled abroad. Yet in the first year of her reign Richard Smyth of Brockhampton started his will with the hope of salvation 'through the mercy of my Saviour'; a clear indication he had accepted the ideas of the Reformation. Four years later, in the last year of her reign, Alice Byglyn left a bushel of barley to pay for the rood and porch lights and Alice Greenway left 12d for the rood light. In 1559, even after Queen Elizabeth I had come to the throne, John Hobbs continued to act in a traditional way leaving 6d to the high altar and not to the poor as the bishop had requested. This suggests that some people had welcomed the return to the old ways.

When Queen Elizabeth I came to the throne in 1558 she brought back Protestant ways. The next year John Parkhurst returned as rector, 'Parkhurst is gone to his people at Cleeve, where he reigns like a king, and looks down on all bishops.' wrote one of his reforming friends. But this did not prevent his accepting the bishopric at Norwich in 1560, which he held with Cleeve until his death four years later. Just what his impact was on the parish is unknown, but a visitation in 1576 found the churchwardens had hidden away the altar cross, the censor (for incense), two bells, two candlesticks, the pix (to keep the sacrament), and the priest's vestments and capes – all trappings of the old religion, and that they had not displayed the Ten Commandments – a trapping of the new. They were obviously hedging their bets against further change. They were duly admonished and nothing more was heard. But by then the parishioners' memories of the old days were fading away, and their wills became pre-occupied with bequeathing their belongings to their next of kin, rather than leaving money to the church or even to the poor. So in a single lifetime, the old beliefs had been destroyed and religion had become more of a private matter between the individual and God, which reduced the ceremonies

of the church which had focused on the community worshipping together. It is difficult not to see this change as an important factor in the long-term decline of church attendance. However, St Michael's church with its wealthy, but often absentee rectors, its hard-working curates and its position at the centre of village life and administration continues to provide a strong theme of continuity in our story. In 1563 it was reported the nave was in decay and the absentee rector Richard Reeve, who was also the queen's chaplain, refused to find a curate, even though he was required to pay only £24 a year from his vast income. Then in 1696 the tower collapsed as we read in the previous chapter. It is true that by 1850 the church was in a poor physical state, but as a symbol of the community it provided an easily recognisable central place. It became important as the centre for the administration for the whole parish as the more important villagers meeting as 'the vestry' came to replace the bishop's manorial court, and the community now largely governed itself.

THE SELF-GOVERNING COMMUNITY

In 1561 Queen Elizabeth I took over the Bishop of Worcester's estates and over 600 years under the same landlord abruptly came to an end. Many such estates were broken up and manors granted by the Crown to men to whom it was, literally, indebted. Perhaps the best local example is the granting of Chipping Campden to Sir Baptist Hicks in 1606; it is said he had lent some £150,000 to King James I. In a similar way, Bishop's Cleeve and Woodmancote were granted to two Londoners, Sir Peter Vanlore and William Blake, in 1604. Sir Peter came from the Netherlands and had been royal jeweller to both Queen Elizabeth I and King James I. The grant was entirely to provide them with an asset which they soon began to strip, for example, William Fowler bought 43 acres (18ha) for £103 15s in 1616. Then in 1618 they sold the manor to the rising gent, Giles Broadway of Postlip, for £2700. He was keen to expand his local landholding, but again he did not keep the manor long, selling it to the rector Timothy Gates in 1624, as we have seen. It continued to pass from hand to hand until in 1735, when it was but 550 acres (229ha) with few rights, it came into the possession of William Strachan, originally of Nova Scotia, who had acquired the Haymes estate by marriage in 1719. His father-in-law, Thomas Gooding, a London lawyer, had bought it from Charles Loringe for £3300 in 1692. Thomas Loringe, the father of Charles, was killed fighting for King James II in Cirencester during the uncertainties of the Glorious Revolution in the struggle between Catholic and Protestant for the English throne in the late seventeenth century – a rare instance of a major national event affecting the locality. Another was the appearance of

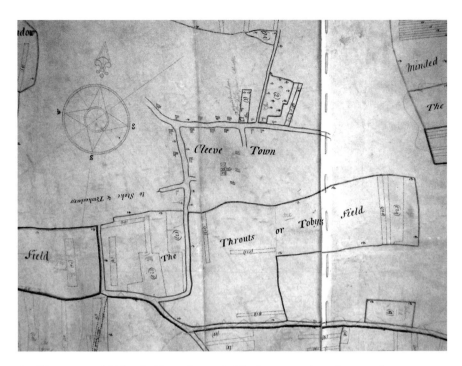

81 The centre of Bishop's Cleeve in 1778. The houses and roads are only impressions, but the church and open fields are clearly shown. Plot 1 is the Old Manor House belonging to William Strachan's combined Cleeve and Haymes estates, which by 1778 lay in the hands of Letitia Farmiloe. (Gloucestershire Archives)

82 Haymes House taken from an untraceable sketch of 1760 by Thomas Robbins. Today only a wing survives

a Roundhead army marching down Cleeve Hill into Prestbury on its way to relieve the siege of Gloucester in late summer 1643. In 1733 William Strachan rebuilt Haymes modelling it on Chesterfield House in Mayfair but he was later declared bankrupt, and the manors were sold to two Worcester businessmen John Thorniloe and William Lely in 1773 for £7000. In August Lely sold his share to Thorniloe for £3736 but the manor had become little more than a large farm with rights to quarrying on Cleeve Common.

The lack of real power of the lord of the manor can be judged when William Strachan needed permission from the vestry meeting to build a personal pew in St Michael's church in 1746. It was no modern pew, but a box 10ft x 6ft and 5ft 6in high (approx. 3m x 2m x 2m) situated in the centre of the nave. Another very good example to illustrate how the lord of the manor was little more than a name can be shown by returning to 'The Manor' in Woodmancote. In 1657 Charles Cocks bought the Sewells' freeholding for £600. Charles was the son of Peter Cocks, the rector of Bishop's Cleeve. He had fought for King Charles I in the Civil War and now moved to Woodmancote to establish another branch of the Cocks family. As there was a year between purchase and his moving in, it is reasonable to suppose Charles was responsible for the present building; certainly he was sufficiently pleased with his new house to have a large coat of arms carved in the panelling of his drawing room. It remained in the family until 1815 when the Lawrence family of Sevenhampton became the owners. By 1884 it was known as 'The Manor'. Although it was only a large tenanted farm, there was no powerful lord of the manor of Bishop's Cleeve and Woodmancote to stop the name being used. This could never have happened in neighbouring Southam where from 1609 to 1833 most of the land lay in the hands of the Delabere family of Southam House. Despite the magnificent tomb of Richard Delabere and his wife Margaret in St Michael's church, built in 1639 at a cost of £400, the family's influence never extended to Bishop's Cleeve or Woodmancote. However as resident lords and owners of nearly all the land, the Delaberes were able to control what happened in Southam, so it remained a small village under their thumb; a situation which Lord Ellenborough was only too pleased to continue after 1833.

In the absence of a traditional lord of the manor, it might be expected that the rector would have been the most influential individual, but the huge income from the rectory meant generally that the rectors continued to be absentees and the church was served by a succession of curates. As a result, the government of the villages lay in the hands firstly of the churchwardens and then from the early eighteenth century in the hands of a self-selecting vestry which described itself as the 'principal Inhabitants and Proprietors of the Township of Bishop's Cleeve'. Their main concerns consisted of the upkeep of the church and its services, the regulation of farming, the treatment

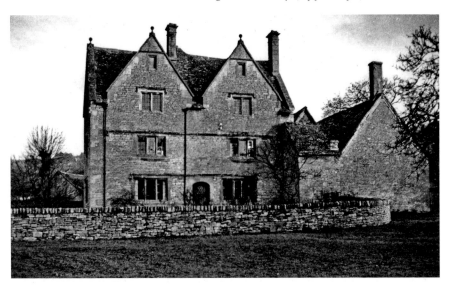

83 Woodmancote manor in the 1960s before Hillside Gardens blocked this view. This seventeenth-century part was built at right angles to the medieval building

of the poor, the upkeep of roads and the keeping of law and order. In Queen Elizabeth I's reign new laws began to instruct communities in how to deal with such community issues. By 1850 much of what the vestry did was in response to national government legislation, which meant control from outside the community had moved from bishop to monarch and Parliament. Many decisions of the vestry had to be ratified by a local Justice of the Peace who served as the key link between central and local government. Apart from the rector, none ever lived in Bishop's Cleeve or Woodmancote, but the Delaberes were never too far away, and it was but a manageable walk into Cheltenham or Winchcombe and so here was another reason why the local worthies enjoyed relative freedom in government. We can understand how this was done by investigating the surviving churchwardens' accounts, and the vestry minutes stretching back to 1694.

Occasionally we find references to the church itself. In 1755 the present porch room, then described as 'once the schoolroom', was fitted out as a meeting place for the vestry. In 1815 and 1836 workmen were paid to lime wash the church. In 1838 the old three-decker pulpit was sold for 10s 3d. In 1843 a new table was purchased for the porch room; it remains to this day. From the minutes we learn that the south aisle of St Michael's church was considered the Southam aisle, and the north aisle the Gotherington aisle. More interestingly, the church was responsible for the village fire engine, and we find that by 1850 the callout charge was £3, although it could only have had an effect if the fire was small.

As there were no substantial charities attached to St Michael's, much of the work of the churchwardens and vestry was taken up by dealing with the poor; a responsibility given to the parish in Queen Elizabeth I's time. Funds were raised from levies placed on the occupiers of property, and there was always the tension between keeping the levies low and providing adequately for the poor. Yet there seems to have been a real effort to meet individual needs, particularly of single mothers and the widowed. 'Agreed in vestry to allow Edeth Clements t(w)o Shifts and a Sheet and an Apron' (27 July 1766). In 1811 a Mr Hood was paid 7s 6d for vaccinating the local children against smallpox. There was tension, both nationally and locally, between buying garments, fuel, furniture and/or handing small sums of money to paupers to enable them to live at home, criticised for encouraging laziness, compared to having a poorhouse where people had to go to receive poor relief, 'ordered at this vestry that an Almshouse be erected where the late (one) stood' (14 May 1758). Perhaps this was the almshouse later knocked down in 1835 to allow easier access into Pecked Lane. Yet in 1759 12 paupers in their own homes were still receiving a weekly allowance of between 1s and 2s 6d. In March 1783, the overseers of the poor made an agreement with Winchcombe churchwardens to pay 30s a year and then 3s for each pauper sent to the Winchcombe poorhouse, but less than 20 years later, the vestry 'Agreed to purchase a house and ground for the use of the poor of Bishop's Cleeve and Woodmancote' for £200 (2 November 1801). In that year the cost of the poor had reached a record £360 – two years earlier it had been £108. Population everywhere was rising, but in rural places like Bishop's Cleeve and Woodmancote there was little alternative employment to agriculture, so unemployment and low wages added to the traditional demands on the Poor Law from the old, the sick and single mothers. The vestry considered that the solution was to provide for the poor in a parish poorhouse and pay John Phillips £180 a year to 'farm' the poor. This meant that he had to house, clothe, feed, find work for the inmates and make a living from that sum. When the number of paupers declined so did his fee so that four years later he was receiving annually £120. When the annual cost rose again to £362 in 1810 the payment system was changed and he received 4s per pauper per week. By 1815 costs had dropped and there were only seven paupers in the poorhouse for most were receiving relief in their own homes. Woodmancote had its own poorhouse by 1808, at the bottom of Gambles Lane, for in that year it was re-thatched at a cost of £2. In 1815 it had just three inmates.

Where a pauper could legally ask for poor relief had been fixed by law since 1662. A few documents survive in Gloucestershire Archives to show this system in action, but who knows what personal and family tragedies lie behind the bare statements given before a local JP? On 12 June 1756 Richard Harford,

84 Standing in Station Road, this was probably the poorhouse for Bishop's Cleeve and Woodmancote built in 1801

his wife Hannah and children, Richard (4) and Hannah (2) were ordered to be sent back to Dauntsey in Wiltshire – a very long walk. On 25 May 1765 Sarah Moseley was told she could only seek poor relief in Brockworth. She had been hired at the Cheltenham mop fair by Mr Charles Cocks, and now, no doubt, the contract had come to an end but she was still living in Bishop's Cleeve where she tried to get poor relief. On 13 November 1760, Thomas and Mary Page with their six children were sent from Woodmancote to Bishop's Cleeve to receive their poor relief.

So the poor were dealt with as members of the local community in ways guided by national legislation. Many people still lived in that cycle of family poverty which had changed little since the Middle Ages. By and large the members of the vestry successfully balanced humane treatment with keeping down the poor rates, remembering especially that they themselves were amongst those who paid the highest rates. Until 1836 there was little fundamental difference in the experiences of paupers compared to the poorer agricultural labourers, in fact, paupers were very often temporarily

85 Roadmending by W.H. Pyne

unemployed agricultural labourers. However in that year a brand new workhouse was opened in Winchcombe and the local poorhouses were sold to defray its costs. The Poor Law Amendment Act of 1834 was perhaps the first ever piece of legislation which tried to set up a national system and did not allow for local interpretation. To be a pauper was now to be stigmatised; life in the new workhouse was made so deliberately harsh that people would do anything to keep out of it, for the driving force behind the act was to reduce Poor Law expenditure and, therefore, the rates. Even so, we still find the overseers granting small sums of money to the 'deserving poor' – usually the aged. It still made good sense as it was much cheaper than sending them to the workhouse, and they also could retain some dignity. Yet the fear of poverty in old age, and especially a pauper's funeral, haunted the villagers. Not until 1908 was this fear largely removed by the introduction of an old age pension of 5s a week for a single person over 70 and 7s 6d for a couple.

Poor relief was the major concern of the vestry, but there were others. It gave to the local JP the names of men to serve as surveyors of highways to look after the local roads and bridges. From 1555 to 1835 every able-bodied man was supposed to work for four, and later six, days a year unpaid on the upkeep of the roads. The surveyor himself was not paid until 1838, so the job was not at all popular. Before the use of tarmac in the 1920s repairing the road meant filling potholes with stone. Most of it was rag stone from The Slades on Nottingham Hill. Seven hundred and forty-four tons were bought from the quarries there in 1836-37, compared to 13 tons from Cleeve Hill. The local

166

roads served local needs; turnpike roads served long distance travellers and the vestry was not prepared to subsidise the commercial trusts set up to maintain the turnpikes and make a profit from their tolls. Turnpike roads were driven through Bishop's Cleeve and Woodmancote because they lay near Cheltenham, which was developing rapidly as a spa after King George III's visit in 1788. Five years after the visit the road between Cheltenham and Winchcombe was turnpiked along the line of Ashleigh Lane, Spring Lane and across the common to Postlip. In 1823 part of it was lowered to the route of the modern road. Down in the vale, in 1810 the Cheltenham to Evesham turnpike road was built providing a much shorter route to Cheltenham compared to the old route from Bishop's Cleeve through Southam and Prestbury, which itself had only been turnpiked in the previous year. When the turnpike trustees approached the vestry in December 1837 about repairing the Evesham turnpike they received a frosty response, although the vestry did agree to repair the road where it ran through the village itself. A similar response met the request one year later from the Gloucester and Birmingham Railway Company to improve Stoke Road from the village to the proposed railway station halfway to Stoke Orchard. The vestry replied that the road was perfectly adequate for its usual purpose, implying it was the railway company's responsibility to improve it for the increased traffic it might generate. The vestry was no more enthusiastic in its support for the new station, 'It was agreed at a Vestry duly called (that it) do guarantee one quarter of an acre of land *and no more* (my italics) for the purpose of erecting a station' (7 February 1840). Such then was the local reception to the possibilities of joining the modern world with its improving communications, easier cheaper travel and cheaper carriage of all manner of goods. Apart from carrying goods and providing a telegram office, it seems the railway age passed Bishop's Cleeve and Woodmancote by; it was still as quick to walk to Cheltenham as to catch a train. Not all change had a great impact.

We have seen that when change came from outside, the vestry was sufficiently flexible to manage it. So far in our story the influence of the growing spa town of Cheltenham has hardly featured. It did not have a direct impact on the area until June 1818 when Cheltenham races arrived on West Down on Cleeve Hill. They were so successful that the Cheltenham Turf Club was set up to make it a permanent occasion. So who would defend the commoners with their ancient rights to pasture now being so clearly challenged? It was the vestry. From 1822 it demanded £30 annual rent from the stewards. The stewards were often in arrears, but the money came in very useful. It was used to subsidise the poor rates and pay a hayward £9 annually to keep the walls of Cleeve Common in good repair and impound the animals of 'strangers' put to graze on the common. The hayward continued to be an essential community figure

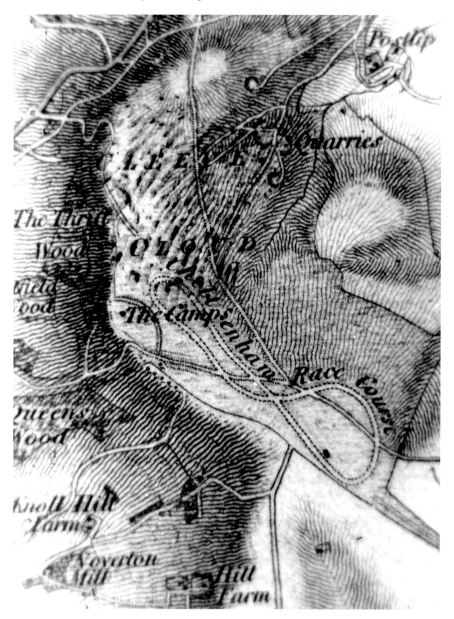

86 Cheltenham Racecourse laid out on Cleeve Common

throughout the nineteenth century, being funded from trainers' payments after the races ended in 1842. In this last year some of the money was used to repair St Michael's; horses on Cleeve Hill provided the vestry with useful supplementary income.

168

There is one final institution for which the vestry was responsible – the recommending annually to the local JP of the name of another unpaid office – the parish constable. This was an onerous unpopular job and not until 1662 were his expenses paid for by a parish rate. It was the constable's responsibility, for example, to ensure the removal orders on the poor were carried out. He also had to bring those accused of crimes to the local JPs, which meant a walk to Southam, Cheltenham or Winchcombe. More serious cases appeared at Gloucester in the Quarter Sessions. Thirteen cases involving people from Bishop's Cleeve and Woodmancote were handled by the Quarter Sessions between 1817 and 1843. They were all cases of petty theft derived from poverty: a pair of shoes, a dozen cakes, a bag of walnuts, a silk handkerchief, two scythes and a shirt. In 1836 William Turberfield, ten, and John Tarling, 11, were whipped for stealing a purse containing 10s. In 1843 the same John Tarling was sent to Northleach for 12 months for stealing a shirt. Was this the start of a life of crime? Nevertheless, the impression given is that the medieval pattern of communities living a reasonably law-abiding existence continued. Even when farming in the southern half of England was hit by the 'Captain Swing' riots in the 1830s, when farm labourers destroyed hay ricks and the newly introduced machinery which was threatening their livelihood, no outbreak was recorded in Bishop's Cleeve or Woodmancote.

It might seem strange to us that the acceptance of the decisions made by a few self-appointed men meeting as the vestry were never really challenged by those who were directly affected by their decisions. So who were these men who met several times a year in the church? Occasionally the minutes are signed by those who they might have considered their superiors and betters; William Strachan in the 1730s; Samuel Pickering (1778 to 1815) and his successor Robert Lawrence Townsend (1815-30) were both rectors who lived here and played a full part in community life. On one occasion, 30 September 1842, Lord Ellenborough attended a meeting called to start proceedings against the trainers of racehorses trespassing on Cleeve Common. Yet the main members were men from local families as the list from July 1822 indicates. The rector signed first. John Phillips is the person who ran the poorhouse. Of the remaining 14 names, seven were those of farmers; Taylor and Spencer seemed to have been of independent means; four were the names of craftsmen, one of whom, baker Richard Kearsey, left a widow who described herself as a landed proprietor. The Holders were father and son, and several were probably related; Thomas Ballinger had married an Ann Yeend. These and those like them were the men who made the decisions on behalf of the wider community.

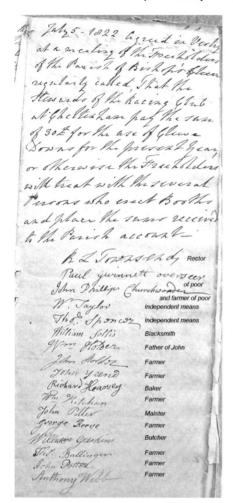

87 The vestry minutes of a meeting in 1822 with the members' occupations added. (Gloucestershire Archives)

SO WHAT MIGHT IT ALL MEAN?

We end this chapter at a time of considerable change. The Enclosure Act had brought a fundamental reshaping of the farming upon which the whole community still largely depended. A new railway station gave opportunity for greater contact with the outside world, although it remained little used for passengers. A new school also gave opportunity for the children to enter into a wider world opened by literacy, which had been denied their predecessors. In 1550 few people except the reforming rector John Parkhurst, Kennard Delabere at Southam and William Loringe at Haymes looked beyond the local communities. The vast majority of the villagers lived their lives through their own experiences, cut off by their illiteracy and relative immobility from the

wider world, unless it came to them, as in the Reformation or the Poor Law Amendment Act. By 1850 all were aware of this wider world, even though their experience of industrialisation might be second or third hand. They probably realised that they belonged to that older world with its roots in the distant past; their lives still governed by the round of the seasons and the weather. The differences between those who were comfortably off and those who were poor had become greater, but the former still had concerns for the latter. The status of women was still defined by the status of their husband, unless they were single or widowed, and there were very few job opportunities for them. Whether a landowner, farmer, shopkeeper, craftsman or the majority agricultural labourer, by 1850 the people of Bishop's Cleeve and Woodmancote still lived lives which had more common features than differences. To examine the community more closely we can now turn to our second snapshot, provided by the 1851 census.

SOURCES AND FURTHER READING

The main sources for this chapter start with the key book to show the use of parish registers, Peter Laslett: *The World We Have Lost – further explored* (Oxford 2005). Eamon Duffy's book on the Reformation is *The Stripping of the Altars: Traditional Religion in England, 1400-1580* (Yale 1994). A copy of Caroline Litzenburger's invaluable D.Phil. dissertation: *Responses of the laity to changes in official religious policy in Gloucestershire (1545-1580)* (1993) can be found in Gloucestershire Archives. William Marshall's survey is: *The Rural Economy of Gloucestershire* Vol. I (Gloucester 1796 reprinted 1979). Joan Thirsk's interesting article on tobacco farming is *Projects for Gentlemen, Jobs for the Poor: Mutual Aid in the Vale of Tewkesbury 1600-1630* in P. McGrath and J. Cannon (eds.) Essays in Bristol and Gloucestershire History (Bristol 1976). Chapters 16 and 17 in Hugh Denham's book describes many of Woodmancote's historic houses, some of which we visited together.

Gloucestershire Archives hold nearly all the original documents used in this chapter. Bishop's Cleeve parish records are indexed as P46. I am very grateful to Eunice Powell for making her transcripts of the parish registers available to me. The records of the manor are indexed under D127; D2025 Box 30 contains papers of Lord Ellenborough; D2216 Box 21 contains the records of enclosure. There is a printed list of wills and inventories *Wills proved in Gloucestershire Peculiar Courts* available in the search room. A measure of the status of the rector was that he was able to prove local wills in a *peculiar court*; they did not have to go to the bishop's court in Gloucester. Finally the *Hockaday Abstracts* volumes for the parish of Bishop's Cleeve have continued to provide copies of sources found elsewhere.

6

SNAPSHOT TWO: 1851

As early as possible on the morning of Monday the 31st March 1851 the Enumerator should commence his labours, having provided himself with a pencil or pen and ink – blotting paper – a portfolio or piece of strong paper, in which to carry the Householders' schedules and these Instructions.
Instructions to Enumerators 1851 census

COUNTING THE PEOPLE

Early on the morning of Monday 31 March 1851 a lone figure could be seen carrying a leather case, making his way up Bushcombe Lane to the farthest part of the township – Providence Place towards the end of Butts Lane, which is now in Woodmancote, where he knocked on the door of George Sheppard. Benjamin Slack was on an important mission to collect the forms he had left the previous week with every household in Bishop's Cleeve, because he was the local enumerator for the national census of 1851. It counted every person who had spent the previous night somewhere in the United Kingdom. He was prepared with his pen and pencil to fill in the forms when the labourers found them too difficult. We don't know how long it took to visit the 192 households but back home he had to make a fair copy of each form into his book, which he then took to the district registrar in Winchcombe. His fair copy survives today to provide the historian with a detailed snapshot of Bishop's Cleeve in 1851.

The first census was taken in 1801 during the Napoleonic Wars, at a time when the government was worried that the population was increasing too quickly for available food supplies. Since then it has been taken every ten years except 1941. Benjamin Slack had been born in London but had moved to Cheltenham where he worked as a confectioner. He came to

Bishop's Cleeve in 1831 when he married Ann Kitchin of Woodmancote and acquired property from her. By 1845 they were living in a house which stood at the northern end of Tobyfield Road. Benjamin owned five cottages which provided him with an income of £75 a year and ten acres of land including the field through which Tobyfield Road was cut a century later. In the 1841 census he described himself as a registrar, aged 40, with a wife Ann (35), and daughters Ann (8) and Elizabeth (3). When his son Benjamin William was baptised in 1843, Benjamin described himself as a farmer. It is doubtful that he ever farmed as such, relying on his land rents and income as registrar, for in the 1861 census he described himself as 'landed proprietor'; a clear case of upward social mobility, at least in his own eyes. When he died in 1885 he was buried in Cheltenham cemetery, although Benjamin William was buried in Bishop's Cleeve; his headstone recording he died in 1925 at the age of 83. It was ironical that almost the first person Benjamin visited was George Sheppard, nurseryman and assistant overseer of the poor, for George had the responsibility of carrying out the census in Woodmancote. The census tells us that in 1851 he was aged 35, unmarried with a single female servant. Later censuses inform us that he became a farmer of 22 acres (10ha) and married late in life becoming a father at the age of 55. We have to be grateful to George and Benjamin for carrying out their work so carefully.

The 1851 census followed not long after the 1847 Enclosure Act with its detailed map. By adding in the evidence from other sources such as the vestry minutes and churchwardens' accounts, we can build up a good picture of Bishop's Cleeve and Woodmancote in the early part of Queen Victoria's reign. And we mustn't forget that the gravestones in St Michael's churchyard now begin to record the people who enter our story providing another valuable resource.

The census confirms that Bishop's Cleeve and Woodmancote were still rural communities depending upon agriculture. Along the road Cheltenham had now become a thriving spa town of over 35,000 inhabitants but its impact on our two villages was quite limited. In England and Wales the population had reached seventeen million and for the first time in history more than half of the population lived in towns and cities rather than the countryside. Bishop's Cleeve and Woodmancote were now part of a rural minority which was becoming increasingly untypical of the average British experience. In 1851, according to the census, there were 745 people living in 192 households in Bishop's Cleeve and 424 people in 99 households in Woodmancote, but we must remember the boundaries between the two were by no means as clear-cut as they are today. The graphs show the age-sex structure of the two communities. Both show large numbers of children and fewer older people, although there were some very old people. In Woodmancote two females were

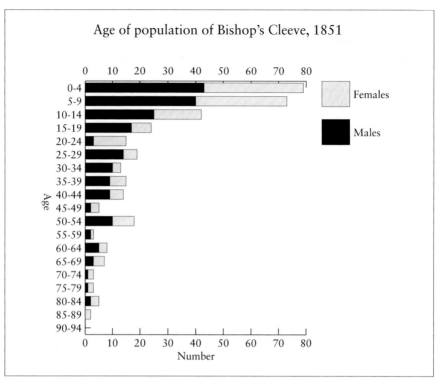

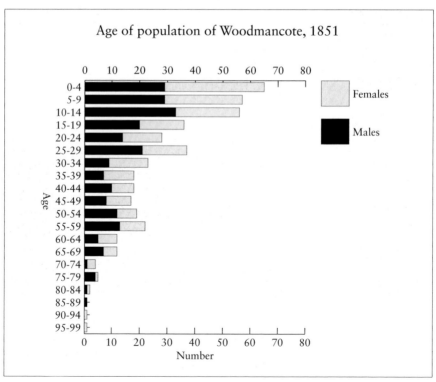

over 90, if they had remembered their age correctly, for civil registration of births had only been introduced in 1837. However, more striking is the number of children. In Woodmancote 40 per cent and in Bishop's Cleeve 26 per cent of the population were under 15. Children would have been everywhere and not all would have been in school. Although the shape of the graph reflects a pre-industrial society, it is not a smooth shape. In Bishop's Cleeve there are few females aged 14-19, possibly due to these having moved to Cheltenham as domestic servants. Similarly, males 20-24 also seem to have moved away for work, which we might expect, as they were very mobile. In Woodmancote, the profile is smoother, but there is no obvious reason why so many males 10-14 were recorded; and to a lesser extent, males 25-29.

EARNING A LIVING

When we turn to the occupational structure we need to be aware that the occupation given was not necessarily that person's only occupation; it might be part-time and/or seasonal. Most females lacked any stated occupation, but this did not mean that they did not contribute to the household economy as

88 Isaac Courtier (51), a shepherd, was living in Littlecroft at the time of the census with his wife Sarah (52) and son William (25), an agricultural labourer, and daughter Charlotte (13) a scholar. Tobyfield Lane is a remnant of the road south out of the village centre which was blocked at enclosure

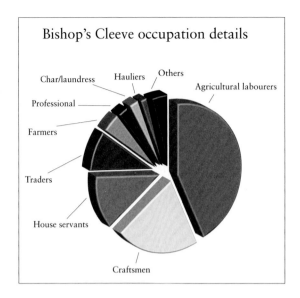

Bishop's Cleeve occupation details

Char/laundress — Hauliers — Others — Agricultural labourers — Professional — Farmers — Traders — House servants — Craftsmen

they had done for 1000 years, by selling produce (eggs, vegetables, butter and cheese), picking stones out of fields, gleaning after harvest, childminding, taking in washing, as well as ensuring their family was fed, clothed and housed as comfortably as possible. There was a slightly higher percentage of employed people in Bishop's Cleeve (41 per cent of the total population) compared to Woodmancote (34 per cent), but Woodmancote had a relatively larger number of children overall. There were 101 scholars in Bishop's Cleeve and 50 in Woodmancote, ranging in age from three to 14. It seems only day scholars were recorded, but we don't know how regularly they attended school for census day on 31 March came at a slack time in the farming year. Of all the scholars, only 26 were aged over ten, so most school children were aged between six and ten. The older schoolchildren tended to be from the families of farmers, craftsmen and tradesmen, with only a sprinkling of children of agricultural labourers because they were more useful contributing to the family's income.

There were 16 people of private means living in Bishop's Cleeve and six living in Woodmancote. These were 'the quality' who lived off investments, pensions and property. At the other end of the social spectrum came the paupers; people in receipt of poor relief, organised from the workhouse in Winchcombe since 1836. There were 16 paupers in Bishop's Cleeve, nine were or had been agricultural labourers and seven were widows, extremely typical circumstances. In Woodmancote, there were eight paupers, five of whom were over 60 years of age and so likely to be too old for a labouring life. We know from other sources that a self-help Friendly Society operated out of The Farmer's Arms from at least 1833-55. Some people were trying to help themselves to keep out of poverty, but we don't know who the members were.

The graphs of occupations help us to understand how Bishop's Cleeve and Woodmancote had continued to grow apart. By 1851 there was a much more varied social and economic structure in Bishop's Cleeve. In the figures the occupations have been arranged in the same order to make this point clear. 61 per cent of Woodmancote's employed population (95) worked as

agricultural labourers, but only 44 per cent (136) in Bishop's Cleeve. These figures include eight farm servants who lived in with the farmer's family, which by this time was most unusual and a relic of older farming practices. Significantly, the census also tells us that there were only 22 labouring jobs on farms available in the two villages, in theory leaving 201 having to look for work elsewhere. In this

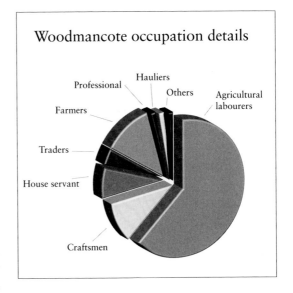

respect, the two villages were hopelessly overpopulated – a typical situation in rural England, for although farming still largely depended on muscles rather than machines, there was a limit to the number of jobs, even after the farming improvements brought by enclosure. One of the problems was that the farms were so small. The national average farm size was 111 acres (46ha), but in Bishop's Cleeve only two farms were over 100 acres (42ha) and five of the remaining 11 were under 15 acres (6ha). The average size was 58 acres (24ha). There were 17 farms in Woodmancote, the average size was 29 acres (12ha) but ten farms were smaller than 20 acres (8ha), so these were all family farms where sons (and daughters) were enough for the demands. Fortunately for the surplus labourers however, next door in Southam there was a great shortage of labour. Here land was almost wholly in the possession of Lord Ellenborough with ten large tenant farms, eight of which were over 200 acres (83ha) in size. These included Elizabeth Woodward with 330 acres (138ha) at Wingmore Farm; Eliza Roberts with 200 acres (83ha) at Manor Farm (both widows) and William Holder at Haymes with 260 acres (108ha). There were only 19 agricultural labourers living in Southam, but there was employment for 95. Even so, many agricultural labourers from Bishop's Cleeve and Woodmancote must have gone further afield; some walking to Cheltenham to be employed as general labourers in the town.

Craftsmen and women formed the next largest occupation group in Bishop's Cleeve. They totalled 65 including the nine females who worked as dressmakers and in other needlework, possibly as out-workers for the shops in Cheltenham. There were only 15 craftsmen in Woodmancote, and this is another measure of how different the two communities had become; Woodmancote was now

89 The windmill at Southam sketched on a map of 1831. (Gloucestershire Archives)

dependent upon Bishop's Cleeve for many of its services. For example, there were no carpenters in Woodmancote, but 13 in Bishop's Cleeve. Woodmancote did have five shoemakers; but there were ten in Bishop's Cleeve, where there were also six tailors and six stonemasons, compared to just four stonemasons in Woodmancote. No doubt they all worked the local stone from Cleeve Hill. Slaney's brickworks in Stoke Road employed four men and one foreman. Bishop's Cleeve had all four blacksmiths and five bakers in two businesses compared to Woodmancote's one. By 1851, it was unlikely the windmill in Southam Field and the two mills in Stockwell Lane were still in use, for none of the Barnes family who had traditionally run the mills, described himself as miller, so the flour must have been brought in from Cheltenham, Tewkesbury or Winchcombe. Four laundresses and three charwomen were the only other occupations employing three or more people in Bishop's Cleeve. There were none of these in Woodmancote.

With its more varied social structure, it is not therefore surprising that after the craftsmen and women the next largest occupational group in Bishop's Cleeve were the domestic servants; 39 were recorded compared to 11 in Woodmancote. Many of these were day servants, especially children living at home with their families, but who worked in other households during the day. There were many single overworked and under-rewarded general family servants in the households of the farmers, craftsmen and traders. However, in one place in Bishop's Cleeve, the hierarchy of domestic servants could clearly be seen. At the rectory lived Henry Palmer, the 39-year-old curate, with Louisa his wife, and Henry and Frederick, their sons. They employed a

butler, cook, housemaid and two house servants. The butler Henry Pockett lived nearby with wife Hannah and five children. Only Septimus Pruen at The Cleevelands, solicitor for the Enclosure Act and county coroner, had a household to compete in any way with that of the rectory. Living with his wife Louisa, son Frederick, mother Susanna and brother William, were three general servants. Septimus probably enjoys a minor claim to fame in being the first person we can positively identify who chose to live in Bishop's Cleeve, but did not work there. Today, of course, this is the norm. His solicitor's practice was in Cheltenham but he chose to live in this convenient village. Yet the domestic staff in both these households seemed small fry in comparison to Southam House. Here could be found the household of Edward Law, Lord Ellenborough, described in the census as widower aged 60 and a peer, born in London. His staff comprised two butlers, a porter, helper and groom, then a laundry maid, kitchen maid and three housemaids, but strangely no cook was recorded. Nearby could be found three gardeners and the family of one of the butlers. So too could be found Hebe Coleman, described as living on a private income, with her four-year-old daughter Ida Villars, described in the census as 'daughter of the Earl of Ellenborough' and provided with two servants. Interestingly, in his will three years later, he did give Ida's surname as Law, by which time she had a younger sister Eva.

The girls from the houses of the poor could experience the lifestyle of the rich through their domestic service. Nevertheless, the gap between rich and poor was there for all to see. Yet what their seventeenth-century ancestors had called 'the middling sort' were increasing in number, especially in Bishop's Cleeve. Next after the servants in number came the traders. There were 24 in Bishop's Cleeve and six in Woodmancote. Five from Bishop's Cleeve were market women who would have taken the villagers' produce to the local markets, particularly Cheltenham's Thursday market. Six were involved in selling beer; Ann Little kept the King's Head with her brother Thomas brewing the beer; Robert Beech kept the Crown and Harp; William Wood Teal, The Plough by the Old Manor House; William Taylor sold beer at what is now Anchor Cottage on the Evesham Road; William Mills kept the Butchers' Arms (now lost, but possibly near the war memorial) and William Cole kept a beer house somewhere near the chestnut tree at the end of School Road. George Bowles sold cider near St Michael's from a house now demolished. In Woodmancote James Morris sold beer at Hyatt's Mead at the top of Pecked Lane, Isaac Simmons ran The Rising Sun and John Little also sold beer somewhere on Cleeve Hill. The beer houses were enough to keep a cooper busy making barrels in both Bishop's Cleeve (Henry Minett) and Woodmancote (George Etheridge at The Green). Bishop's Cleeve had four butchers and three grocers, whilst Woodmancote had one of each. Bishop's

90 Cleevelands House as it must have looked when home to Septimus Pruen and family. Today it is Cleeveway Manor

Cleeve alone had two thatchers and a number of single examples, including a milkman, cow dealer, a brick layer and coal merchant, the latter no doubt profiting from the arrival of the railway in Stoke Road. Opposite Cheapside in their purpose-built police station (now 40 Church Road), John Humphries and George Cook would hardly have been considered professionals, but as representatives of the newly-created Gloucestershire Constabulary, they were examples of a newly emerging (lower) middle class (*colour plate 22*). So too were Henry and Elizabeth Green, husband and wife, the resident teachers at the nearby National School.

To summarise this survey of society in the two villages, it is clear the villagers of Woodmancote must have looked to Bishop's Cleeve for many of their needs. Bishop's Cleeve was not only larger than Woodmancote, but it had a much more varied social structure. People's personal experiences were increasingly differentiated. Both villages had their farms, but most labourers walked to work elsewhere; both villages were able to provide some education for their children. For the basic needs of groceries, bread, meat, shoes and beer, Woodmancote was largely self-sufficient, but if the people needed a carpenter or blacksmith, a thatcher or even coal for their fire, then Bishop's Cleeve was their nearest source, but we mustn't forget that part of Woodmancote extended nearly as far as the Cheltenham Road so many lived as part of the community of Bishop's Cleeve. As noted, Cheltenham seems to have had little obvious impact on the villages, perhaps providing opportunities for domestic

service for the girls, a market for the produce of the gardens and orchards, and jobs for the labourers. Yet if the people of Bishop's Cleeve and Woodmancote needed a doctor, dentist or even the post office, then a trip to Cheltenham (or Winchcombe or Tewkesbury) was necessary. It would still have taken half a day to walk there and back.

INVESTIGATING FAMILIES

One of the great frustrations of the census is that in only a handful of cases does it give an address. Maps of 1839 and 1847 help, but most labouring families rented their property and so were very mobile. Of the 68 houses paying poor rates in Woodmancote, 35 were rented. At nearby Gotherington we know that half the population moved between the 1841 and 1851 censuses. In general, the craftsmen and tradesmen and tradeswomen lived around the central core in Bishop's Cleeve and the labourers farther out in those cottages, described in the last chapter, which were already over 200 years old and had changed little – wells and earth closets providing water and sanitation. Floors were often still a mixture of mud and animal blood, beaten hard; walls were lime washed; furniture would still have been familiar to Richard Hobbs in 1691. In Woodmancote cottages and small farms mingled with each other around The Green and along the three lanes running up the scarp recorded in the census

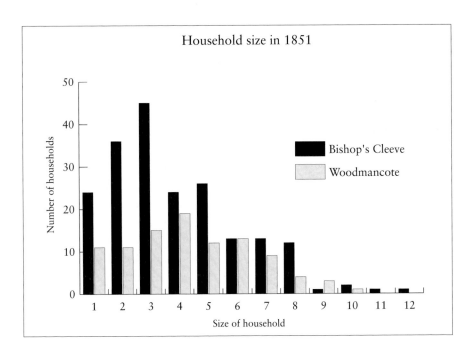

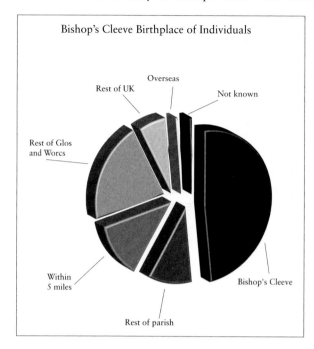

Bishop's Cleeve Birthplace of Individuals

Overseas
Rest of UK
Not known
Rest of Glos and Worcs
Within 5 miles
Rest of parish
Bishop's Cleeve

as North, Middle and South Streets. In Bishop's Cleeve, John Holder farmed 160 acres (67ha) from Old Farm, the Yardingtons' former holding; William Taylor farmed at Cleevelands Farm, and John Minett farmed from what is now the Old Manor House. Richard Rayer farmed for the rector at Gotherington Fields. In Woodmancote, Neighbour Hobbs farmed 60 acres (25ha) at Home Farm; William Potter farmed 27 acres (11ha) at King's Farm at The Green; Richard Stanton lived at Longwood Farm and John Leech at Box Farm. The buying and selling of land during the previous 500 or so years, had allowed farms to develop in different ways, from large farms to very small plots, often owned by people outside the parish who wanted the right to put their animals on Cleeve Common. As we have seen the large number of landowners was probably a reason why enclosure took place as late as 1847.

One of the recurring themes in our story has been to investigate popular myths about the past. The 1851 census helps us to put several more myths under the spotlight. The first is that very young children were put to work in the fields – but the youngest agricultural labourer recorded in the census in Bishop's Cleeve or Woodmancote was nine years old. This was Arthur Chew, who lived with his widowed father and three older siblings opposite the end of Gotherington Lane. Most children were either described as scholars or just 'at home'. We have already seen how there just wasn't enough work available for the adult agricultural labourers, so there was no need for young children to work except, perhaps, at harvest time. The second myth is that families were large in Victorian England. The census counted households, so that on the one hand, servants were included and on the other, there were a few houses, where it seems the one family had been divided into two households. The size of households is shown in the graphs. The average size in Bishop's Cleeve was 3.9 and in Woodmancote 4.3. In Bishop's Cleeve, only 22 per cent of the

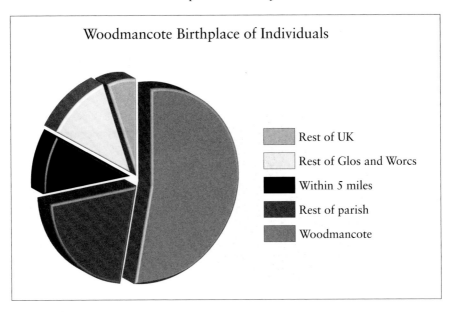

Woodmancote Birthplace of Individuals

Rest of UK
Rest of Glos and Worcs
Within 5 miles
Rest of parish
Woodmancote

192 households were larger than five; in Woodmancote, 30 per cent of the 99 households were larger than five. Of course the census is only a snapshot and families grew and shrank over time, but William and Maria Taylor, living in Cheapside with nine children and a grandchild were exceptional not only for the size of their family but also because William was receiving poor relief at the relatively young age of 51.

A third myth emerged in the 1980s when 'Victorian values' became a popular catch phrase. One of these values concerned families taking responsibility for elderly parents. As we might expect, the 1851 census provides evidence which is largely at odds with this perception. Just seven households in Bishop's Cleeve stretched across three generations with the son/daughter of the elderly relative (four mothers-in-law and three fathers-in-law), apparently caring for them; in Woodmancote, there were six (two mothers-in-law, two fathers-in-law, one father and one mother). Yet there were nine three-generation families in Woodmancote where an elderly parent was considered the head, typically looking after a single female child and grandchild(ren). There were six such households in Bishop's Cleeve but there were six individuals over 65 living alone in Bishop's Cleeve and two in Woodmancote. In 1851, the elderly were much more likely to be living alone or looking after grandchildren than being cared for by their own children, and three-generation families were very much the exception.

Finally, we can now consider where the inhabitants of Bishop's Cleeve and Woodmancote had been born. Another myth which has already been

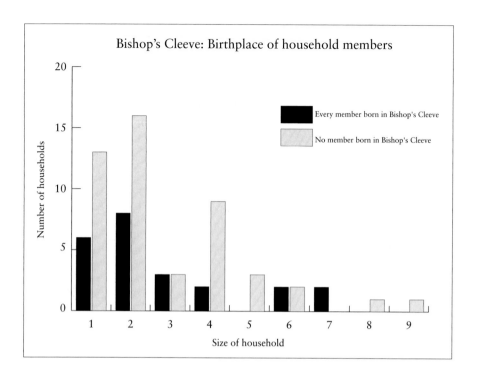

considered is that people in rural England before modern times did not move far from their birthplace. Certainly 59 per cent of the people in Bishop's Cleeve and 70 per cent in Woodmancote had been born in the parish of Bishop's Cleeve. If this is extended to a five-mile radius, we reach 72 per cent and 85 per cent respectively, which broadly confirms the conclusion drawn from the parish registers in the previous chapter. That Woodmancote's population was more locally based reflects its lack of craftsmen, tradesmen, professional and people of independent means who were the most widely travelled. For example, in Bishop's Cleeve, four out of the six beerhouse/innkeepers had been born elsewhere, as was Isaac Simmons, mine host at the Rising Sun, who had been born in Stanway. 'The quality' had generally been born a very long way away. Curate Henry Palmer had been born in Jamaica; Henry Moller, the second curate, in Paris; Septimus Pruen and his brother William in India, and their mother Susanna in London. On the other hand, it would be a mistake to think all the agricultural labouring families had lived their lives in a very limited area: John and Mary Davis had six children under ten and were probably living in Priory Lane. John (37) came from Gotherington and Mary (29) from Guiting Power. Their oldest child, Emma (9) had been born in Gorton, Manchester; their next, Sarah (8), in Hawkesbury Upton, near Wotton under Edge. They had then come to Bishop's Cleeve where their

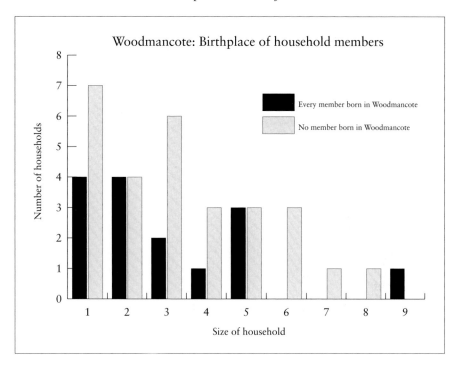

four remaining children had been born. This was perhaps exceptional, but there were many couples like William and Sofia Greening aged 62 and 58 respectively. William came from Winchcombe and Sofia came from Staverton. Their three oldest children still at home had been born in Bishop's Cleeve and the three youngest children in Woodmancote, where the family was living in 1851.

The graphs identify those households where all were born in Bishop's Cleeve or Woodmancote and then compares them to those where none was born there. One-person households are not significant in this conclusion, but in almost every other category, households where none of the household members was born in the village where they were recorded in 1851 either outnumber or are at least equal to those where every member was living in the village of their birth. The household of nine 'stayers' was that of George Etheridge, the Woodmancote cooper. The single household of eight 'movers' was the Ninds who in the last two years had moved from Gotherington. In Bishop's Cleeve, the Palmers and Pruens unsurprisingly formed the eight- and nine-person households of 'foreign' born people. Although other examples could be given, the main outline of the villagers' mobility is clear to see. People moved around, perhaps not very far, but they were relatively mobile; a key factor must have been that most rented their homes, and so it was comparatively easy to move on.

91 The Slades quarry today. This was the main source of road stone for the parish before the development of modern surfaces from the 1920s

So the census provides us with a snapshot of 1851, but it leaves us with a mystery. Neither Benjamin Slack nor his family is listed in the returns; neither are they listed in any of the surrounding parishes. As the enumerator was required to start off early in the morning, he must have been living locally. We know his permanent home was in Bishop's Cleeve. Perhaps he just missed himself and his family off the returns; perhaps we will never know!

THE SELF-GOVERNING COMMUNITY

So what else was happening in 1851? The weather was kind to farming that year. It started mild and wet but turned dry in May, and this was followed by a very hot June. The autumn was relatively dry, suiting the harvest, which was later than usual but better than average. There were no crises. The vestry for Bishop's Cleeve met in St Michael's eight times during the year. Business was mundane, raising a rate for the highways and the church, nominating four parish constables to work alongside the county constabulary. One of their concerns was to keep the roads in good repair and so they fixed haulage rates

for stone from the hill and gravel from Bredon. Neighbour Hobbs at Home Farm was allowed £9 10s to repair Stockwell Lane with 300 tons of stone brought from his quarries at The Slades on Nottingham Hill. All was to be paid for from the licences for horse training on Cleeve Common. Overall five and a half miles of local roads were repaired by labourers paid 1s or 1s 2d a day. In December William Taylor of Cleevelands Farm agreed to employ all the able-bodied paupers at wages fixed by himself; no doubt a mutually convenient arrangement giving employment to the needy in the slack of the farming year, but also financially advantageous to William, who happened to be one of the two overseers of the poor; the fewer the paupers overall, the lower his rate would be for the Poor Law. At the last vestry meeting for the year on 19 December a touch of daily reality shines through the bare recording of the meeting, for the vestry ordered that everyone with 'soil or manure or any other Nuisance on the Public Highways of the said township to remove the same within 14 days'. The problem was not of the scale of that in industrial areas, but too many people in Bishop's Cleeve were dumping their human waste, euphemistically called 'night soil', in heaps on the streets.

The Woodmancote vestry met five times in St Michael's to consider much the same business. The churchwardens' responsibilities had shrunk considerably, from the more general aspects of community life in the seventeenth century, to those more directly concerning St Michael's. William Tarling, son of James Tarling, the parish clerk, was paid 10s 'for keeping order at church'. William Cosher was paid £11 for whitewashing and colouring the inside of the church. Bread and wine, a set of bell ropes and the washing of surplices were continuing expenses. So too were the payments of five shillings for keeping the parish fire engine in good repair and for ringing the bells on the fifth of November, keeping a custom which went back as far as the Gunpowder Plot of 1605. Such anti-Catholic prejudices continued for another nine years.

A further continuing link with the past was that Bishop's Cleeve and Woodmancote were largely law-abiding communities, according to recorded crime details. During the year four men from Bishop's Cleeve and Woodmancote found themselves before the Quarter Sessions in Gloucester. George Sandford (18) from Woodmancote was sentenced in February to one month's hard labour in Northleach house of correction for stealing clothing from a Henry Taylor whilst working in Cheltenham. This obviously did not have much effect for in May he was remanded for reports when again in court for breaking into a house in the Bath Road. In August Daniel Page (37) was also sentenced to Northleach for a month for stealing a scythe and handle, again whilst working in Cheltenham. When Joseph (22) and Thomas (21) Turberfield were accused in December of violent assault and stealing four half crowns from George Windows, a 55-year-old agricultural labourer in

Woodmancote, they were acquitted. No doubt there is quite a story behind this official court record. Two local men sentenced to Northleach, and just one recorded (non-)crime in Bishop's Cleeve and Woodmancote does not suggest the communities were any less law-abiding than they had been in the past.

THE PLACE OF RELIGION

We must now come almost full circle to return to the census of 1851 and to a unique part of it. Sunday 30 March was Mothering Sunday. On that day Benjamin Slack and George Sheppard had an additional duty – to collect returns from every place of worship in their township. These returns survive and give historians the only nationwide snapshot at any time in the country's history of attendance at places of worship. There were three places of worship in the two villages; St Michael's Church, and two chapels, one at the end of Chapel Lane in Woodmancote and one in Bishop's Cleeve in Pecked Lane; now St Ann's. Henry Palmer, the curate, completed the forms for St Michael's and a Mr James Downing from Cheltenham completed the chapel returns. Historians are generally agreed they provide a reasonably accurate picture of religious attendance, although Henry Palmer's addition of 'bad weather' suggests he felt the congregation was smaller than usual. The overall national figures shocked the nation and the local results were even worse; attendance at a place of worship was clearly a minority occupation. St Michael's had seats for 350 people, but only 100 of these were free, i.e. not rented to local landowners. The attendance at morning service was 143 and in the afternoon 201. Henry Palmer thought the averages for the last 12 months were 140 and 250 respectively. Unfortunately, the census can't tell us how many individuals attended; it only counted attendances at each service, so some people were counted twice, or even three times if they attended throughout the day. Trying to calculate the number of individuals concerned people at the time and so Horace Mann, the government statistician, worked out a formula based on adding to the numbers at the best attended service half the number at the next service and a third of the number if there was a third service. Historians are generally happy to accept this formula. For St Michael's, this gave a figure of 273. Horace Mann also calculated that 30 per cent of the population was probably unable to go to any service, being too old or young or ill, or caring for such people. By this calculation, 52 per cent of Bishop's Cleeve's eligible population attended St Michael's. However, as it was the only Anglican place of worship for the parish, which included Woodmancote, Southam and Gotherington, the congregation represented only 21 per cent of that larger population. At best it was only a little over half full, and this in a rural area

92 St Ann's is the former Bishop's Cleeve Independent chapel

where churchgoing was thought to be at its strongest. Nationally it was calculated that 30 per cent of those able to attend church went to an Anglican place of worship. The 21 per cent in Bishop's Cleeve was far below this national figure. Henry Palmer was probably more content with attendance at Stoke Orchard, where 77 attended the only service of the day in the morning, indicating almost 50 per cent of those able to attend did so and the church was three-quarter's full.

The Independent chapels in Bishop's Cleeve and Woodmancote were smaller than St Michael's. The chapel in Bishop's Cleeve could seat 250, and that in Woodmancote 100. In both chapels all the seats were free for anyone to occupy. Woodmancote chapel had been built in 1825, and that in Bishop's Cleeve in 1844. Chapelgoers preferred to worship simply and did not agree with the privileges of the Anglican established church, such as paying tithes, although these were changed to a simple money payment in 1839. In Woodmancote there were three services on that Sunday. Horace Mann would have calculated that 118 different people had attended. Bishop's Cleeve chapel also had three services which gives a figure of 102. If we add together all these estimates and include another estimate of 124 from the chapel at Gotherington, we can work out that 46 per cent of the eligible population of the parish might have attended one of the four places of worship on 30 March 1851, in the ratio 55:45 church and chapel. Of course we don't know whether a few people

93 William Lawrence Townsend, the often-absentee rector 1830-1883. (E. Powell)

might have gone to both church and chapel, or how many travelled outside the parish to worship. We also don't know if any worshipped less formally. In 1841 Thomas Staite, shoemaker, gained a licence for a Methodist meeting in his house near the James Browning memorial chestnut tree in Station Road. He was still living there in 1851, but we have no details whether meetings were still taking place.

This evidence suggests that villagers might still use the church for their baptisms, weddings and burials, but weekly churchgoing was not part of their life. Although far fewer people went to church nationally than had been imagined, the failure of St Michael's to attract the population at large was seen locally to be the fault of the rector, William Lawrence Townsend. From 1844 to 1875 he had annual permission from the bishop to live outside his parish because of ill-health; he was recorded living with his wife and four servants in Lansdown in Cheltenham in the 1881 census, two years before he officially retired. In 1851 there was an ongoing feud between him and Lord Ellenborough. In 1838, his Lordship had been behind an enquiry into the state of the parish but although it had absolved the rector, his Lordship did not rest. In January 1839 he wrote directly to the rector, accusing him of putting 'the cold office of Divine Service' before the proper duties of visiting the poor of his parish. He continued accusing the rector of spending too much time looking after his farm and that he ought to appoint a second curate for his income was

five times the average for a clergyman. At this time the curate's annual salary was about £100 – a small sum compared to the rector's income of over £1500, but considerably more than a labourer's average wage of about 1s 6d a week. His Lordship reinforced his criticism by pointing out that Bishop's Cleeve chapel had been erected during Townsend's time as rector, hinting that it was his failure to minister to his people which was the reason for its existence. Interestingly there is a note attached to the copy of his letter:

Population of the parish assessed to the Union
 (i.e. Winchcombe Poor Law) *1550*
Congregation in the evening *100*
Communicants last Christmas *11*

We also know that in 1855 Holy Communion was only celebrated eight times in that year. The curates must have found the rector difficult to work for. Lord Ellenborough makes reference to the resignation of one curate in 1839, probably Charles Newmarch, and by the end of 1842, a second curate, probably James Cadwallader, had gone. This was despite the rector insisting a pre-condition of appointment was the sharing of the same political beliefs as himself (Tory) to support him against 'the constant interference' in parish affairs of Lord Ellenborough (Whig/Liberal). It seems likely that the cool relationship between the two richest men in the parish lay behind Lord Ellenborough's restoration of the old manorial church at Southam in 1861, and his burial in the parish church of Oxenton, where he had another estate, in 1871.

The enquiry in 1851 into the religious state of the nation spilled over into an enquiry into education. How many children were being educated at a time when schools were voluntary and charged a small fee? We noted earlier that the census listed 101 scholars in Bishop's Cleeve and 50 in Woodmancote. The religious census also counted actual attendance at Sunday School on 30 March. There were 98 attendances at St Michael's; 88 at Bishop's Cleeve chapel and 74 at Woodmancote chapel. Using Mann's formula, we can calculate a total of 212 Sunday School scholars, which would indicate many more children were receiving an education in Bible-based simple reading and writing than the number of 'scholars' recorded in the census. From another set of figures, counted for Poor Law purposes in 1846, 107 children in Bishop's Cleeve and 47 in Woodmancote were said to attend day school regularly. These figures are remarkably similar to those of the 1851 census itself. However, the Poor Law figures further indicated that about 50 children in each village were not receiving any recognised education, although many of them must have gone to a Sunday School. Comparatively more children in Bishop's Cleeve received an education than those in Woodmancote, even though some from

Woodmancote went to the National School in Bishop's Cleeve. In one respect, therefore, William Lawrence Townsend was being successful. Not only was his National School teaching the majority of children to read and write (and therefore ironically to enter into the world of newspapers and books, discussion and debate) but also to accept their station in life and show respect for their betters, especially himself.

SO WHAT MIGHT IT ALL MEAN?

And so we close our snapshot of 1851. Here were two villages which had clearly developed in different ways with a more varied social structure and more differentiated experiences in Bishop's Cleeve than in Woodmancote, which seemed increasingly dependent upon its larger neighbour. Yet the villages were overpopulated in terms of the jobs available, and many labourers had to look for work outside the two communities and many must have lived on the borderline separating sufficiency from poverty, but few were actually labelled paupers who were seeking poor relief from Winchcombe. If this aspect of village life seems to have changed little from the days of Robert King and Henry Bennett, a major change has been the creation of a large number of landless labourers without even the three acres that John *le Gavisare* had to his name. In our final chapter, we will conclude our story by considering the effects of the decline which the villages experienced from the second half of the nineteenth century until the revival in very different circumstances in the mid twentieth century.

SOURCES AND FURTHER READING

Alan Rogers' *Approaches to Local History* (London 1977) was a pioneering book in exploiting the potential of the 1851 census.

Copies of the records filled in by Benjamin Slack and George Sheppard are available on microfilm in Gloucestershire Archives. The parish records are categorised under P46.

7

THE END OF TRADITION
(SINCE 1851)

It is intended to form a community in a village a few miles north of Cheltenham, similar to those of the clock-making villages of Switzerland, where this skilled craft is a natural aptitude and heritage of the inhabitants.

G. Playne, *A Survey of Gloucestershire*, 1946

INTRODUCTION

In Bishop's Cleeve and Woodmancote the life, like the scene, is still essentially rustic ... A shepherd driving a flock to turn out upon the great common up above, or, if descending, bringing the sheep back to the fields for the winter. Kine (cattle) also pass in the lane and thro' the doors or gates of the farmyards, to be milked, or for leisurely return to the fields, staying for mouthfuls torn from the rank growth of the underhedge. Horses you sometimes meet harnessed to various waggons, carts or agricultural machines, ridden, or occasionally turned loose when their work is finished for the day.

When John Henry Garrett described this apparently timeless rural scene during the Great War, he could not have foreseen that in 50 years time the picture he painted would be as outdated as the style in which it was written. It is also a scene which has passed out of living memory, belonging now to the day before yesterday. In fact fewer and fewer people can remember the time before Bishop's Cleeve was changed by the arrival of S. Smith and Sons (Cheltenham) Ltd in 1939; the event which gave birth to the modern village.

We are now at the period in history when the evidence of all types mushrooms, and when our story could falter under its weight. At last we reach the time within living memory. We also reach a time when people's individual

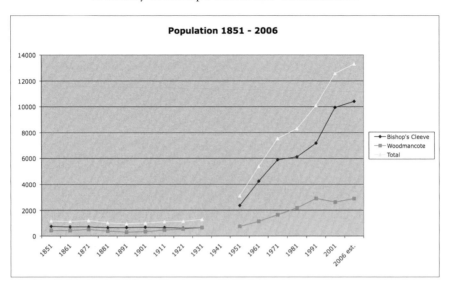

94 Population of Bishop's Cleeve and Woodmancote 1851-2006

experiences of living in Bishop's Cleeve and Woodmancote were becoming so varied that a key theme of this history – that people's experiences have become increasingly differentiated over time, reaches its climax. Today it is difficult to find two people who enjoy identical lifestyles, or memories – just one more example of how the present is different from the past.

We can introduce this final chapter by enquiring how the population of Bishop's Cleeve and Woodmancote has changed since 1851. The conclusions from the graph are obvious: in Bishop's Cleeve in 1931 the population was smaller than that in 1851; in Woodmancote, it had dipped then begun to rise from 1891 so that in 1931 it was larger than Bishop's Cleeve. After the Second World War both communities showed unprecedented growth, particularly 1951-71 and 1991-2001 in Bishop's Cleeve, but with a fall in Woodmancote 1991-2001 as families became smaller. The arrival of Smiths clearly lay behind the rise in figures from 1951, as it also stimulated wider housing developments largely carried on by private initiatives: 347 households in 1931 had become 795 in 1951 and 5550 by 2001. But before 1931, the drift to towns and cities offered hope for better lives and the decline in agriculture, started by competition from the American continent after 1875, meant that rural populations in England and Wales stagnated or even fell; houses and agricultural buildings stood shabby, patched up or abandoned. The countryside had become the town's impoverished neighbour and ambitious sons and daughters were anxious to leave it behind.

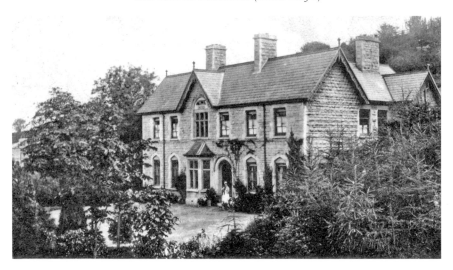

95 The Cotswold Convalescent Home; an early publicity postcard

PART ONE:

A NEW COMMUNITY

These changes in population provide the foundations for the last stage of our story. So fundamental was the impact of Smiths that this final chapter will present the period since 1851 in two parts, meeting in the Second World War. This first part investigates the final years of a traditional way of life.

The pattern of agricultural life established by 1851 continued, except in one place. The increase in Woodmancote after 1891 had little to do with the traditional way of life. Cleeve Hill was becoming a popular resort. On Whit Monday 1875 (the Bank Holidays Act had only been passed four years earlier), the hill 'literally swarmed with pedestrians', according to one local paper. In 1892 mutterings were being made down in Cheltenham for the development of a holiday resort with boarding houses and hotels, but the catalyst was the Cotswold Convalescent Home for patients from Cheltenham General Hospital, which opened with 12 beds in a disused quarry in 1893. The hill was soon advertised as 'The Cotswold Health Resort' ready to attract the shopkeeping middle classes of Cheltenham to enjoy gracious living, literally looking down on their customers. A dozen new houses were built for the middle classes at the turn of the century along the Cheltenham to Winchcombe road. Those above the road were technically in Southam parish, but the community was one. Before the Great War, another 20 or so houses were added, a little lower down the slopes, along Stockwell Lane,

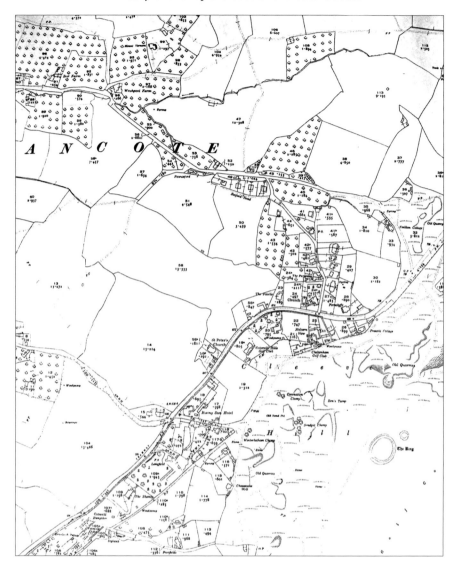

96 The development on Cleeve Hill contrasts with the straggling settlement lower
down the hill in Woodmancote. (Reproduced from the 1923 Ordnance Survey map)

Post Office Lane and Besford Road. Much of this development was the
work of one man, Arthur Yiend, local builder and public figure who lived in
Glendale, unsurprisingly, the largest house in Post Office Lane. His greatest
monuments, however, lie outside our area at Cheltenham Ladies' College and
Besford Court near Pershore. He had helped create an affluent outer suburb
of Cheltenham which swamped an earlier pattern of modest cottages, whose

occupiers, with the exception of the racing stables established in the 1850s, had for centuries made a living farming and quarrying and hauling Cleeve Hill stone. By 1894 Cleeve Hill had become recognised as a settlement in its own right in Kelly's directory (*colour plate 23*). Further house building took place in Woodmancote as Bishop's Cleeve languished. From 1924 Pearts, the Gotherington builders, constructed a dozen houses along the north side of Station Road in Woodmancote and Edginton and Pearce continued building towards the railway line. Nearer The Green, Nutbridge Cottages were built in 1939 in one of the old orchards. Almost the only development in Bishop's Cleeve saw Winchcombe Rural District Council build four council houses in Priory Lane in 1932. Apart from this, the village's population was accommodated in the existing buildings, many of which were several hundred years old and which by the early twentieth century were lacking in most modern conveniences. Unlike the developments on Cleeve Hill, in Bishop's Cleeve there was little social change to disturb this situation.

EARNING A LIVING

The farming pattern of 1851 was still recognisable in 1939. Farmers were still the largest occupational group; 13 in Bishop's Cleeve and ten in Woodmancote, although only Wingmore and Cleeveland Farms in Bishop's Cleeve and Bottomley and Longwood Farms in Woodmancote were larger than 150 acres (63ha). However, a new type of land use was emerging. This was market gardening, which had developed to supply the towns and cities with produce and, importantly, could make greater profits from smaller plots of land than traditional agriculture. It was an attempt to modernise agriculture exploiting the Great Western railway line, which took the produce to market, mostly in the Midlands. By 1914 there were five such operations in Bishop's Cleeve and three in Woodmancote. There were nine in business in 1939 and still five in 1966 since when the land has been even more profitable used for housing. This was an obvious change in the exploitation of the land and yet subtle changes were taking place in traditional agriculture. Pastoral farming was gaining at the expense of crop growing, and sheep at the expense of cattle. By 1901 meadow and pasture totalled 5098 acres (2124ha) whilst arable had shrunk to 1939 acres (808ha), although arable land temporarily increased under the impact of the two wars. Nationally the acreage under crops halved in the second half of the nineteenth century, although the yields increased with more scientific approaches, especially the use of chemical fertilisers. Many local families continued the tradition of keeping pigs and poultry for their own needs and for produce to sell to help ends meet.

97 The lack of large-scale mechanisation of agriculture is shown in this mowing machine working in the fields of Woodmancote during the Great War. It is crossing the medieval ridge and furrow

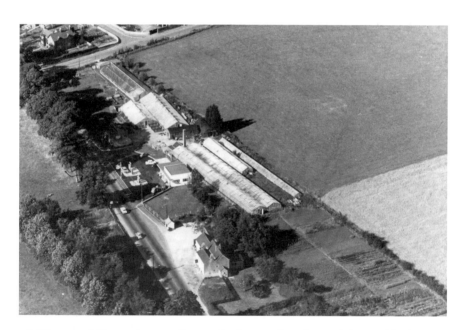

98 Kingswood Nursery's name lives on in the petrol station and the road built on its land. This photograph dates from *c.*1960 when the nursery was one of the largest in the area sending produce as far away as the Midlands. It also shows the now-demolished Crown and Harp Inn. (M. Hughes)

Because so much farming was on a small scale, it is difficult to find any surviving records to give us an insight into the life of a farmer to compare with that of Robert King and Richard Hobbs in earlier centuries. However, some records of The Grange have survived. The Grange was built in 1865 by the Cheltenham solicitor F. T. Griffiths on the land of Southam Fields Farm, owned by his mother Sarah. He claimed for himself the status of a gentleman, creating parkland around The Grange and a farm along Cheltenham Road, where he employed a farm bailiff. By 1900 he was farming 90 acres (38ha) and an account book survives from 1902–03. The Grange was clearly a mixed farm. Wheat worth £250 was sold to Healing's mill at Tewkesbury (from 1904 this went closer to home to Oldacres); pigs, cows and calves, eight horses and a foal were sold for nearly £350; £85 was received for milk and £30 for straw; mangolds and turnips brought in another £16, poultry and eggs £12 but the humble potato only £2. Frederick paid out over £265 in wages at a time

BISHOP'S CLEEVE DEVELOPMENT GUIDE

THE GRANGE

A guide to the Bishop's Cleeve distributor road and associated developments.

MAY 1988

TEWKESBURY BOROUGH COUNCIL
Planning Department

99 The Grange, home of the Griffiths, seemed an unusual choice for the cover of Tewkesbury Borough Council's development proposals, especially as there were intentions to demolish it

when a labourer's basic wage was around 12s a week. Significantly, he was spending over £25 a week at harvest time compared to less than £5 a week in winter. £112 went in rates and taxes and £60 for hay, grain and straw bought for his animals. Income far exceeded outgoings and so he had time to play a large part in village affairs. He and his son Arthur had almost become the country squires that Bishop's Cleeve had always lacked, but they never really managed to live off private means. The Grange still stands, becoming

100 Southfield in Station Road was one of the houses of 'the quality' where a maid was employed

a *cause célèbre* as local people campaigned to prevent demolition in 1989 when Eagle Star built its headquarters on its former parkland – a rare victory for local people.

As in 1851 the few 'quality' were living in Bishop's Cleeve, rather than in Woodmancote. Nothing really changed before the Second World War. They still mostly lived at the lower end of Station Road and in their genteel existence employed a small domestic staff – the Old Manor House, The Priory, Southfield and Rose Villa, then along to The Cleevelands, the home of the Griffiths before The Grange was built. In 1939 Kelly's directory listed 16 people living off private means in Bishop's Cleeve, but only five in Woodmancote, although on Cleeve Hill the 35 'private residents' even outnumbered the commercial entries, made up of hotels, tea rooms, two golf clubs and the racehorse trainers. This new community on the hill stimulated the old quarrying industry for another generation. Explosive black powder was used for the first time, in Milestone quarry in 1878, but its expansion caused concerns 30 years later when Arthur Yiend was accused of undermining the old road which ran across the top of the quarry. The conservators declared that the quarry should have been closed 20 years before to prevent damage to the common. In 1900 11

101 The sign is modern, but these uses of Cleeve Common were laid down in an act of 1890

quarries were still in use and Postlip Quarry had been reopened only 40 years before, but the total rental came only to £55, so use was not very intensive. It was not just the quarrying, but the damage caused by the carts crossing the common that worried the conservators. In 1911 Arthur was forced to stop the quarrying which was destroying the Iron Age hillfort. Conservation was now triumphing over the centuries-old economic exploitation of the common. By 1945 quarrying had ceased and apart from the continuing grazing of animals, Cleeve Common had now become a recreational area.

Another trend established by 1851, which continued with little change into the first part of the twentieth century, was that the traditional traders, craftsmen and the beer houses continued to be found mostly in Bishop's Cleeve. It was also the community where a touch of modernity could be discerned: the dentist and doctors were here. Dentist Ralph Shipway could be found at The Leys in Station Road in 1939, but there was no resident doctor until after the Second World War. In 1914 Dr Richard Davies called at Church Cottage on Tuesdays and Fridays at 12.30pm; by 1927 Dr Wilfred Snowden from Winchcombe held a surgery at Oxbutts where he was later followed by Dr Spiridion who opened the first permanent surgery in the former stables

of Cleeve Hall in 1947. However, in these days before the National Health Service of 1948 doctors and medicines had to be paid for, and so most people seemed to have made do with the centuries-old remedies handed down through the generations. District nurses were probably just as capable of meeting people's needs and by 1927 the district nurses Lilians Moorehen and Slade were living in one of the new houses in Station Road in Woodmancote. Mrs Parker continued to deliver the babies in that village.

Whilst it is clear the established patterns of life remained very strong before 1939, one man broke out of the mould of a traditional world and created something entirely new. Walter John Oldacre, born in 1862, was a young man with ambition. By the time he was 20 he was operating as a country carrier taking local people to Cheltenham three times a week and carrying out errands for those unable to go. In 1881 he purchased his first rick of hay to cut and truss and sell on. From there he moved to buying animal foodstuffs in bulk and retailing them. By 1885 he had the first steam engine in the village, at Owls End House in Station Road where he ground his own feeds and that of local farmers. He began to rent land to grow his own hay for sale. By 1890 he had moved to a much larger site behind the Tithe Barn. Ten years later he was renting Dean Farm; in 1907 he opened a shop in Winchcombe Street in Cheltenham. W.J. Oldacre Ltd was founded in 1923 by which time he was importing maize from the USA via the railway. He now had a transport fleet of ten wagons, 25 horses and even four railway wagons. In 1926 he moved to Fieldgate Farm. The next year he took on land at Withy Furlong Farm west of the village, and three years later took over Walker's bakery and corn business in Charlton Kings. Even though the mill in Bishop's Cleeve burned down in 1931, the business continued to expand and a new mill was built. As he grew older, he passed more on to his son William John, and the expansion continued after the death of Walter John in 1933. A demonstration pig unit containing 600 pigs was set up at Linworth Farm in 1935. From here 30 pigs per week were sent to Birmingham. In 1937 a shop and warehouse in Tewkesbury were added to the business, and by 1938 the company had invested in modern transport with three lorries, soon to be followed by tractors for the farming. This in turn led to the setting up of a garage, primarily at first to service the vehicles, but it soon began to sell petrol to motorists. By the outbreak of war Oldacres had become a modern firm situated in a traditional village. It had done well in the difficult interwar years through innovation, careful management and firm family control as it responded to the commercial market. It was an integrated business with interests in farmland, crops and animals to the retailing of seed, foodstuffs and even bread and cakes. Its land stretched from Stoke Road towards Woodmancote and with the purchase of Cleevelands Farm in 1942 and Yew Tree Farm in Gotherington in 1950, the

company owned practically all the land between the two villages. In 1958 Homelands Farm was built there after Cleevelands Farm had been sold for building. For the first time land in Bishop's Cleeve and Woodmancote had passed from private individuals to a commercial company; a trend set to continue throughout the rest of the century. The firm was Bishop's Cleeve's biggest single employer, with over 30 people working at its Church Road headquarters at the outbreak of the Second World War. Here, undoubtedly, was a touch of modernity which showed how an enterprising member of the farming community was capable of adopting and adapting traditional methods to make a success in the increasingly commercial wider world, where tradition counted for little. Yet few, if any, other villagers followed this modern path and for some landowners with small landholdings, selling out for building as the village expanded following the arrival of Smiths proved to be the sensible option when their small holdings became increasingly unviable in the changing post-war world.

THE DECLINE OF THE SELF-GOVERNING COMMUNITY

Walter John Oldacre also played an important part in the life of Bishop's Cleeve community as a member of the parish council. In 1894 local government was reorganised and the old self-selecting vestries of Bishop's Cleeve and Woodmancote were replaced by civil parish councils to which members had to be elected. At first elections were by a simple show of hands at the annual parish assembly but after 1931 in Bishop's Cleeve, and 1949 in Woodmancote, members were elected, mostly, but not every time, by secret ballot. A vestry did continue in Bishop's Cleeve after 1894, but its work was reduced solely to church matters, for example, electing the churchwardens each spring and maintaining the church clock. Although the parish councils were responsible for the well-being of the communities and no longer linked to the church, their make-up hardly differed from that of the parish vestry of 1821. The local farmers and traders dominated. John Minett and his son Fred from Cleevelands Farm acted as chairmen for over half a century. Heming Shipway of Malvern View and the Griffiths of The Grange, father and son, were also prominent in the early years of the twentieth century. So too was William Edginton the baker and John Stallard the postmaster. The rectors continued to play a part, although the parish council was no longer church orientated and the minutes record that meetings were moved from the rectory to the school in 1922. They were occasionally held at the home of the chairman – the newly-elected council of 1922 first met at the home of Fred Minett and in 1946 the first meeting under William Shipway met at his home

at Yew Tree Farm, which is actually in Woodmancote. Business of the new parish council continued to be very local. In the second half of the nineteenth century the vestry had controlled and charged for the training of racehorses on Cleeve Common. The legal situation between the vestry, the commoners and the trainers was not clear and some of the latter felt they were being blackmailed, so when the Board of Conservators was set up in 1888 one of its first responsibilities was to regulate the licences. The income continued to be used to offset a parish rate, especially for the roads; Prestbury-based George Holman paid £210 over a period of six years from 1868. In 1907 56 licences were issued. Much time was also spent on organising the repair of the local roads, on overseeing the development of a water supply and sewerage system and on managing the allotments at Northenham on behalf of the church after 1921.

The parish council was now increasingly subject to decisions taken outside the parish, as the trend which had started largely with the Poor Law gathered momentum. In 1872 the last parish constables were elected; now all policing was the responsibility of the county force; in 1883 the boundaries between Bishop's Cleeve and Woodmancote were tidied up after an external enquiry; in 1908 the council objected to being charged a rate for Cheltenham Grammar School, because it had not been consulted; in 1930 it objected unsuccessfully to the removal of the village policeman. A year later it bitterly criticised Winchcombe Rural District Council for allowing overhead electricity lines in the village without any consultation. Woodmancote parish council minutes only survive from 1907, but they illustrate the same trends. Meeting in the Stockwell Lane chapel vestry until the village hall was completed in 1923, much of its business seems to have been in response to demands from Winchcombe Rural District Council. The first entry in the minutes of 17 June 1907 records an approach to the Rural District Council to extend the sewer at Gambles Lane to the Rising Sun; in 1925 it requested unsuccessfully for better representation on the Rural District Council because of the growing population; in June 1930 it unanimously agreed to stay in Winchcombe Rural District Council and not move to Cheltenham Rural District Council. However, it could neither prevent Winchcombe Rural District Council from being abolished in 1933 nor Cheltenham Rural District Council in 1974 with the move into Tewkesbury Borough. By this time parish councils had little independence.

Perhaps it was because the work and power of the parish council seemed unimportant that generally few people outside the councillors seemed to have any interest. Unlike the Bishop of Worcester, they could not compel villagers to appear at their meetings and there seems to have been general apathy in the community. In 1922 Woodmancote had difficulty in finding its five councillors;

in 1931 only two attended one meeting 'because of haymaking'. Although the secret ballot had been introduced in Bishop's Cleeve in 1931, the election was back to a show of hands in 1937, because not enough electors were sufficiently interested to demand a secret poll. Woodmancote councillors continued to be elected by a show of hands until 1949. References in the minutes to outside events are very limited, even including the Great War. In 1922 Woodmancote Parish Council agreed to employ a second roadman 'considering the amount of unemployment in the district' and in 1924 it showed concern that the Cheltenham and District Light Railway Company had reduced its employees' wages – both faint echoes of the years of slump following the war. However, despite the lack of references to the outside world in the minutes, changes were clearly taking place which brought the outside world closer to the two communities. A number of developments appeared which made the villagers realise that the times were indeed changing.

IMPROVING COMMUNICATIONS

By 1880 all roads were free to use; the tollgates had been abolished and the local carriers were among the first to take advantage. Walter John Oldacre was one of the first; by 1914 five different carriers went to from Bishop's Cleeve to Cheltenham on Saturday, but by 1939 only Gilletts from Winchcombe provided a service. Carriers' carts were just one type of vehicle then seen on local roads as the vestries and parish councils expended much energy in trying to ensure the roads were fit for purpose. In 1879 New Road was finally completed between Woodmancote and Southam, for since 1840 it had stopped halfway between the two villages because Lord Ellenborough had refused to release land. At the start of the new century the local roads were in terrible condition; a state of affairs that lasted until the Second World War. In January 1908 Woodmancote Parish Council criticised George Preston from Hales Farm in Gotherington for steamrollering the local roads before the holes had actually been filled in. The continuing inadequate road surfaces of the lanes running up the hill preoccupied the council. In the interwar period these lanes found themselves on the Cotswold leg of the Colmore Motor Trials based in Birmingham. Their steepness was seen as a good test of motor car and driver, but the parish council was not amused when the trials damaged the surfaces, yet it had no powers to stop them. It was particularly annoyed in 1925 when Bushcombe Lane had only just been repaired before the trials churned it up again; in 1933 the trials made it 'impassable'. Complaints about the 'nuisance and danger' of motor cars parked on the road outside the Malvern View on Cleeve Hill first emerged in 1914 and as the complaint was repeated in 1925

102 The tram terminus on Cleeve Hill. (T. Curr)

it is clear the problem of parking is not a recent one. As traffic increased the traditional way of repairing roads by filling the holes with local stone was becoming hopelessly inadequate. In 1920, 120 tons of stone were laid between Bishop's Cleeve station of 1906 and the King's Head, but increasing traffic created dust and soon damaged the surface so the first tar was laid in 1926, between Gilder's corner and Gotherington Lane, significantly past the houses of 'the quality'. The move to tarmac local roads had begun, but as late as 1936 Walter John Oldacre was criticised by his fellow parish councillors for letting the weekly movement of his pigs damage the village streets. This was ten years after the parish council first requested that the county council bypass Gilder's corner; it had to wait another 60 years. However, by the early twentieth century road transport was no longer the only means of communication.

In 1901 the Cheltenham and District Light Railway built a line from the present railway station in Cheltenham to the Malvern View on Cleeve Hill at a cost of £5000. Horse-drawn buses had toiled up the hill from Southam for seven years before this. Now not only could the wealthy inhabitants use the trams to get to and from their businesses in town, but the working classes of Cheltenham no longer had to walk to enjoy the delights of the hill. Some inhabitants were not amused, complaining about the discarded tickets, 'pop' bottles, orange peel and other day-trippers' rubbish, but others were happy to take the trippers' cash by providing food and drink. The inhabitants on

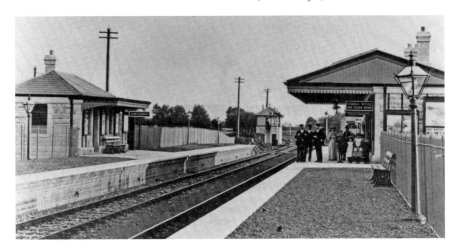

103 Bishop's Cleeve station shortly after opening in 1906. This finally brought the advantages of the railway to our two communities

the hill were generally well-served by the trams. Not only were they carried up and down the hill effortlessly, but also their parcels were brought up and then delivered by hand cart to the residents, although occasionally a manure truck was attached to the tram, much to their disgust. However the trams formed part of the scene for less than 30 years, for on 31 March 1930 the route was converted to buses, leaving a tram body to serve as the bus shelter for a further 30 years.

Down in the vale in 1906 the Great Western Railway completed its route from Cheltenham to Honeybourne. The new station was conveniently situated for both Bishop's Cleeve and Woodmancote and was impressively built from Cleeve Hill stone by Arthur Yiend. Now local people could travel quickly and cheaply into St James' station in Cheltenham, and further afield; no longer need they walk to the Stoke Road station so far out of Bishop's Cleeve. It was the new railway which enabled people like Walter John Oldacre to have easier access to supplies of grain. John Williams of Cheltenham soon set up a coal depot to bring in coal for the villagers' heating and cooking. Until the 1950s much of the fruit and produce of the market gardens was dispatched from the station. Yet the physical impact of the railway on the community was limited to a stationmaster's house and a pair of semi-detached houses for other staff – all of which survive. The local train service lasted until 1960, when it became the victim of the private car and more convenient bus services. Bus services started in 1923 and by 1927 there were four daily Bristol Blue buses to and from Cheltenham and two Stratford Blue buses to and from Evesham.

Other communications improved. In 1889 there were two daily deliveries and collections of post in Bishop's Cleeve. Until the mid 1930s the village's other postal services were limited – postal orders were issued but not paid; telegrams could be sent and collected from Cleeve station, but not delivered. Cleeve Hill had its own telegram service; it was also the site of the local telephone exchange, opened in 1899. By 1927 there were 68 private subscribers, but not until 1932 did the first telephone kiosk appear in Bishop's Cleeve, very near its present site in Church Road. From here only local calls could be made during the day – trunk calls still had to be made from the post office opposite. Woodmancote had to wait until 1937 for its kiosk by The Green and not until 1958 did Bishop's Cleeve have its own telephone exchange, off Gotherington Lane.

INCREASING LEISURE

John Henry Garrett recognized that Bishop's Cleeve and Woodmancote were being increasingly drawn into the wider world:

> *The truly native life ... is represented in its modernised form in the farmer and peasant proprietor, and labourers of various grades, still attached to the land in more or less complete degree. But a greater modernity, due to touch with the fashionable town that lies but three miles away, shows its influence in sons and daughters who have lived there and have returned, or who go to and fro daily by bicycle or train, bringing back with them innovations of dress and ideas, manners and speech.*

Dr Garrett's *From a Cotswold Height* is the best example of a trend new in these years – the arrival of visitors and day-trippers encouraged by guide books. They didn't only visit Cleeve Hill. In 1879 John Middleton produced the first detailed analysis of St Michael's church for an outing of the Bristol and Gloucestershire Archaeological Society; in 1897, the famous geologist, S.S. Buckman recommended Nottingham Hill as a picnic spot with milk 'and suchlike requisites' obtained from local farms; in 1904 Henry Branch included a chapter on Bishop's Cleeve in his book *Cotswold and the Vale*. He relates how a cyclist chose to find the key to St Michael's and investigate its interior, instead of 'scorching through the village at 20 mph'. We might consider here a touch of artistic licence, given what we know about the state of the roads. J.D. Newth wrote the description of Bishop's Cleeve at the start of this book in 1927. Yet already the nature of the centre of the village was changing. Newth's 'delightful' was becoming a rather dubious description. Local traditional materials were already being replaced by machine-made, mass-produced red

bricks, brought in by the railway, which lacked the variety of colour of the bricks from Stoke Road (*colour plate 24*). It's about this time (1922) that the Rev. E.C. Hanson, the curate at St Michael's wrote a slim volume called *Bishop's Cleeve and its Church*. He was clearly writing for this new type of visitor for the book was intended as a 'collection of interesting and amusing facts about the parish' to spread knowledge to 'a wide circle of visitors'. It could hardly be called a history, but until the Victoria County History appeared in 1968 it remained the only published history of the village. Today its value lies in its period charm rather than its miscellaneous historical content.

We might suppose that most visitors to Bishop's Cleeve, encouraged by Buchman, Branch and Newth belonged to the more literate middle-classes, but for over 25 years until 1939, most were from the working classes on organised outings to Denleys' Eversfield Tea and Pleasure Grounds in Station Road. In 1898 Andrew Denley moved into Eversfield House to develop a bakery, but not content with this, around 1912 he bought some secondhand amusements from Charlton Kings, and rebuilt them in his orchards to create an institution which, except during the years of the Great War, continued until the Second World War. Conveniently situated a short walk from the railway station, Eversfield offered 'unique facilities for Sunday Schools, Temperance Societies, Young People's Guilds, Mothers' Unions, etc'. It opened from Easter to the middle of September, but never on a Sunday. In 1919 it was providing Good Plain Teas for 9d or Cheaper Teas for 6d per head. The Denleys described their pleasure gardens as 'a Noah's Ark of those things that delight a child's heart', offering (at various times), attractions which would not have been out of place at the seaside: donkey rides, deck chairs, candyfloss, sticks of rock and various souvenirs inscribed 'A Present from Bishop's Cleeve'. People came from as far away as Worcester in the north to Chipping Sodbury in the south; in the 1920s St Paul's Sunday School from Cheltenham was said to have regularly brought 1000 scholars and teachers by special train. They must have made an impressive sight marching down from the station behind a banner and band. No wonder local people turned up just to watch the visitors. And so the wider world came to Bishop's Cleeve. Like Oldacres before them, the Denleys showed how members of a traditional community could seize the opportunities of better communications opening wider markets and prosper in doing so.

Eversfield Tea Gardens can serve as our symbol for the increasing leisure activities which appeared in the century after 1851. Only in this period did regular leisure become for ordinary people an established part of their lives and at last a few records survive to illustrate what was happening. Two acts of parliament helped create more leisure time. In 1871 four Bank Holidays with pay were introduced, and from 1904 shops could close for a half day each week. How did people spend this time, and the other free time on evenings

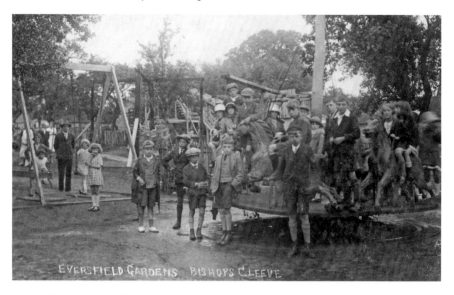

104 This undated publicity postcard clearly shows the rustic nature of the attractions at Eversfield Tea Gardens

and Sundays? There was already a tradition of using Cleeve Common for recreation going back to the races of 1818. In 1890 the uses of Cleeve Common were laid down by law. Cheltenham corporation paid £50 per annum to ensure its inhabitants enjoyed free access to the common. In 1891 the gentlemen of Cheltenham set out a golf course, taking over Rock House as their clubhouse. The local middle class, being only traders and merchants, could not join this exclusive club and so in 1902 they set up their own golf club and built their own clubhouse (now 1 and 2 Cleeve Hill) three years later. In 1935 the gentlemen's club failed and its clubhouse was sold to the YHA for £200, but the traders continued to play, opening the present clubhouse in 1938, partly to accommodate the influx of 50 members from the failed club. In 1976 this Cotswold Hills club moved to Ullenwood leaving Cleeve Hill to Tewkesbury Borough Council as a municipal course.

The archives only provide hints of what else the villagers did in their leisure time, although we can assume the various beer and cider houses made a living out of the village menfolk. National events were celebrated with enthusiasm and in the absence of a paternalistic squire they show how the community could organise itself. The villagers celebrated Queen Victoria's Golden Jubilee in 1887 on 24 June by holding a church service at 11am, then sitting down to a 'general feast' in a tent near The Rectory. The Winchcombe Town Band played at the sports which followed in the afternoon and the celebrations did not end until 10pm with the singing of the National Anthem. If newspaper accounts can be

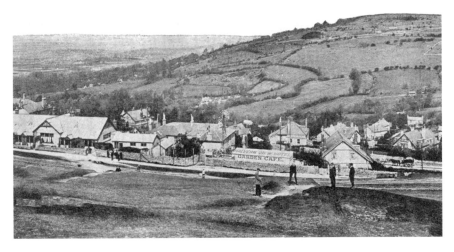

105 The Cheltenham Golf Club house and the original first tee

believed, the whole of the village took part. For George V's Silver Jubilee in 1935 the villagers enjoyed a day of sport at Eversfield Tea Gardens. A field opposite the Tithe Barn in Bishop's Cleeve and the present cricket field in Woodmancote, which was bought in 1959 by the parish council, were the places for large-scale activities. In the 1920s the Bishop's Cleeve flower show took place in the Tithe Barn, with sports in the field opposite. The Tithe Barn was clearly used for village events before its conversion to a village hall in 1956, for in 1932 the parish council noted that 'in view of the rector's attitude' the Michaelmas revels were to be discontinued. What story lay behind this simple statement in the minutes? In Woodmancote Pottersfield was being used in the 1920s and 1930s for cricket and football and the annual village flower show.

At this point we can consider St Michael's as a leisure interest of the few. The religious census of 1851 showed that regular churchgoing had become a minority interest. People continued to blame the absenteeism of William Lawrence Townsend for this. It is also clear that he cared little for the physical condition of the church and he even recommended the demolition of the Tithe Barn because of its poor condition. In 1872 it was estimated £820 needed to be spent on St Michael's. The rector was responsible for the chancel and the nave was causing most concern, but even so his offer of £5 to open a subscription list seems particularly miserly. The repairs were said to have been most inadequate and when John Middleton visited in 1879 he recorded that 'the present condition of the church generally is one of neglect'. After

106 Unsophisticated horseracing continued in Pottersfield into the 1950s.
(H. Denham)

Townsend's retirement in 1883 £1000 was spent on repairs, but three years later it could still be described as 'a spectacle of desolation and dust, of fallen plaster and mouldering timber'. In 1890 a summer visitor wrote to the *Cheltenham Examiner* that, although the church looked fine from the outside, the interior of falling plaster and rotting floorboards told a different story. Under the Jacobean gallery he found 'a heap of mouldering hassocks, a stock of coke, two wicker hampers, several rusty fireirons, half a spade and a barrel hoop. Of the state of mind which allows this, indignation and disgust forbid me to speak'. Crisis point had been reached and so two rectors, Benjamin Hemming (1883-95), and his successor Thomas Jesson (1895-1919) oversaw a programme of renovation costing over £4000. Townsend's estate gave £500, whilst Thomas Jesson himself contributed £1000. Yet congregations remained 'sparse' in the view of John Henry Garrett, despite the church's continuing use by the community at large for baptisms, marriages and burials. By this time people were blaming the 'extreme ritualism', first noted in 1871, for St Michael's lack of attraction. The creation of the secular parish council in 1894 can be seen as another lessening of the church's influence, yet ironically as the church's influence lessened the rectors became resident and showed a clear interest in the village, for not only did both Thomas Jesson and his successor Nigel Morgan-Brown (1919-32) serve as parish councillors, but they took the chair in 1909-19 and 1920-22 respectively.

Day schools formed another aspect of life over which the church was losing control. At the end of 1873 the National School ran out of funds and closed. Two years later it reopened as a Board School, paid for from the rates under the 1870 Education Act, which led to the education of all children up to the age of 10. In 1885 an attendance officer was appointed to chase unwilling pupils back to their lessons – no doubt his job was hardest at harvest time. In 1905 the building was extended to its present size to accommodate 220 pupils and 182 pupils were attending in 1906, approximately 20 per cent of the total population of Bishop's Cleeve and Woodmancote. It is much more difficult to trace schooling in Woodmancote because records have not survived except for one private school started by a Miss Waghorne soon after 1906. During the Great War it was held in a house called Rochdale off Stockwell Lane. Then in 1922 Miss Lawrence took over and 16 years later moved it to Red Roofs in Rising Sun Lane, where it continued until 1943. People still remember the hit-and-miss curriculum, but it provided some education for around 20 pupils up to the age of about 12.

One function of the church which did not change at this time was its responsibility for distributing charity money. It might be surprising that charities for the poor have not featured in this story of Bishop's Cleeve and Woodmancote so far, but there were so few they had little impact on people's lives. This lack of charities can be seen as another indication that the villages did not have a traditional landed family capable of setting up a charity by donating worthwhile sums of money. People in poverty continued to receive small weekly sums from the overseers of the poor or until 1929 were forced to enter Winchcombe workhouse. The total annual value of all Bishop's Cleeve and Woodmancote charities was £27 in 1914 and still only £92 in 1982. The largest recorded bequest was made in 1837, when Mary Stanton left £1000 to be invested and used to pay ten poor people a small sum on the first of each month.

However we must not forget that St Michael's did not have the monopoly of worship. In 1878 the pastor of Bishop's Cleeve chapel, Rev. Pearson Cooper, speaking at the harvest festival quoted a recent speech from the Bishop of Liverpool that in rural districts the Church of England was weak and unpopular and 'such appeared to be the case in this large village of Bishop's Cleeve' and 'it was out of touch with the people'. Ironically St Michael's survives, but the chapel closed in the early twentieth century and is now a house. Woodmancote chapel closed in 1854 but only because a larger chapel was opened in Stockwell Lane, where it continues to provide a place of worship in Woodmancote. Since 1912 it has belonged to the Countess of Huntingdon's Connexion. Two more chapels were both opened and closed during this period. One was the so-called 'Iron Church' in Two Hedges Road

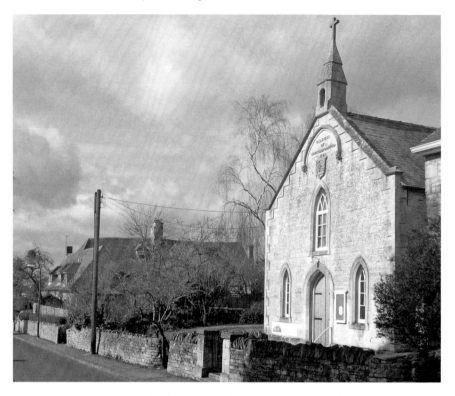

107 Woodmancote Chapel was built in 1854 to replace the one in Chapel Lane

immediately east of the railway bridge. This was very much the brainchild of the Rev. J. E. Walker, a son of the rector of Cheltenham, who founded the Cheltenham Evangelical church on the corner of Whaddon Road, which still exists. Bishop's Cleeve was its daughter chapel. Details are uncertain, but it was in existence by 1885. Every Sunday and many a week night, the Rev. Walker walked out to take the services, but so dependent was the chapel upon him personally that it did not survive his death in 1911. By this date another chapel had been opened in the village – a Methodist chapel on the corner of School Road and Station Road. Although Thomas Staite had gained a licence to hold services in his house in Station Road in 1841, not until 1899 was a purpose-built chapel opened at the back of the old poorhouse. Congregations were never large, and it closed in 1934 after which the building was taken over by the Women's Institute.

The journey to the existing places of worship down in the vale seems to have been too much for the increasing population on Cleeve Hill. The Rev. Henry Taylor from London began to hold Anglican services in a building in Rising Sun Lane from *c.*1870. After he left in 1896 the services stopped and

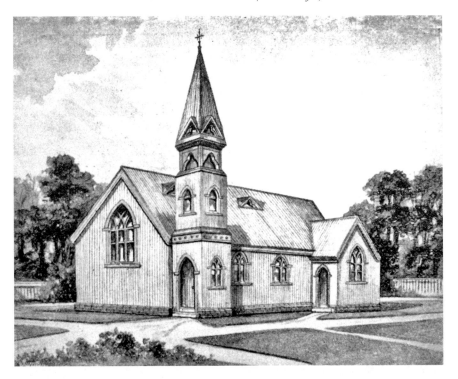

108 The Tin Tabernacle as featured in the *Cheltenham Chronicle and Gloucester Graphic* on its opening in June 1901. The artist has flattened the considerable slope of the plot!

new premises were needed. In 1901 the Cleve Hill Free Church of England was opened. Known to all as the 'Tin Tabernacle' it served as a focus of community, as well as providing services and a Sunday School. The middle classes of Cheltenham living on the hill paid for a pastor and his manse in Post Office Lane from 1909. The chapel flourished until the further decline in church attendance after the Second World War and it closed in 1972, although an offshoot behind Bootenhay in Station Road in Bishop's Cleeve continued for a few more years. After 1907 it had a competitor on the hill when St Peter's Anglican church was opened as an outpost of St Michael's. Whereas the Tin Tabernacle had been of a lightweight prefabricated design to overcome the dangers of subsidence, St Peter's was built with hollow bricks supplied by the Frazzi company of London. The interior was heavily influenced by the popular Arts and Crafts movement of the time. Although there was lively competition and even ill-feeling between the two places of worship in the early days, both later struggled for congregations and finance and St Peter's itself only just celebrated its centenary before its closure. Increased mobility allowed the

churchgoers a wider choice of places of worship and they no longer needed to worship locally. Yet the churches were not just places where a few people could assemble on a Sunday and during evenings in the week. Although attendances at services could be sparse, it could be argued that their chief influence was to provide the local children with a Sunday School. We have already considered how the Sunday Schools helped children to read and write and know their place in society and the difference between right and wrong. They were also important for providing almost the only organised leisure activities for the children. The Sunday School treat developed to give encouragement for good attendance. In 1876 Woodmancote chapel was providing a public tea, with prizes to scholars with good attendance. About the same time the Iron Church in Two Hedges Road was taking its scholars to Haymes for its annual outing. Before the Great War the Tin Tabernacle organised a Band of Hope every Wednesday evening to encourage its young people to reject drink and follow the path of temperance – a popular Victorian middle-class campaign.

In 1885 the *Cheltenham Free Press* reported that Mrs Stephenson of Southfield opened 'a cheerful and well-appointed reading and temperance room seating one hundred and twenty people' where papers, books and magazines were provided and evening classes, singing classes, and bell ringing and a choir were organised to 'improve' its members. When it opened it was said to have a membership of 130 adults and 180 children but, perhaps because of the over-emphasis on temperance, it had a short life for we find only seven years later the same newspaper reporting 'Joy unto Bishop's Cleeve' as a new reading room was opened, heavily financed by the Rev. Henry Taylor of Cleeve Hill. At its opening Arthur Griffiths from The Grange remarked how sorry he was 'to see so many young men loitering about' but whether *The London Illustrated News* and similar publications ever would entice them into the reading room seems unlikely as three years later it had closed. Unfortunately no more details are known about these two reading rooms, not even where they stood.

The reading room movement is a long-forgotten attempt at the end of the nineteenth century to provide labouring men with an alternative to the public house, where the middle classes accused them of squandering their wages. The movement started in the area in Gotherington by Elizabeth Malleson who moved from London to Dixton in 1882; the present village hall in Gotherington began life as a reading room in 1905. In Woodmancote the Rev. J.E. Walker took the aims of the movement literally, for he bought and converted an old thatched cottage, which had been a public house, into a reading room in 1883. It stood towards the lower end of the present Nutbridge Cottages in Station Road, until it was destroyed by fire in 1896. The Rev. Walker then used the £60 insurance payout to build a replacement 'comfortably furnished and supplied with games, paper and books' near where the bus shelter stands. It is

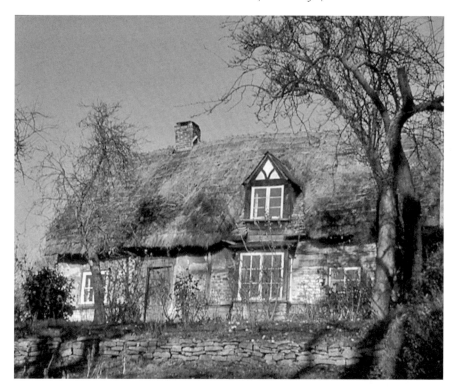

109 The former 'Waggon and Horses' in Stockwell Lane; one of the many traditional places for drinking cider in Woodmancote, which the Reading Room movement hoped to make redundant. This photograph was taken in 1965

not clear how long this kept open, for in 1909 we find Woodmancote chapel opening its schoolroom as an institute. There then seems to have been political friction between the ministers of this chapel and the Tin Tabernacle on the hill, which sponsored the refurbishing of the 1896 building in Station Road in 1912 through its pastor the Rev. Edwin Lewis. It had 40 members paying a penny a week. Despite the early enthusiasm and high hopes, the reading room seems to have faded away by 1920, after which it was converted to a house which in turn was demolished in the 1940s. On the other hand, the institute at the chapel continued until 1922 by which time thoughts of a building for more general use led to the opening of a village hall in 1923 in Stockwell Lane at a cost of £300. It opened with a whist drive and dance, neither activity normally associated with labouring men. Although these reading rooms did not last long, they were convenient, but not so the one on Wickfield Lane on Nottingham Hill provided in 1893 by the same Rev. Henry Taylor who had so generously funded the reading room in Bishop's Cleeve. It only survived three

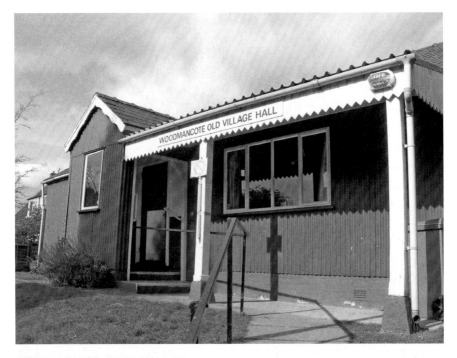

110 Woodmancote Old Village Hall, opened in 1923, provides a direct link to the Reading Room movement at the end of the nineteenth century

years until he left the area, but its location must have been a major disincentive to any working man after a hard day's work. Perhaps we shall never know quite why this inconvenient site was chosen. The building itself survived long enough to have been used as a Royal Observer Corps' hut during the Second World War.

The observant reader will have noticed that practically all these leisure activities were targeted at men, particularly young working men. We know even less about the activities provided for women and girls. Much of their life seems to have been supporting the men, but we do know that they shared in general celebrations and exhibitions and played a full part in church and Sunday School activities, for example they supported the Bishop's Cleeve flower shows, which started in 1869 as an attempt to encourage the labourers to take pride in their gardens. Although the golf clubs allowed women to play, most of them came, like the men, from outside the local communities. The direct references to female activities are limited: they were tolerated as members of the Cleeve Foresters, a self-help society formed in 1888 to encourage thrift in working men, but which, from a report of 1896, had failed to do so and had become a middle-class club; a Girls' Club was established in Bishop's Cleeve

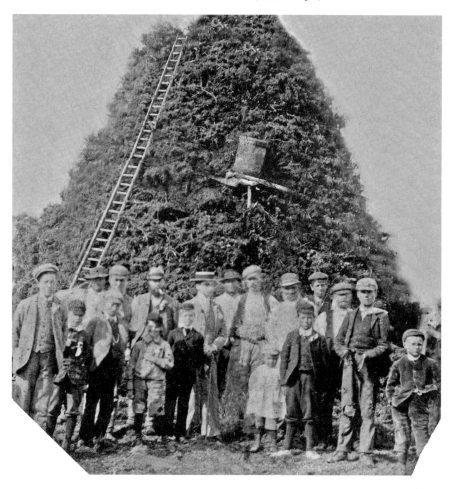

111 The jubilee bonfire in 1897 before it was 'prematurely fired by some evil disposed person'. Unfortunately the reactions of the builders, proudly pausing here for their photograph, are not recorded. (T. Curr)

in 1912, and by 1927 the Women's Institute had arrived. Quite clearly, the female half of the population were felt to be less in need of 'improving' than their male counterparts, especially as some of the latter continued to annoy the community with their antisocial behaviour.

Despite popular beliefs, young men behaving badly is not a phenomenon of the last 20 years. In April 1870, the Bishop's Cleeve vestry appealed to the churchwardens to stop 'boys etc.' causing annoyance in the graveyard and damaging graves. In 1890 vandals destroyed some of the new fences protecting the quarries on the common; in 1897 the jubilee bonfire on the hill was 'prematurely fired by some evil disposed person'. Skilly Alley opposite the

219

King's Head has attracted antisocial behaviour for at least a century. In 1910 young men were causing a nuisance in there; in 1926 the police were called to stop annoyances. Four years later, this was a reason why the parish council unsuccessfully opposed the withdrawal of the local policeman for economy reasons. Bishop's Cleeve was then without a policeman for nearly a decade. In Woodmancote in 1925 the clerk of the parish council wrote to the master at Bishop's Cleeve School because his boys had damaged the fence around the tree on The Green; three years later he wrote to the police concerning similar damage. Not everyone was able to use their leisure time in ways acceptable to the wider community – another recurring theme.

REAL IMPROVEMENTS

Many aspects of our modern way of life can be traced back to the 90 years after 1851. We have already noted the development of local government and improved communications. Perhaps the most important aspect of this period could be considered the development of the utilities, which made modern living immeasurably more comfortable and arguably have been the most important change ever in people's everyday lives. In 1851 nearly everyone took water from a spring or well, cooked and heated by wood or coal and used an earth closet for their waste. The arrival of piped water and sewerage, gas and electricity changed all this, but not without problems. The supply of mains water was so important that nearly as soon as they had been formed in 1894 the two parish councils set up a joint committee to oversee it. The story actually starts in 1885, when a Mr Bryant of the Malvern View on Cleeve Hill, wrote to the Winchcombe Rural Sanitary Authority enquiring about 'the disgusting filth' which passed as water. Two years later, the medical officer of health, Mr William Cox, condemned nearly every well and ditch used for drinking water in Bishop's Cleeve and Woodmancote. So began protracted negotiations between the Sanitary Authority and local landowners to supply water; the Sanitary Authority and central government to obtain loans to pay for laying the pipes and the Sanitary Authority and local ratepayers to finance it. The water came from springs on Cleeve and Nottingham Hills; the first from Holder's Hill above Woodmancote in the 1890s. Almost immediately demands were made to extend the pipes to Bishop's Cleeve. Yet the water supply was really quite limited. In 1911 water diviners were employed on a 'no find, no fee' principle. Presumably they went away unpaid because for years the water was still being turned off each night at Woodmancote to improve the supply in the village, which meant Bishop's Cleeve went without water. Maie Willetts, speaking to Hugh Denham in 1992, remembered the time when she lived by

The Green in 1928-30 when she had to fill all her buckets whenever the water was turned on. In 1929 Eversfield Tea Gardens were accused of causing water shortages and using the water for the visitors who didn't contribute to local rates; the annual payment of 10s from the tea gardens was considered to be wholly inadequate. Not until 1931 did Bishop's Cleeve parish council feel the water supply was sufficiently good that it could subscribe to Cheltenham fire brigade for £9 per annum. What was the point of paying such a sum when there was not enough water pressure to fill the hoses? And so the old parish fire engine continued in use. By this time water was being piped over from Charlton Abbots, then later from The Hewletts until the main supply came from The Mythe at Tewkesbury. However, the inadequate water supply was a major concern for Smiths' new factory and there were proposals to bring more water from Stanway, but this came to nothing.

As the water supply was piped down from the hills, so too was the sewage. Disposal of waste had always been a problem. In 1899 there were complaints that the ditch near The Cleevelands was nothing but an open sewer. In 1901 Bishop's Cleeve parish council refused to build a system, instructing all householders to make their own arrangements for the disposal of waste, no doubt because of its impact on the rates. People dug cesspits in their gardens but this caused major problems on Cleeve Hill, for the underlying limestone did not soak up the effluent as the clays in the vale, and the water supply was liable to become contaminated. Only the water from springs above the road was said to be pure. Outbreaks of typhoid and diphtheria, diseases more associated with industrial cities, forced the issue and in 1906 Winchcombe Rural District Council secured a loan of £3000 from the Local Government Board to begin to build two sewers; one to a treatment plant west of the railway in Woodmancote and the other to near Dean's Farm to the north of Bishop's Cleeve. All the residents of the hill were in favour, but Woodmancote inhabitants petitioned against it on the grounds of lack of need and increased rates, but the petition was dismissed by the inspector as he found that the numbers had been swollen by non-residents. The system developed by fits and starts as the parish councils encouraged householders to contribute to the expense of laying it. The mains were laid down to Bishop's Cleeve in the 1920s; in 1924 the cost of laying the main sewer from Bushcombe Lane to the railway was £500. Mr Peart from Gotherington, who was building his houses along Station Road was asked to contribute. Yet in the same year the occupants of the cottages which stood opposite the present Mill Parade in the centre of Bishop's Cleeve were criticised by the parish council for dumping their sewage on the road and ordered to remove it at their own expense. As late as May 1940 the ditches along Stoke Road were described as 'in the nature of open sewers and a real menace to health' with human faeces floating down

them, but the main sewer was not built here for another four years. In 1946 the effluent discharge from the Dean's Farm sewage works was said to have been 'fair'. Today most sewage is treated at Brockhampton.

Solid domestic rubbish also needed disposal, and as the population grew in number and grew more sophisticated, burying it in the garden or in communal pits such as that in the former Cherry Orchard towards the bottom of Station Road, was no longer adequate. However, once again, the desire to keep rates down remained a hindrance to adequate disposal; in 1935 Bishop's Cleeve parish council successfully objected to any scheme which would increase the rates, even though some ratepayers wanted one. Quarries on Nottingham Hill, and Milestone Quarry on Cleeve Hill were considered as tips and rejected, but by 1937 the county council was temporarily using Stockwell Common as a tip and Woodmancote parish council was powerless to stop it. The next year the parish council asked for donations from the public to provide bins for visitors' rubbish on Cleeve Hill. As late as 1939 Cheltenham Rural District Council refused to organise a refuse collection, complaining there was not enough demand, and it would mean an extra 2d in the £ on the rates. Not until the sand and gravel workings from the 1960s along Stoke Road became available was there a large area to deposit domestic (and other) waste.

There were no such mixed receptions for gas and electricity. Gas came first, reaching Cleeve Hill before 1914. In 1920 the first eight gas lamps were erected in Bishop's Cleeve, followed by three more in the next year. In 1988 May Wood, who kept the post office in Woodmancote after the Second World War, remembered the arrival of domestic gas in Woodmancote about 1929 and how each house was given three lights and a cooker, only the gas had to be paid for. In her own words, 'What a luxury not to have to dry sticks overnight to heat up the kettle for the first cup of tea in the morning'. Electricity followed a little later, again going first to Cleeve Hill, then reaching Bishop's Cleeve in 1932. The first electric street lights, all nine of them on Smiths' estate, appeared in March 1949, but not until 1951 were the gas lamps completely replaced. The people of Woodmancote rejected streetlights in 1949 and 1983 – a rare victory for the locals. Butts Lane seems to have been the last place in the area connected to the electricity supply; it had to wait until 1954. So the crucial groundwork for the utilities was laid down in the first half of the twentieth century and according to the 2001 census every dwelling in Bishop's Cleeve and Woodmancote had electricity, an adequate water supply and sewerage. Despite the slowness to adopt water and sewerage because of the cost to the rates, the result was that by 1950 the lives of almost everyone had been immeasurably improved by the spread of the utilities we now take for granted.

As we now move into the final stage of our long story of the two villages, we can make a comparison of the impact of the two major wars of the twentieth century in order to link the two parts of this chapter together. Every Remembrance Sunday 55 names on Bishop's Cleeve war memorial are read out. It is an act to remember the men whose sacrifice in the Great War would otherwise be forgotten. Yet the war memorial is an unreliable historical source, for only 21 of the men were actually living in Bishop's Cleeve or Woodmancote when they enlisted. Apart from two names about which nothing is known, and the 11 from Gotherington or Southam, the remainder had only a family link. Although the two Large brothers also have a headstone in St Michael's churchyard, they and William Pearce fought for the Canadian forces because they had emigrated. Edward Smith's parents had moved from Dursley to Wiltshire and so it is not at all clear at this distance in time how his name came to be on the war memorial. Over half of those killed died in the last year of the war, which is when their deaths must have hit the community hardest, and all except five were aged between 20 and 30. Only two deaths were recorded before 1916, which suggests only a few local men volunteered for Kitchener's army and most enlisted only after conscription was introduced in that year. On the north wall in St Michael's church hangs a roll call of all those who served in the war. It contains 268 names including all those on the war memorial. Again, it is not clear just what these names actually represent.

Most of the men died fighting on the Western Front, where conditions often seemed unbearable, but how was the war affecting their families back in the two villages? The answer seems to be not very much. Early in the war Cleeve Common was regularly used by the 9th Gloucesters as training ground; the Cotswold Convalescent Home became a Red Cross hospital in November 1914. Two years after the war it was sold to Courtaulds and then 60 years later into private hands. Eversfield Tea Gardens closed down; some rationing, and even blackout after air attacks on the South East, occurred towards the end of the war; but in this part of rural England life continued much as before. The war hardly featured in parish council business except when the councils tried to reassert a long-lost authority. Therefore Bishop's Cleeve parish council refused a collection to support the relief of Belgium in September 1915; it then refused a request from the government to cultivate more land, stating there was only enough labour for existing cultivation. In 1917 it agreed to set up a rat and sparrow club to encourage the eradication of 'vermin' but in 1918 it refused to set up a pig club and declined the government's offer of seed potatoes. In the last months of the war it again turned down the national government when it declared that no new houses would be required in the post-war world. The war also remained distant from the concerns of Woodmancote parish council. There is just one clear reference in the minutes to the war when in April 1917 they condemned the Agricultural War Committee over the manner

112 This is the only Commonwealth war grave from the Great War in St Michael's churchyard. Donald Page was one of the few who did live in the village. He died of illness at Hilsea Military Hospital in Portsmouth. There are two similar graves from the Second World War: Douglas Cresswell and J. Hanson but the latter name is not on the war memorial

it had dealt with the parish council over the distribution of seed potatoes – a very minor storm in a very large teacup. It was obviously possible to live a life from 1914 to 1918 largely unaffected by the war. However, 20 years later the

113 The site of the US army camp along Gotherington Lane is still evidenced by the bleached grass growing above the dumps of material

two villages were not quite so distant from the Second World War, particularly as its consequences had the most profound effect on Bishop's Cleeve and Woodmancote, by transforming their nature as small rural communities.

Superficially the Second World War had little direct impact on the area. An army camp, at first for the British army, then the US army, along Gotherington Lane brought villagers into contact with large numbers of overseas people for the first time and so increased awareness of the wider world. Three hundred US troops were stationed there and they inevitably brightened up the village. Children hoped for sweets and chewing gum to be thrown from passing vehicles. The dances and films put on in Denley's Hall at Eversfield attracted the villagers. David Wilson in 2004 remembered that one Christmas party the youngsters ate 'food we didn't even know existed'. These were almost the last entertainments to be seen at Eversfield. It was also used for billets and for evacuated Birmingham schoolchildren. After the war the hall was used as overspill from the local school then for industrial purposes before being demolished after the pleasure grounds had been sold for building in 1987. In November 1940 five bombs landed in Woodmancote; in 1942-3 a total of seven men were killed as their gliders crashed on training exercises from Stoke Orchard aerodrome, which itself was a development brought by the war; in August 1944, a Halifax bomber crashed on Cleeve Hill, killing all seven crew.

By and large this was a safe area – safe enough to receive evacuees. The school admission registers record 112 evacuees between the ages of four and a half and 13, very few of whom stayed longer than two years; some stayed a matter of days and by the end of the war only five remained. The first 13 evacuees came from Eastbourne in September 1939 to be followed by 19 from Birmingham in May 1940 and seven from Dagenham in June 1940, at the

114 An occasion when the war became more obvious was on 8 June 1941 when Henry Cotton and Alf Padham played a round of golf on Cleeve Hill against W.J. Cox and A.F. Parker for the War Relief Fund. (T. Curr)

time of the Battle of Britain. As the German doodlebug rockets began to hit the south-east in 1944 there was a second wave of evacuation and 38 children came here to safety. The area was also safe enough to receive prisoners of war. Oldacres took as many as 25 Germans and Italians from Ashchurch to help with potato harvests. Smaller numbers or even individuals helped elsewhere, for example at Kingswood Nurseries. The villagers themselves were much more involved in the war effort than during the Great War. Government campaigns urged them to carry gasmasks, dig for victory, observe blackout, use ration books, volunteer as Air Raid Precaution wardens or join the Home Guard, Red Cross, St John's ambulance and the fire brigade set up by Smiths. Some were obliged to join the armed forces, the Women's Land Army or essential industries. Bishop's Cleeve war memorial contains 11 names, two of men not actually living here when they joined up, but missing three more local men. All were young men between 19 and 26. The losses hit the community hardest from 1944 onwards and every loss was a tragedy for family and friends but their numbers were much smaller than in the previous war. Overall living in the country enabled the villagers to continue with their lives much more easily than those living in large towns and cities, even if the night sky glowed with the bombing of places like Bristol and Coventry and in the spring of 1944 the local roads were made impassable by the US tanks being driven to the south

coast in preparation for D-Day. Nevertheless, it was the indirect impact of the war which so obviously changed Bishop's Cleeve and Woodmancote.

PART TWO:

THE ARRIVAL OF S. SMITH AND SONS

The story of the arrival of S. Smith and Sons (Cheltenham) Ltd in 1939 has been well told by Chris Ellis. As part of the government's strategy to create shadow factories in safe areas of the country, 300 acres (125ha) at Kayte Farm were bought for £25,000 in April 1939. This was followed by another purchase of land at Grange Farm. The Grange itself was used for manufacturing hairsprings and the first new building (CH1) made aviation clocks. Although the factory was strictly speaking in Southam parish, its impact was overwhelmingly on Bishop's Cleeve. It is rightly considered that this event laid the real foundations for the present village, as its demand for labour and the associated housing overwhelmed the small agricultural community on its doorstep. How did this happen?

The demand for workers was well in excess of the local population which lacked the high-level skills needed, and so the workers came with the factory. In the short term, nearly 200 caravans were parked in the grounds of The Grange for families, whilst single people were lodged in Cheltenham. Houses were built along Gay Lane and the first ten of the 52 were occupied in March 1941 but Meadoway was only a very small solution. So Bishop's Park hostel was opened in Stoke Road the following year with accommodation for 1200, many of whom, at least in the early days, still had a permanent home in London. Modelled on a Butlin's holiday camp, it soon became an attraction for the villagers with its weekly cinema and dances. The school admissions registers can give us an indication of where these families had come from. All the caravan families came from north London, relocating from Smiths' factory in Cricklewood, but in Bishop's Park there were a smattering of people from the local area, from the Forest of Dean to Cheltenham, thus supporting Smiths' stated intention to train local people for its work. In practice most local people were young females who now had an alternative to domestic service or shop work; in 1942 40 per cent of the workforce of over 1000 were female. In August 1940 the decision to move seemed to have been vindicated when the Cricklewood factory was bombed. In Bishop's Cleeve the factory was protected by elaborate camouflage, which was so successful that a surviving Luftwaffe aerial reconnaissance photograph identifies the racecourse as the military target. On the other side of Cheltenham Road the company laid out a sports field on land that

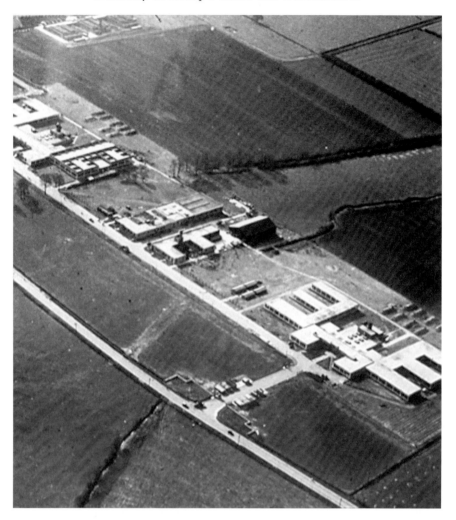

115 Smiths' factory from the air in 1948. (T. Curr)

had originally been planned as an airfield and in 1940 Smiths' Sports and Social Club was established. By 1964 there were 30 different organisations within it, catering for a workforce of nearly 4000. It is perhaps difficult for us in our modern profit-and-loss culture to realise how paternalistic large companies like Smiths could be at this time. The factory bought alternative, clean and modern employment to the area, and in so doing it brought people from outside, reversing almost 100 years of population loss. It was obvious in these years that Bishop's Cleeve was changing forever, but few people could have foreseen the long-term impact on the village of the building of Smiths' estate.

116 Meadoway has changed little since it was built for the workers at Smiths' factory. It still suggests a garden suburb

THE GROWTH OF THE VILLAGES

During the war the question of housing arose periodically, both in terms of the need for new housing and the repair or demolition of historic buildings, many of which were now in very poor condition. In 1943 Bishop's Cleeve parish council was asked by the Ministry of Health to give estimates of post-war housing needs. They replied that there was an immediate need for 12 farm cottages and 30 council houses because 'It is not thought likely that the majority of factory workers at present in the area will become permanent residents'. How wrong they were! At the same time Woodmancote parish council estimated 12 new houses were needed. So, what actually happened?

In 1946 Gordon Payne, formerly the county planning officer, published a monumental survey of the county in which he looked forward towards a better post-war world, writing the words at the top of this chapter. The aspirations might have been too high, but the effects were very real. The Bishop's Cleeve Housing Association was set up, a body largely funded by the government through Cheltenham Rural District Council, which worked with the company to provide housing for the employees. Apart from the council's 'temporary

117 These first six houses in Tobyfield Road were built by Cheltenham Rural District Council for local people before the road was developed for the first houses on Smiths' estate

bungalows' built on glebe land in Woodmancote at Crowfield in 1946 and six houses in Tobyfield Road built in 1947, the housing association was responsible for all the significant immediate post-war development of Bishop's Cleeve and Woodmancote (*colour plates 25* and *26*). As the largest landowner in Bishop's Cleeve and Woodmancote, it is not surprising that Oldacres were the owners of the land where the estate began – between the village and Two Hedges Road. The plan was for 300 houses, a shopping centre, cinema, children's playground, sports ground and community centre.

The building of the estate highlights that the parish council misjudged what was happening. As the voice of the local community it found it had little say in the matter. In the 1948 parish assembly the resolution was carried that 'This meeting strongly deplores the attitude of the Rural District Council towards the Parish Council in matters affecting Bishop's Cleeve, and particularly in regard to housing.' Two years previously Woodmancote parish council had objected to the loss of agricultural land where this new estate was built in the parish of Woodmancote. The 1883 boundary was still in existence and the problems this caused for the estate led to the boundary being redrawn in 1953 largely along the line of the railway. However, the parish councils were not totally neglected and under an agreement with the Housing Association every fifth house had to be made available to tenants chosen by the local authorities. Traditional ways of thinking persisted, for the first five nominees were all

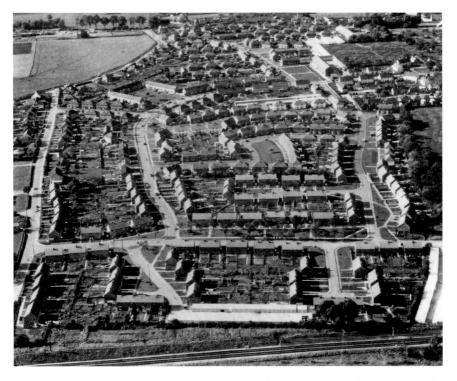

118 Cleeve Estate *c.*1960 showing clearly the second phase of development around St Michael's Avenue. (T. Curr)

agricultural labourers. The Housing Association ultimately became responsible for 478 houses, ten shops, and 226 garages built on 48 acres (20ha) of land at a cost of £1 million. A village green was created in front of the shops and sites were left for a public house (the Swallow) and a church (Methodist), but there was no sports or playground, cinema or community centre, although a home for senior residents was built at the end of Woodman's Way in 1961. The final phase covered the area between Pecked Lane and Tobyfield Road and here at last in 1954 land was left for a playing field, although the parish council complained it was never consulted. This final phrase meant that no one needed to live at Bishop's Park, which was closed in the spring of 1955.

The estate was set out as a garden village completely separate from the existing centre. It won prizes for its design, and it's not difficult to understand how its well-built houses, open spaces and flowering cherry trees earned such praise. Yet today it can appear almost as much as part of history as the much older surviving timber-framed houses in its spaciousness and inconvenient garaging. We forget how few people then owned a car. In 1961 only nine out of 51 households in Millham Road had a car. Those who thought that the expansion of Bishop's Cleeve was at an end must have been disturbed

119 The spaciousness of the estate is still apparent today. The houses on the left were in Bishop's Cleeve parish; those behind them in Hemming Way were mostly in Woodmancote parish until 1953

when the county planning officer addressed the parish council in September 1956. His plans for Bishop's Cleeve foresaw the population rising to 6000 i.e. more than double the existing expansion, with most of it being to the north of the village, and so at a time when landowners might consider that selling land for building was more certainly profitable than the uncertainties of post-war farming and where planning decisions would look favourably on planning applications, expansion continued, but now very largely through private enterprise. Even before Smiths' estate had been completed 24 houses had been built on land at Fieldgate Farm, and nearly double that number in an orchard off Chapel Lane in Woodmancote. Millham Road was completed by the Rural District Council. In Woodmancote developments like Bushcombe Close tended to be in individual fields, but in Bishop's Cleeve development was on a larger scale. In the late 1950s and early 1960s Oldacres sold land at Cleevelands Farm for the Cleeveview estate; Longlands Road was built to the west of railway line to rehouse the remaining 90 families living on the former airfield at Stoke Orchard Park; the Delabere Road estate marked a southern extension of the village beyond Two Hedges Road and the Oakfield Road

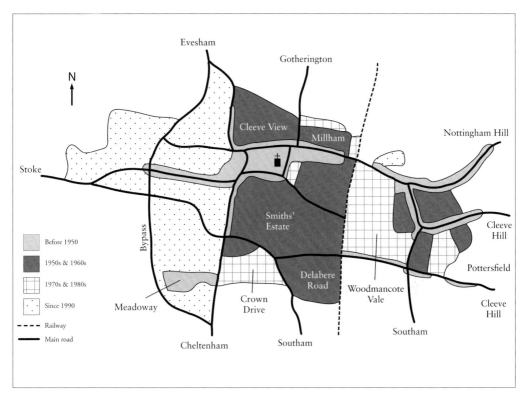

120 Main areas of expansion since 1950

development filled the fields which had once belonged to Bert Long's Pecked Piece Farm. In Woodmancote the Cranford Road development was built on Pottersfield.

The parish councils could complain but to little effect. In 1960 they complained that Bishop's Cleeve was being 'swamped'; in 1967 they opposed J.A. Pye's application to build an estate of houses and bungalows off Kayte Lane, but to no avail. When they were presented in 1973 with the North Gloucestershire Sub-Regional Strategy, which envisaged Bishop's Cleeve would grow to 18,000 inhabitants by the year 2000, they complained that sewerage, water and schools needed to be improved first, but they could not stop the developments. They did, however, have public opinion on their side when a parish survey taken in 1976 showed that 73.5 per cent of the respondents were against further development, but they were powerless to stop it. Perhaps the most contentious of all the developments was that at Woodmancote Park between Bishop's Cleeve and Woodmancote. The villagers and the councils were unhappy that the

121 Crown Drive was built in the 1970s when land could be spared for open spaces. Here was low-density standardised building at a time when small semi-detached bungalows were still an attractive proposition for builders

nature of Woodmancote would become 'suburban sprawl' and that the greenbelt between the two villages would be lost, although nobody ever mentioned that until the 1953 boundary change, houses in Woodmancote parish had been part of the community of Bishop's Cleeve and the idea of a green belt dated only from that boundary change. But despite the objections, the need to increase the housing stock won the day and by 1989 353 houses had been built. Together with Churchfields, on the former playing field of the old primary school in School Road, this was one of the last developments before the large-scale developments linked to the bypass described in Chapter One.

Although the most recent estates are mixed in house size and style so that developments at Dean's Lea in Bishop's Cleeve, and the Collyberry Road development in Woodmancote have been built in a quasi-local tradition, with the houses cleverly arranged to mask their density, the earlier estates have a uniformity derived from mass-produced materials and standardised building methods which provided good-quality housing on similar sized plots at reasonable prices for people who moved into the village and who were not necessarily concerned to keep its traditional face. Unfortunately, this lack of concern led to the demolition of many of the older buildings, before a time when renovation became fashionable. It was this lack of concern which partly

122 It is somewhat ironic that houses on the developments since 1990 have adopted elements of traditional architecture, but the problem of car parking remains

led to the establishment of Church Road as the commercial centre of Bishop's Cleeve. How did this happen?

By the 1940s there was very little commercial property in Bishop's Cleeve or Woodmancote except Cleeve Hill; a dairy built in 1937 in Gotherington Lane; two bakeries, Denley's in Station Road and Edginton's which had been established in Tobyfield Road since 1830; two grocers with only Beckingsale's in Church Road; two small grocery shops in Station Road in Woodmancote; a post office by The Green in Woodmancote and one at the bottom of Church Road in Bishop's Cleeve. In 1939, except for the rural craftsmen in Tarling's yard, Church Road was more known for its public houses and Evesham Road seemed more commercial with Sid Gilder's butcher's shop, Earnest Freebery the shoe repairer, Joe Power's 'motor spirit service station' and George Wick's blacksmith's forge. Yet they have all disappeared as Church Road came to dominate the commerce. At its eastern end lay the abandoned plots of the rector's manor, now used as gardens. Towards Cleeve Hall some of the buildings were the descendants of the medieval half-yardlanders which were now in a very poor condition so that at a council meeting in

123 One of the last links with traditional crafts can be seen in Tarling's yard. The small plaque explains it was a wheelwright's furnace

September 1956 the county planning officer could recommend that about 20 old houses 'in the low category' should be pulled down. These are the houses photographed for Edwardian postcards to show the village as an old-fashioned rural community – picturesque but insanitary (*back cover*). Not until 1979 were the centres of the two villages given Conservation Area status, which would have given some protection to the old buildings, but by then Church Road had been transformed into the commercial centre through the building of lockup shops which although keeping the traditional colouring of (reconstituted) Cotswold stone, were of styles out of keeping with the traditional buildings. In 1968 Edginton's bakery was replaced by a small supermarket and with the shops on The Green and two new shops in Woodmancote, this remained the basic pattern until the mid-1990s when, despite strong objections from many people who felt the village (and its shops) would be destroyed, Budgens supermarket was built at Home Farm and Tesco on the Oldacres' site. The objections had really come 50 years too late. The transformation of the centre of Bishop's Cleeve had already taken place (*colour plates 27 and 28*).

We have now come a long way from two small pre-war villages still largely dependent upon the land. Although the catalyst for change was the arrival of Smiths, the continued growth of the two villages as pleasant places to live has meant that increasing numbers of people are employed elsewhere. This is not new as our study of the 1851 census proved. But workers no longer leave the villages to work as agricultural labourers as they did then. So how have people been employed since the Second World War?

EARNING A LIVING

The rapid decline of farming has essentially cut off Bishop's Cleeve and Woodmancote from their own past. The arrival of Smiths' factory was an important factor, but post-war government and European Community policies have reduced the number of farms in Bishop's Cleeve to a mere handful, all outside the village, and turned many of the medieval enclosures in Woodmancote into horse paddocks for leisure riding. Some fields in the vale still grow grain and sheep can be seen grazing on the few remaining patches of ridge and furrow. They can also be seen on the common during the summer months, and cattle have been re-introduced as part of the conservators' management programme. This is almost the only place where cattle are now seen in our area. Therefore it is not surprising that the 2001 census recorded only 1.8 per cent of the employed population was still

124 Sheep can still be seen grazing on the former ridge and furrow in the vale to the west of the villages. This remains a link with the village's farming past

engaged in agriculture. There can be no clearer measure of how different the villages are today compared to even a century ago, let alone during the remainder of their recorded history. But what of the largest employer, before the arrival of Smiths – Oldacres?

Oldacres continued to expand in the post-war world and not just by acquiring land. It diversified into intensive beef rearing and fat lamb production. In 1953 it bought out W. Ride and Company, seed merchants in Cheltenham; in 1969 it opened a new feed mill in Calne in Wiltshire, at which time it had over 100 employees. In May 1975 it bought the former bishop's palace as its headquarters – a visible sign of self-confidence. The rector had moved in 1972 to a suburban-style detached house by the churchyard – a visible sign he had become an equal among equals as the enormous wealth attached to the rectory was diverted to the Church Commissioners. Oldacres had become the largest animal feed processing company in private ownership. In December 1978 it opened a car showroom, as it became a multi-million pound business with diverse interests. It became a public company in 1984, but then in the next year one of those factors from outside changed the course of its fortunes, for

the European Community introduced quotas on milk production, which directly affected the market for animal food. At about the same time food surpluses began to build up in Europe. Although the company was still profitable, it made the directors think, and a good offer from Unigate of £26 million in August 1986 saw this important local company sold out of local hands. There was no longer a local connection for as Denys Charnock wrote in his book, 'At the time of the takeover, not one of the family lived in Bishop's Cleeve'. Seven years later, Unigate sold it to Dalgety for £23 million. As part of a much larger company, it was now subject to decisions taken far away from Bishop's Cleeve, and in May 1996 the mill was closed. It had been a significant feature of the village for just over a century but now it had become part of its history.

So Oldacres' site in the centre of the village was ripe for redevelopment and viewed by the planners for mixed commercial use. One of the arguments put forward by Tesco for opening its store was the promise of 80 full-time and 120 part-time posts, which instantly made it one of the larger employers in the area. Oldacres' former headquarters was bought by Bovis homes where 120 staff were employed in 2008, at which time Cleeve School was employing over 200 full-time and part-time staff. These three had become substantial employers, but the main employers continued to be Smiths Industries, which became part of the American company G.E. Aviation after a £2.5 billion takeover in May 2007, and Zurich/Capita at The Grange, opened in 1992 with 1000 employees. Both are 'satellites' of much larger companies, and the people of Bishop's Cleeve and Woodmancote have little or no say in their fortunes. In August 1990 Smiths employed 3200 workers but had to lose 450, largely because the government cancelled 33 Tornado aircraft. In January 2009 it was announced 250 of the 1400 posts at Capita had to be lost because of changes in the financial world. It's developments such as these which indicate that Bishop's Cleeve and Woodmancote now play just a very small part in a much wider economy and so are fundamentally different from how they were in the past, even when they formed one manor on the wider estate of the Bishop of Worcester.

There is also another crucial difference comparing employment now with that in the past. Although we know there was always a movement of people in the past, today it is the norm rather than the exception. Most people no longer rely on work in the villages and most people travel some distance to work. The 2001 census can help us to understand this. In Bishop's Cleeve 71 per cent of the employed population (16-74) worked in service industries (in local government, finance, trade and retailing) and 27 per cent in manufacturing. The figures for Woodmancote were 81 per cent and 19 per cent respectively.

The figures do not give details of where people work, but they do give figures for how far people travelled to work. The following table gives the figures, although for Woodmancote the figures are only available for the larger Cleeve Hill ward.

	Bishop's Cleeve	Cleeve Hill Ward
Within 2km (1m)	29%	29%
2 – 10km (1 – 6m)	38%	47%
11 – 60km (6 – 38m)	29%	19.5%
Over 60km (Over 38m)	4%	4.5%
Average distance	12km (7.5m)	13km (8m)

These findings suggest that Cheltenham dominates employment opportunities and that Bishop's Cleeve has become its outer suburb. The percentage travelling to work by car was 77 per cent in both communities and only eight per cent of households in Woodmancote, compared to 15 per cent in Bishop's Cleeve, lacked a car. A measure of how much more mobile people are today, compared to before or even immediately after the Second World War, is that Bishop's Cleeve now enjoys a bus service which runs to Cheltenham every ten minutes. No other suburb of Cheltenham enjoys such a frequent service. Woodmancote has an hourly service, compared to three a day immediately after the war.

The car has increased choices in other ways. A survey of Bishop's Cleeve taken in early 2008 found that this mobility had also given people choices in shopping. It counted three national retailers and 24 independent local retailers in the village. These were enough to make the village itself sufficient for its daily needs, but 54 per cent of the people questioned still drove to Cheltenham for their main grocery shopping, compared to 38 per cent who used Bishop's Cleeve. Eighty-six per cent went to Cheltenham for their non-food shopping. Unfortunately the survey did not extend to the numbers of non-residents who come into Bishop's Cleeve for their shopping, although anecdotal evidence suggests it is considerable.

So how can employment since 1851 be summed up? For most of this period, the traditional dependence upon agriculture held sway, but it did not prevent innovation as shown by the Oldacres and Denleys. The arrival of Smiths Industries had a profound impact, but the developments in the post-war world, the increased access to education, personal mobility, and ever increasing variety of opportunities, have played a key part in changing the historic nature of Bishop's Cleeve and Woodmancote and bringing them into a wider, even global, economy.

125 A measure of the post-war importance of Smiths' estate is that Kearsey's bus no longer ran through Bishop's Cleeve but through Cleeve Estate; a photograph from the early 1950s. (T. Curr)

126 Stella Way industrial estate is a rare redevelopment of a 'brown field' site as it was built where Smiths' hostel had stood. In common with modern trends, the businesses have no need to locate in Bishop's Cleeve. 'Stella' commemorates the cottage which used to stand here

DEVELOPING AMENITIES

Employment has only ever been one of the concerns of living in a community, although an important one. We can now turn to pick up some of the earlier threads, starting with education. As the population increased so did the pressure on the schools. By 1953 the former National School had 580 pupils and lessons overflowed into the Old Manor House in Station Road. Despite temporary classrooms the only proper solution at that time was to open a new senior school for the older pupils. So in 1956, as part of a county council-funded wave of development of new secondary schools, Bishop's Cleeve Secondary School opened in Two Hedges Road, on the very edge of the village on land that had been part of Linworth Farm. Children who did not pass the dreaded Eleven Plus exam no longer had to learn in the same school that they entered at four or five years of age. In 1965 when its numbers had grown to 500 pupils, it became a comprehensive school for all pupils over the age of 11. Forty years later numbers had

127 The new secondary school which opened in Two Hedges Road in 1956 was sufficiently significant to appear on a postcard. (Bishop's Cleeve library)

trebled and many pupils came from outside our two villages. Conversely, some pupils travel out of our area, principally to the schools and colleges in Cheltenham; another result of the increase in mobility since the war. Yet the opening of the new school only temporarily relieved pressure, and by the mid twentieth century the fabric of the Victorian National School was wearing out, so in 1965 the infants moved to a new site off Tobyfield Road, where some of the traditional village orchards had escaped previous development. In 1981 the juniors joined them and so William Lawrence Townsend's National School came back to the church to be used as St Michael's Hall. But still the numbers of local children increased and so in 1973 Woodmancote Primary School opened and in 2000 Grangefields School opened on the landscaped parkland of The Grange, in response to the developments to the west of the village.

When rector Townsend opened the National School in 1847 education was clearly seen as part of the church's responsibility. A century later the link was maintained only by Sunday Schools. It is now hard to realise how important Sunday Schools were in the mid twentieth century, when there was little alternative activity for children on Sundays. St Michael's even organised a short-lived Sunday School at Stoke Park on the edge of its parish. From 1949 another was provided at Bishop's Park which came to be linked with members of the Tin Tabernacle on Cleeve Hill, which also had its own Sunday School.

Woodmancote Chapel had a lively Sunday School and when the Methodist Church was built on its present site in Bishop's Drive in 1959 there were 125 children on its roll. Methodism had reappeared in Bishop's Cleeve in 1951, not out dissatisfaction with St Michael's, but as a result of the post-war immigration into the village. So the old chapel of 1899 again held Methodist services by arrangement with the Women's Institute until the new church was completed. Then the old chapel became part of St John Fisher Hall for a Roman Catholic congregation until this was declared unsafe in March 2000, when the congregation moved across School Road to St Michael's. In the words of the then rector Canon John Mead, 'It was yours originally anyway'. Dr John Parkhurst must have turned in his grave.

The Sunday School was one activity to occupy leisure time – a concept which has become so important in modern society compared to the past. It has been difficult to identify all the leisure time activities of the last 60 years because the records and memories are incomplete. In 1952 the *Gloucestershire Echo* reported the following village activities in Bishop's Cleeve: a Choral Society, Scouts, Cubs, Guides, Girls' Friendly Society, an Annual Horticultural Show and church-run Young Wives, Mothers' Union and Boys' Club. In the 1970s and 1980s each year in April Woodmancote parish council heard reports from all the organisations in the parish. In 1982 the following organisations reported: Youth Club, Junior Boys' Club, Brownies, Guides, Cubs, Playgroup, Mother and Toddlers' Group, Cricket Club, Horticultural Society, Woodmancote Society, Women's Institute, Free Church, Dog Training, Friends of Woodmancote School and Old People's Welfare. In the Bishop's Cleeve list at least two organisations were omitted. The Senior Residents' Association had been formed in 1945 and from 1959 to 1988 it used huts placed on the former Eversfield Pleasure Ground in Priory Lane. Since 1988 it has met in Denley Hall in Churchfields, the name being chosen to commemorate the earlier site. A year after the Association was founded, a branch of the Royal British Legion was formed for ex-service personnel, moving to its present premises by the railway line in the mid 1960s. Some of these groups are local but others are local examples of national or international organisations like the scouts and guides, mirroring in their own way the post-war patterns of employment and retailing.

One of the most important developments in providing activities for the people of Bishop's Cleeve was the purchase by the parish council in 1949 of the former Bishop of Worcester's barn for £500 for a village hall. The Tithe Barn, as it was known, cost over 20 times the purchase price to make it fit for purpose, with Smiths granting £5,000 towards the cost. It reopened in 1956 and has had many uses over the years including being used for meetings of the parish council from 1957 until the opening of purpose-built offices in Church Road in January 2009. Until 1975 it was also the home of the library and of

The Tithe Barn
Bishops Cleeve. Glos.

128 After the Tithe Barn had been converted to a village hall in 1956, it produced a publicity leaflet to encourage hiring

a youth club before the old Elm Tree public house in Church Road was taken over by the county council in 1959. Clubs and societies have mushroomed as the villages expanded rapidly after the war. They now have a choice of places to meet. The builders Bovis provided a community building as part of the Tesco development. The nearby parish council offices, the Methodist Church in Bishop's Drive and St Michael's Hall are all available to community groups (*colour plate 29*). Woodmancote provides its two village halls and the clubhouse at Bishop's Cleeve's football club's purpose-built premises in Kayte Lane is also available for community use. This lies next to the cemetery, built for the enlarged population, and Bishop's Cleeve's parish council sports field which stretches to the Cheltenham Road. Further sporting opportunities are provided at Cleeve School during the evenings, weekends and holidays. The wide choice of leisure activities which we now take for granted is yet another aspect of life which can be traced back to the decision of Smiths Industries to relocate to Bishop's Cleeve.

Activities for the younger inhabitants have continued to follow the nineteenth-century Reading Room philosophy of keeping them constructively occupied. It has worked to a certain extent but anti-social behaviour has continued to be a feature of community life. Misbehaviour by young US servicemen in Skilly Alley in November 1943 led to a delegation of parish councillors meeting with the commanding officer, who expressed his 'complete surprise'. Ten months later the servicemen damaged the war memorial

although they quickly repaired it. Within a year of Bishop's Cleeve's bus shelter being built at the side of the King's Head public house to commemorate the Festival of Britain, it was damaged by 'irresponsible people' in February 1952; in May 1959 the pipes were ripped from the walls. The bus shelter in Woodmancote was also that community's effort for the Festival of Britain but on the same day it was opened in December 1953 there were complaints that it was being used as a goal by young footballers. In 1957 there were reports of Teddy Boys from Cheltenham beating up local boys after dances at the Tithe Barn. The following year the parish council was preoccupied with the need to occupy the local youths to stop them 'lounging about at corners' and the word 'lawlessness' occurs in its minutes three times in three months. The Elm Tree youth club opened in the following year but this did not stop one councillor again complaining that 'lawlessness' was rife throughout the village. In February 1962 the Boys' Club was told to leave the Tithe Barn as members had caused £45 worth of damage. Such accusations of low-level antisocial behaviour are a constant theme throughout the recorded history of our two villages. Just occasionally the other point of view emerges. Only ten residents turned up to a meeting in September 1985 to set up a Neighbourhood Watch and in April 1989 the Chief Constable turned down a plea for extra police because recorded crime had actually fallen. Today's perceived problems have a long history.

WHO GOVERNS THE COMMUNITY?

The years since the Second World War have seen the ability of local people to govern themselves through the parish councils increasingly eroded. They became mouthpieces for the community's opinions but now had little real power. In fact a Parish Councils' Act of 1957 laid down their responsibilities as little more than looking after seats and bus shelters, street lights and car parking. Yet both parish councils still met regularly to debate issues of the day. How were these changing in the post-war world?

The make-up of the parish council actually changed little for over a decade. When Fred Minett of Cleveland's Farm retired in 1946 after 35 years as chairman, he was replaced by William Shipway of Yew Tree Farm in Woodmancote. James Stammers from Meadoway was the first councillor who worked at Smiths to serve on the parish council. He was elected in March 1946, but he was an exception. Another exception was Mrs M.J. Hayes who became the first woman councillor in 1952 and for the next four years it was only because county councillor Mrs G.S. Ward attended the parish council meetings that she was not the only female on the council. Mrs Nell

Whitehouse, the wife of the head teacher at Bishop's Cleeve secondary school, was the first female councillor in Woodmancote when she was co-opted to fill a vacancy in January 1966. In October 1970 she was appointed to chair the council; it took another 30 years before Mrs Vera Ayres filled that post in Bishop's Cleeve.

So what exactly were the parish councils now discussing? Much of the business in Bishop's Cleeve concerned relations with Cheltenham Rural District Council and if there were disagreements, then generally the RDC triumphed. As Cleeve Estate developed we find meetings deploring the fact it had not been consulted over post-war housing (May 1945), being presented with the estate as a *fait accompli* (March 1947), not being consulted regarding over 200 houses to be built off Pecked Lane (October 1958), arguing over the names of the new roads (July 1962) and opposing the Woodmancote Vale development (October 1967). We hear a similar tale from Woodmancote where the parish council objected to Smiths' Estate on the grounds that good agricultural land would be lost (November 1946). It then lost the argument to transfer all this estate into the parish of Woodmancote (November 1949). Although Bishop's Cleeve parish council was successful in the short term in both November 1973 and April 1984 in preventing development along Stoke Road, it came anyway with the opening of the bypass in 1989.

All these examples indicate that since the war parish councils have had less and less freedom to make decisions in the interests of the local community and they are more and more driven by national government directives. To give one example: the current Tewkesbury Borough Council Local Plan to 2011 is a response to the county council's structure plan, which itself is in response to Westminster's Regional Planning Guidance for the South West (RPG10). This puts the continuing debate over the continuing expansion of our villages into its wider context, with local councils squeezed between the residents' wishes and national government directives, which demand over 5000 new houses in the South West. In May 2008 Councillor Mrs Marjorie Everett resigned from the chair of Woodmancote parish council. In the local newsletter she wrote, 'Over the last five years I have been disappointed by the lack of response to our submissions when consultation has been offered'. It sums up well the powerlessness that local councillors can feel in matters which directly affect daily lives.

It is a measure of the perceived powerlessness of the local democratically elected councillors that a trend since the Second World War has been the springing up of single-interest pressure groups. One of the early forerunners locally seems to have taken place in 1957 when Woodmancote parish council polled its residents on the siting of a new village hall on land behind the bus shelter in Station Road. Ninety per cent voted against it and the matter was

dropped. In more recent years Bishop's Cleeve parish council called public meetings in November 1982 (50 attended) and May 1985 (200 attended) to gauge opinion on proposals for 1000 new houses. Yet residents have set up their own action groups independent of the parish councils. A Ratepayers' Association had been set up by 1954 for its secretary was the only member of the public to attend the annual parish assembly in Bishop's Cleeve. A similar group was set up in the Woodmancote in 1967 to strengthen the parish council's objections to the proposed development at Woodmancote Vale. In 1978 it succeeded in preventing the development at the Longlands (now Collyberry) but in both cases it ultimately failed in its opposition. However a consequence of such pressure groups is that developers now feel obliged to take their proposals to the people themselves. One of the earliest took place in March 1974 when 980 people visited a public exhibition outlining a proposed bypass – yet only 40 people bothered to return the questionnaire. The bypass proposals, like those of 1926,1932, 1951, 1954, 1958 and 1960, were shelved; this time because it was said the new M5 motorway took the through traffic away from the village. So it was no surprise that when Tesco announced its intention to build a store in Bishop's Cleeve the company was careful to carry out a public consultation exercise in July 1997. This resulted in a vote of 1200 against the proposals and 694 in favour, which in turn led to the accusation that Tewkesbury Borough Council had betrayed the community when the development was allowed.

Yet some pressure groups have had some success. In 1995 residents fought to prevent a roundabout at the Meadoway – Cheltenham Road junction, but this victory in a small matter only served to emphasise the lack of success in greater matters. The Bishop's Cleeve Village Action Group has formed in March 1996 to prevent development on Homelands Farm between Bishop's Cleeve and Gotherington, which by then belonged to developers Taylor Wimpey. Although the original plan for 1800 houses was successfully opposed, a revised plan for 450 houses was allowed by the Home Secretary after an appeal in 2007. Perhaps the best example of a pressure group is SWARD (Safety in Rubbish and Waste Disposal), set up in 2001 specifically to oppose a waste incinerator and monitor the use of the former sand and gravel extraction sites in Stoke Road which since 1970 had been used for domestic rubbish and industrial waste. SWARD is well organised with over 250 paid-up members, a newsletter and a website and it has succeeded in making the waste disposal companies step up their public consultation even if it has not succeeded in changing their plans. Such pressure groups are now important if only because people feel that democratically elected councillors have little real powers and the low turnout in local government elections over recent years seems to confirm this view.

Why should you have to travel outside Bishop's Cleeve to do your main food shopping?

Dear Resident

We have sent this brochure out to every household in Bishop's Cleeve. It contains a brief summary of the reasons why we want to come to your large village and what benefits we think we will bring.

More detailed information will be available at the Tesco Drop-In Centre, where the Tesco team will be available to answer any of your questions and listen to your views.

At the end of this brochure is a free-paid postcard for you to send me your views. I look forward to receiving them and I will be publishing the results in the local paper.

Nicole Lander
Corporate Affairs Manager

TESCO
Every little helps.

129 The Tesco flyer which appealed directly to the villagers

SO WHAT MIGHT IT ALL MEAN?

When Hyder Consulting produced their report for Tewkesbury Borough Council in July 2008 they summed up their study of Bishop's Cleeve with these words, 'The overwhelming first impression that one gets of the town (sic) is that of an outlying suburb to Cheltenham'. They based this judgement on the extensive housing estates and a centre (Church Road) with its large glass shop frontages and signs 'more in keeping with larger centres'. It is true that the development of this central commercial area came 20 years too early to preserve its historic atmosphere (*colour plate 30*). The area around Woodmancote Green has also suffered in a similar but more limited way. There is no doubt that neither central area strikes the casual visitor as a place with a long history. On the other hand Station Road, Priory Lane and Stoke Road in Bishop's Cleeve and the three lanes running up the hill slopes in Woodmancote have fared better in keeping some historic atmosphere. Through a combination of factors, the arrival of industry, the decline of farming and its traditional dependent trades, increased mobility, directives from outside the communities, the two villages are now modern communities where peoples' lives are immeasurably more differentiated and individualised, yet ironically more regulated, than at any time in the past. The events which brought these changes have been the focus of this chapter.

SOURCES AND FURTHER READING

As indicated in the text, the material now mushrooms and it is necessary to be very selective. Key books for this period have been C. Ellis (ed.) *Smiths Industries of Cheltenham* (Surbiton 1990) and D. Charnock *Oldacre: a Gloucestershire family and business 1881-1986* (Lewes 1990). David Denley's *Eversfield Tea and Pleasure Grounds* (Falmouth 1997) provided the detail about the tea gardens. My own *Bishop's Cleeve to Winchcombe in Old Photographs* (Gloucester 1987 reprinted Stroud 2004) and *Around Bishop's Cleeve and Winchcombe in Old Photographs* (Gloucester 1989 reprinted Stroud 2004) contain images from the period of this chapter. Also my *Cleeve Hill* (Stroud 1990) has a detailed account of the growth of the health resort. J.F. Daubeny's *Cleeve Common Glos: Rights and Regulations over this Common* (London 1900) gives a good description of the common and its uses at that date. P. Cox and N. Furley's *One Hundred Years of Golf and Good Fellowship* (Cheltenham 2003) provides a very detailed history of golfing on Cleeve Common. Hugh Denham's book on Woodmancote has again proved invaluable, especially Chapter 18 for the Woodmancote Vale controversy.

Noel Septimus' *Under a Cotswold Height* (privately published 2003) provides a personal insight into life in post-war Woodmancote. John V. Garrett does the same for Cleeve Hill in *Cleeve Common and the North Cotswolds* (Cheltenham 1993). C. Henry Warren's *The Land is Yours* (London 1944) has a fascinating account of traditional cider making in Woodmancote. J.W. Freebery's *Bishop's Cleeve Then and Now 1927* (privately published 1983) describes Bishop's Cleeve before the great changes. David Wilson does the same for the 1940s in a typescript deposited in Bishop's Cleeve library and available on Mike and Sheila Rall's useful website www.imagesofbishopscleeve.info/index.htm which covers several aspects of Bishop's Cleeve's history including other reminiscences and photographs. Other useful websites include www.neighbourhood.statistics.gov.uk for the 2001 census details and www.swardbishopscleeve.co.uk for details of the activities of SWARD. The survey produced in July 2008 by Hyder Consulting (for Gloucestershire First) is entitled *Tewkesbury Borough Vitality, Viability and Vulnerability Study*. Finally, details of the villagers who lost their lives in the First and Second World Wars can be found in Graham Sacker and Joseph Devereux's *Leaving all that was dear: Cheltenham and the Great War* (Cheltenham 1997) and Graham Sacker's *Held in Honour: Cheltenham and the Second World War* (Cheltenham 2000).

The main primary sources used in this chapter are the minutes of both parish councils deposited in Gloucestershire Archives with reference numbers P46, P46a and P403a. Bishop's Cleeve school admissions were found under S46/1/2/4. The Archives also have a large number of historic ordnance survey maps for consultation. Cheltenham Local Studies Library has microfilm copies of the Cheltenham Examiner from 1839 to 1913 with an index which has been invaluable in finding reports on the reading rooms and on the water supply and sewerage debates. Finally Bishop's Cleeve library has a useful collection of newspaper cuttings relating to Bishop's Cleeve and Woodmancote.

EPILOGUE

SO WHERE ARE WE NOW?

Looking back it is easy to think that the past has led directly to our present. In some ways this might be true. Familiar scenes and circumstances are easier to understand if we know how they have developed over time. But history isn't really like that and I hope I have shown how each age needs to be seen in its own terms – whenever people lived that was their present. If their lives appear as more of a struggle, shorter, less predictable, more reliant on nature than ours, they could not make comparisons with us. Today the individual seems generally to have triumphed over the community and so it is ironical that when we have much more freedom to choose where we live, where we work, what we spend our money on and what we do in our leisure time (a comparatively recent concept), we live in a society where people can feel they have less actual control over their lives than people in the past. I hope this book puts such perceptions into an historical perspective.

We are told we live in a global village. Whilst part of the message of this book has been to try to explain how this happened, the end message must be that people who live in Bishop's Cleeve and Woodmancote today are largely cut off from all but the most recent past. This has happened comparatively quickly, caused in particular by the impact of Smiths' Industries, and in general because our age has largely lost touch with the natural world which for thousands of years directed people's lives. Apart from the relatively few people who have deep family roots in the area or who continue to farm the land, it is perhaps only the importance of place, lying below Cleeve Hill and an Area of Outstanding National Beauty and so well described by J.D. Newth at the top of my introduction, which distinguishes our two villages from many similar communities which have been transformed by modern transport into the outer suburbs of nearby towns. If this book only succeeds in illustrating and explaining how the past of Bishop's Cleeve and Woodmancote really was different from the present, it will have been worth writing and, I hope, reading.

Also available from Amberley Publishing

Life and Traditions on the Cotswolds
by Edith Brill

Price: £14.99
ISBN: 978-1-84868-036-4

Available from all good bookshops or from our website
www.amberleybooks.com